LUCID DREAMING

LUCID DREAMING

Conversations with 29 Filmmakers

PAMELA COHN

OR Books

New York · London

All rights information: rights@orbooks.com
Visit our website at www.orbooks.com

First printing 2020

Published by OR Books, New York and London

"Barbara Hammer" first appeared in modified form in *Still in Motion*, 19 May 2009.
"Khavn" first appeared in modified form in *BOMB Magazine*'s Arts Blog, 29 September 2010.
"Deborah Stratman" first appeared in modified form in *BOMB Magazine*'s Arts Blog, 21 January 2015.
"Chico Pereira" first appeared in modified form in *Filmmaker Magazine*, 3 March 2017.
"Orwa Nyrabia" first appeared in modified form in *BOMB Magazine*'s Arts Blog, 10 October 2014.
"Terence Nance" first appeared in modified from in *BOMB Magazine*'s Arts Blog, 26 April 2012.
"Ognjen Glavonic" first appeared in modified form in *BOMB Magazine*'s Arts Blog, 6 January 2017.
"Adam and Zack Khalil" first appeared in modified form in *BOMB Magazine*'s Arts Blog, 29 February 2016.
The author would like to express her deep appreciation to these publications for permission to reprint those interviews here.

Library of Congress Cataloging-in-Publication Data: A catalog record for this book is available from the Library of Congress.

Typeset by Lapiz Digital. Printed by Bookmobile, USA, and CPI, UK.

paperback ISBN 978-1-68219-232-0 • ebook ISBN 978-1-68219-235-1

In memory of my grandmothers
Rose Franzman and Sarah Cohn

I can't photograph these spaces and show you how to move within them, but I can show you where I went. I can't tell you how long I was there, but I can construct an idea of the time I occupied. The paths and boundaries I created are vaporous and already gone, but the space remains, waiting to be ambled through once again.

—Sky Hopinka, *Around the Edge of Encircling Lake*

Our lives, our stories, flowed into one another's, were no longer our own, individual, discrete.

—Salman Rushdie, *Shalimar the Clown*

CONTENTS

PROLOGUE

A few of the filmmakers, or perhaps certain film and video works, featured here might be familiar to some readers since many of them have been making work for decades. But I've used this opportunity to put together a compilation of voices that likely won't be known to anyone at all, even by many working in the sectors of independent nonfiction or experimental cinema. That is not to say that every artist presented here has not realized major awards, prestigious grants, fellowships, festival prizes, high critical praise for their works and, in some cases, international cinema releases and television broadcasts. But the unchanging reality of making independent film and video work is that the oftentimes quiescent and brief durational aspects of these acknowledgements rarely turn into substantial support for any kind of sustained artistic practice. Whether a maker acquires enough support, financial or otherwise, to conceive, make and complete new projects, or whether he or she is used to working within the confines of a studio using homemade resources, everyone here works in virtual obscurity. There might be only a handful of people to acknowledge or witness their daily toil. The artists represented in this compilation either work with a select group of stalwart colleagues or completely solo—fundraising, writing, researching, producing, directing, editing, scoring, and completing post-production, all on their own.

My hope is that the effect of disparate personalities gathered together in one volume evokes an expansive and global conversation, not merely a series of dialogues strung together. One of the many joys of putting together a book like this has been following the paths the process has taken me down, how the roster that would end up here coalesced purposively (of course!), but also organically, serendipitously, and in some cases quite accidentally. It was only as this wonderful cast of characters started expanding, as each conversation began to emerge, that I started to seek out very

specific makers, ones who would complement, offset, and challenge the other voices contained herein. This is not a box of chocolates—there's not one of every flavor. My purpose was not to introduce these filmmakers as merely representational of a group or a persuasion or a movement. They are artists with something substantial to contribute to the overall discourse of making art in the twenty-first century.

Organizationally, I've selected from my own archive of what I call "legacy" interviews to head each section of the book. These are conversations I've conducted over the past decade. The twenty new conversations were recorded for this compilation between August 2018 and March 2019. The placement and juxtaposition of certain makers in certain sections in a certain order should be taken as an attempt to turn this compilation into an overarching human-scale story. Any of these individuals could slip into any one of the themes presented so it's not really meant to be a hard and fast classification of where I think someone should fall within this contrived pantheon. Right now, there are many talented makers crafting film and video work that reflects the more liminal spaces between fiction and nonfiction, or portrays some kind of enhanced reality wherein discrete aspects of memory and personal history coalesce into distinctive narratives.

This book is meant to capture a sort of zeitgeist moment in nonfiction moving image as it reflects the world around us in very specific ways, encompassing the socio- and geo-political nature of the creative impulse, activism, debate, cogent argumentation, notions of beauty, sonic espionage, borders both mobile and immobile, disruption, visual anthropology, and the specific stories and events that have caused small ripples of impact and change—how certain artists choose to utilize the power of personal histories to tackle legacies of colonization, racism, sexism, ethnic warfare, and the constant endings and beginnings and re-endings and re-beginnings all held in the crucible of memoir.

This is why I always insist—and have insisted here—that we initially engage in verbal discourse. And even though the transcripts of the talks were edited and reworked by both myself and the subjects for the best read possible, their genesis came from a human-to-human conversation, full of grappling, spontaneity, improvisation, and the concomitant awkwardness and intimacy one experiences when you're talking about deep and weighty matters with a virtual stranger.

Fortunately, they all embraced the challenge.

Berlin, Germany
January 2020

YOU CAN HAVE BOTH LOVE AND
ART—BARBARA HAMMER

In Memoriam: 15 May 1939, Hollywood, California–16 March 2019, Manhattan, NY

We know death through life, our vitality and the appreciation of it, and being conscious of that vitality.

Barbara Hammer passed away in the spring of 2019 at the age of seventy-nine. Ten years ago, shortly before her seventieth birthday, she invited me to her Manhattan studio. In an email, I had explained to her that I had started a blog dedicated to female directors and was interested in presenting these conversations and that I'd like a couple hours of her time. Initially, I had decided to dedicate most of my attention to female makers because in this milieu of documentary and experimental work women really shone—as directors, producers, writers, and agents of their own creative visions. This phenomenon was fairly singular in film because that wasn't generally the case with narrative work. A couple of years after starting my blog, Still in Motion, my long-form conversations (sometimes very long) started appearing regularly in various publications such as *BOMB Magazine*'s Arts Blog, *Filmmaker Magazine*, *Guernica*, *Senses of Cinema*, and *DesistFilm*. At the time I met with Barbara, I was basically just an unknown film blogger who she agreed to meet with anyway. It was an essential time in her long career and there was much to share.

There are many reasons to begin this book with Barbara Hammer. While her corporeal presence might be gone, she has left behind an oeuvre that is staggering not only in its fecundity, but in the way her legacy as a lifelong working artist lives on in hundreds of filmmakers creating work today—whether they realize it

or not. Part of this legacy, which she managed very carefully and conscientiously, included giving some of her own footage or materials from unfinished projects away to other makers, materials she had unearthed from her personal archive. One of these instances involved giving some undeveloped film stock to Deborah Stratman, an artist also featured in this book. Deborah made a film titled *Vever (for Barbara)*, which world premiered at the 2019 Berlinale in the Forum Expanded section. The twelve-minute piece consists of a cross-generational conversation between three filmmakers—Hammer, Deborah Stratman, and Maya Deren (1917–1961)—all of whom engage in artistic investigations of power structures, including that of the power of the filmmaker with a camera in her hands. The film grew out of abandoned film projects of both Deren's and Hammer's, the color film material from footage Barbara shot in Guatemala in 1975 while on a solo motorcycle trip. For her film, Deborah recorded Barbara via telephone, and we hear Barbara's voice, scratchy and faded—but her signature laugh and emphatic way of speaking are still evident.

On February 24, 2019, *The New Yorker* published "Barbara Hammer's Exit Interview" by Masha Gessen. Shortly before Barbara died, Gessen sat with Barbara and her spouse of thirty-one years, human-rights activist Florrie Burke. Gessen describes encountering a woman intent on squeezing every precious moment she had left to continue discussing her life and work. This was year thirteen of Barbara's battle with cancer and she knew her death was imminent. Barbara had opted for palliative care—no more treatments, surgeries or other interventions for her illness, only enough drugs to keep her as comfortable and pain-free as possible and able to enjoy her last days in her own home among loved ones.

In the decade since I met with Barbara, she had continued to make work, but much of her time had been spent traveling around the world presenting the films she had made over the course of her long career to newer, younger audiences. She had also continued to put her affairs in order since she'd been so consistently aware of her mortality, finding institutions and archives to donate and house her written and moving image work. An activist (and example) for the right-to-die-with-dignity movement, Barbara penned a lecture titled "The Art of Dying or (Palliative Art Making in the Age of Anxiety)" delivered at Temple University, Yale University, and the Whitney Museum of American Art. She received funding from Yale for her paper archives and used the proceeds to establish an annual award for lesbian experimental artists.

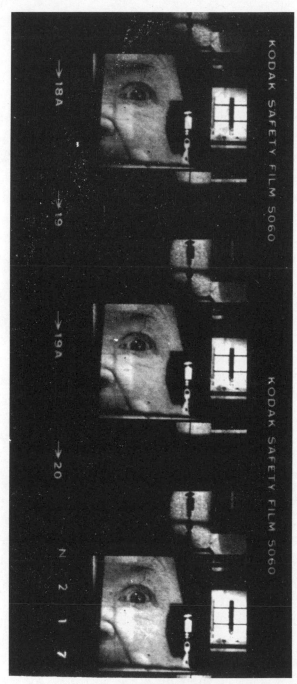

Still from *Optic Nerve*, © 1985. Courtesy of the Barbara Hammer Estate and Electronic Arts Intermix (EAI), New York.

Sensuality and immediacy were markers in Barbara Hammer's work, and she always remained fluid in terms of form, allowing the material to dictate the manner in which she chose to tell a certain story. Her work always strived for three-dimensionality and visceral heft, and she remains alive in that work.

In slightly modified form, here is the conversation I had with Barbara in her Manhattan studio a decade ago, published on my blog *Still in Motion*, on May 19, 2009. Barbara greeted me at the door in the midst of a flurry of book preparations and other projects, gripping the collar of a wildly excited dog she tried in vain to hold in check. Tersely, she informed me that I had an hour because this was all the time she had to spare—although she ended up giving me much more than that. Initially, she was quite intimidating and severe. But as we continued to talk, she relaxed and ended up sharing so much with unending generosity, forthrightness, and her signature flair.

BARBARA HAMMER

PC: The last few years have been an exceedingly intense time, filled with profound transitions. As an artist, a creator, you share a lot about what you've been through recently in your new film *A Horse Is Not a Metaphor*. What compelled you to document your illness and recovery?

BH: Upon discovering I had ovarian cancer, I went through surgery and eighteen rounds of intensive chemotherapy, a very aggressive treatment. I've been in remission for two and a half years. I never thought I was going to make a film of that experience, never ever. When people would ask me about it, I would say no. I went deep inside myself during that time and hung out very quietly and waited for recovery. Then, as I got better, I did feel like I wanted to give people hope because ovarian cancer is pretty severe. I was also able to get women who own ranches to lend me their horses to ride—I love to ride. You know, the C-word helps you get things sometimes. [*Laughs.*] You get on the airplane first, that kind of thing.

But now I've been in remission for two and a half years, the film has been out for about a year, and life has come back to normal. At first I was just so happy to be alive; I still am. I noticed every little thing, like irises pushing through the soil in early spring; those things meant a great deal to me because they helped me to push through, too. Now I find myself wrapping up because once you get a life-threatening illness. . .

PC: You have a few retrospectives next year so you'll have a very well deserved year of celebration.

BH: Yes, a year of travel and celebration. So, I'm getting my archives in order and I also have a large paper archive [pointing to many boxes lined up against a wall of her studio] to get organized by decade, or by film. Now, I need to sell them to a university; there's one that's very interested in the works from the '70s. My archive goes back to the '60s. I kept everything all the way through. I didn't know that it was valuable but there's interest. Universities, oddly, don't purchase film collections. The artist gifts them to the institution. The archive will be compiled and moved out when it feels like the right moment.

Every time there's a completion, there are new beginnings. I don't know what mine will be. The trouble is, I always have a new film. I have a film I'm working on now with a young woman called *Generations: Two Bolex Dykes*. We're waiting on a grant for that. We just did a shoot last Wednesday, so we finished all our filming. Gina Carducci hand develops and cross-processes the work so it looks very do-it-yourself. We still have some sound to collect and then we both will be editing over the summer.

The idea is based on Shirley Clarke's *Bridges-Go-Round*, a film she made in 1958 about the bridges of New York City, a beautiful film. There's a jazz track and also a classical track. When you watch the film, the images are repeated but the sound is different; you feel like you've seen two different films or two different versions of a film. You can't remember that you ever saw a certain shot before, and yet you have. Gina and I are going further with that by taking all our own visual and sound elements. She'll get the packet and I'll get the packet to make our films. It's a mentoring kind of project but we're going to reverse stereotypes since she'll edit in film and I'll edit digitally; we'll have the exact same material and then her work and mine will be joined, displaying two different versions.

PC: How does she perceive herself as a working artist versus your own perception of yourself as a working artist? Are there generational differences that you can discern, different approaches or sensibilities?

BH: I think in Gina's particular case, I wanted to inspire her to make this work because she hasn't made a film for five years. Here's a talented person not using her talent. Like many women and men who come out of college and are used to the structure of that environment—due dates, assignments—once you're out in the working world, you can lose your way. She works at a film lab so she's working with

film all day long. It's hard to generate enthusiasm for her own work there. But she's *so* enthused now. She lives, drinks, and breathes this film. I have to say, "Down, girl!" I wanted to jumpstart her. The letting go will be in the editing process where we each do our own work. If we continued to work together through the editing process, there would be a concern that at the end, she would not make a film again. I don't really think so in this case. At some point, the person who's mentoring wants the one being mentored to recognize her own development and then there's a letting go. This is the reason for this kind of editing structure. She'll realize so much authority.

The other leg up for her will be making the film with me because it'll be shown at the Museum of Modern Art. Her first film is great; she showed it at the Venice Film Festival [*Stone Welcome Mat*, 2003]. The bottom line is that I can't generalize about a generation; I can only talk about this one person that I chose to work with to pass on my skills. She's a technician so she's very measured in her approach to film and I'm not a technician; in fact, one might say I'm the opposite of that. I work very spontaneously. We both mentored one another in those differences. That's the great thing about collaborating. You get to be more than yourself.

PC: What kind of characteristics does it take to be a working artist over the course of a lifetime?

BH: Belief in yourself: that you're worth it, that you've got something to say and that it's important to say it.

PC: Does that belief ebb and flow? Is it fairly consistent? Do you have a choice in the matter?

BH: For me, it wasn't so much a choice as much as it was a compulsion. I was driven to make work. I felt like I had a lot to say, especially after I came out. In my film history classes there was absolutely no women's cinema, let alone lesbian cinema. I spent a whole semester watching films at least three hours a week in this class and then we finally saw the films of Maya Deren. Then I knew, for sure, I was a filmmaker. There was a whole blank screen to be filled. I guess after a while I thought if I kept making work, it couldn't be ignored. Stan Brakhage was my model; he made a hundred films. Like him, I have discipline and a commitment. I don't think you can make discoveries in your work unless you're at it every day—discoveries in writing or interviewing techniques, whatever you're doing. I have chosen to make this my life's work. An option to do something else just never came up.

PC: Tell me more about how the discovery of Deren inspired and informed your own work.

BH: She was not only the director of her own films. She was *in* the films. Her presence in her films exhibited a kind of creative imagination I'd never seen before. You knew that an image of a person clad in black with a mirror had come from her own aesthetic decision or dream or vision. It gave me, and many others, the strength to believe in my own vision and put it out there, to not do a traditional narrative or a traditional documentary but to work in film as a poet. That's what she writes about.

Also, there's *Man With a Movie Camera* by Dziga Vertov from 1929. That inspired me because of the spontaneity, because the camera was a protagonist. Somehow the camera's always been my friend. In fact, in one of my films, *Sync Touch* from 1981, I take it to bed with me. People film me with my camera in bed. Or you can feel the camera as it's swimming underwater with me in *Pond and Waterfall* [1982]; you feel the presence of the gathering of that light by this machine. When I use the optical printer, I try not to hide the fact that I'm using a printer; I show the frameline and you hear the click of the printer in *Optic Nerve* [1985].

PC: You also pay a lot of attention to sound and music, creating really rich counterpoints to your visuals.

BH: I've also done some experiments by leaving the sound completely off. In the instance of *Multiple Orgasm* [1976], you see eight orgasms on the screen, four vaginal, four facial, and I left it silent because I wanted people to hear their neighbors in the theater breathing. But everybody held his or her breath so that didn't work. [*Laughs.*] Another film in which I experimented with this silence was *Pond and Waterfall*, which I just mentioned, an underwater film. I wanted people to be aware of how much water they have coursing through their veins and in their blood. So I brought stethoscopes and had members of the audience wear them and listen to their blood flow so they would have their own personal soundtrack. I also ended up chucking that because everybody was spending so much time looking for some area on their body to listen to, they missed the film. So those films both remain silent experiences for the viewer—as much silence as there can be, anyway.

But I like to work with composers. Meredith Monk is someone I work with a lot. Neil Rolnick is another one, as is Helen Thorington. There's also Pamela Z. I'm lucky to have been involved with a number of composers who bring their talent to the films. I specialize in visual imagery; they specialize in aural imagery.

For me, filmmaking is a very singular process, a very internal process, but sound collaboration is something I'll always be interested in.

PC: How has your relationship with audiences changed from early days? Have there been certain times when your work seemed to resonate more forcefully than at other times because of what was happening in the larger culture?

BH: In the late '60s and through most of the '70s, I didn't know there were places to show films like museums or cinemathèques. I showed my films at women's centers, dyke coffee houses, bars, community centers, anyplace where there could be a projector installed and a wall to project images upon. One day, Terry Cannon called me from the Los Angeles Filmforum and invited me out of my community in San Francisco to come down to L.A. I went down and was given a check at the end of the screening, imagine. I showed my lesbian films to a mixed audience, most of them not gay, I don't think. People enjoyed them. I got paid for it. There was a program, an announcement in the *Los Angeles Times*. I saw a whole world open up.

Audiences have definitely changed. They're more sophisticated now. But people also like to peg you. Audiences get stuck in their ways just as much as any of us. I made a dozen documentaries during the '90s, essay documentaries for the most part; some are more traditional. When I returned to experimental film with *A Horse Is Not a Metaphor,* I think most people who knew my name thought I had made a straightforward film on what it's like to have cancer. But they wouldn't be familiar with the depth of imagery I used, the layering I used for the emotional development of the piece. Maya Deren talks about this poetic way of working, how a poem carries emotion versus how a story carries it. This poetic way of working is when images build upon one another nonlinearly. These build in *Horse* through superimposition. So this is a way that I let audiences know there's been a change in the way I'm approaching current work. It behooves all of us to mix it up a bit and be more open to different ways in which an artist might work.

PC: The stakes are pretty high for artists now and being creative in the work is not enough anymore, somehow. The creativity has to extend to how you supplant that work into the larger community. It's called outreach or audience engagement in documentary circles.

BH: I never chose to make big budget films, which might be an expectation after a certain point in one's career. I never chose to make films that would be shown commercially. I don't think about meeting anyone else's expectations. As we spoke about before, we're all definitely more sophisticated—we have the Internet, YouTube

where you can see literally anything, anytime; we can download programs whenever we want. But still, experimental cinema doesn't have its place in the world that it should have. It should be just as strong as documentary film.

PC: Why do you think it isn't?

BH: I think for the simple reason that young people aren't exposed to it. How many eighth graders see the work of Maya Deren? I've taken my films—not the sexual films, but the underwater films, for instance—and shown them to kids that age. They all get it, of course.

PC: What you also have in your work, to a large degree, is a lot of joy and humor that's very childlike, no matter the subject matter or how it's treated. That resonates deeply with anyone of any age. It's very effective in breaking silences, breaking societal rigidity.

BH: I agree that by being playful you can change people's minds. But it's not like it was a conscious decision to use humor for that effect or to think of play as a political strategy. It is, but I wasn't conscious of doing it. I just think it's more fun; I mean if you can find a way to enjoy, especially if you're not getting paid for what you're doing as many of us artists are not, well, we have to find our own pleasure. Pleasure can be in the making of work or the discovery of a creative impulse; concomitantly, you get to share that pleasure with others.

PC: What's happening in experimental work now that excites you?

BH: There's a feeling that anything can be art right now. It's a period where a certain kind of art like "abstract expressionism" or "geometric art" or "feminist art" is not dominating the field. In other words, everybody is out there working. There's a rebellion against the wealth of the '80s and '90s before the recession. So that if you make something out of ice cream sticks and Kleenex, it's a good way to show a creative piece made by a creative mind out of the simplest materials. I think it's an attempt to shake up the curators and collectors and the big auction houses that have raised the prices so high. Those things become a truer sign of the times. And, in turn, they are curated, gathered, purchased. It's cyclical.

PC: For your forthcoming book, what themes emerged for you as you were writing it and structuring it?

BH: Essentially, the book is organized by decade. It's the easiest way, really, because in each decade, I took my work in a different direction. In the '70s it was a time of coming out, both physically and in my film work. I wanted to put lesbians on the screen in the 20th century and into the 21st, so there were a whole group of

films that did break taboos from that period. In the '80s, I wanted to be known as an artist because I was only known as a lesbian filmmaker. That wasn't the way I defined myself; I defined myself as an artist. I kept working on films that exhibited at the Museum of Modern Art until I got my own show there.

There was also the thrill of working with the optical printer. I tried to become a painter before I became a filmmaker but I decided I could use every frame as if it were a painting. With the optical printer, I was able to paint the film as I did in *Optic Nerve*, a film about my grandmother when she was in a nursing home. John Hanhardt saw it and asked that I send him a print. He called me up, told me it was brilliant and that he wanted to put me in the Whitney Biennial. That put me on the map as a film artist in 1989. From there, we move into identity politics in the '90s but I felt I had already been there way before then. I was doing that in the '70s. But I returned to it with more of a "cultural studies" bent and brought theory into my practice, developing an intellectually rich cinema, as well as this hallmark of sensuality that I'd been doing since the '70s. Now, in the 2000s, I'm looking at mortality; I'm looking at death and that shouldn't be something that we're afraid of talking about.

PC: That's the taboo of all taboos, seemingly, beyond anything else.

BH: Indeed. I'm reading David Rieff's book on Susan Sontag and her fear of death. [Rieff is Sontag's son; his book is called *Swimming in a Sea of Death*.] It's quite extraordinary because she was such an intellectual and faced so many things but had such a difficult time coming to terms with her own demise. That's been in my films since '89 or '90 where I danced with a skeleton, looking it right in the face in *Vital Signs* in 1991. But that's quite different than having an illness and seeing your own bones deteriorate because the chemotherapy is destroying them. We know death through life, our vitality and the appreciation of it, and being conscious of that vitality. All that is coming together in the work that I've made and am making now. The book has newly-written intros to each of those periods, followed by reprints of articles I've written. There will also be the first thirty pages of a novel I wrote in 1970. So it's a diverse collection touching on many things: sexuality, film form and structure, the politics of abstraction. It's more of a compilation, not so much a memoir that I sat down to write except for these introductions for each section. It's tedious right now because I'm checking facts and dates, getting permissions from photographers, trying to track them down. I'm also working with an amazing editor. Amy [Scholder] comes over and looks at photos with me because they're too close

to me. It's too hard for me to see objectively and I really respect her eye. My partner Florrie Burke helps me with the writing sometimes since she's so good with the English language and grammar and Amy does the fine corrections. So that's where we are. When I get the galleys back, we'll do the whole process again. It's a lot of work but I've always wanted to have a book. I always wanted to be in the library.

PART ONE

ANTONYMS OF BEAUTY

Khavn, Roberto Minervini, Khalik Allah, and Shengze Zhu are all products of the places they've called home, whether they be native or adopted citizens of their communities. They all share a feeling of deep connection and rootedness, using those influences in their art making. These makers have crafted their storytelling methods and narrative styles in relation to their particular home environments, unveiling what some of us might call the underbelly of society—people and places otherwise all too easy to ignore.

KHAVN

According to Filipino artist Khavn there are "divine intersections" everywhere you look. I believe my first encounter with him in early August 2010 to have been just that; I was inspired and refreshed in his presence. Musician, poet, writer, film-maker, Khavn is known as "the father of Philippine digital filmmaking." He's made twenty-eight features (and counting), including *Son of God*, which recently premiered in Copenhagen at CPH:DOX, and more than a hundred short films, many of which have received prizes in international competitions. Khavn is also an acclaimed composer, songwriter, singer and pianist, having produced several albums (sometimes writing an entire album in one day) with his band Vigo in addition to staging several rock operas at the Cultural Center of the Philippines. The Isola International Film Festival in Slovenia recently showed his film *Cameroon Love Letter (for Solo Piano)* accompanied by a live musical performance. He is currently working on his "craziest, biggest film to date" *Mondomanila* and completing his fourth book of poetry entitled *Shockbox*. He often describes himself as lazy.

Though he sat still for the entirety of our talk, I noticed over the course of the week that Khavn had an odd habit of literally jumping up from his seat as if an electric bolt had gone through his body and taking off down the street at a fast clip, his peripatetic muse caught by a flash of color, an interesting scent, or some other high-frequency sensation that shifted his inner compass and commanded him to follow it. He was gone, seen suddenly in the middle distance before you knew what was happening.

PC: The proliferation of your work is staggering. I come from a world where it takes some filmmakers several years to finish one film. You come at your work in such an intensely focused, obsessive, and unfiltered way.

K: If I came at work in a more structured, commercial, strategic way, I don't think I would have made the films that I've made. It is intuitive. I make music, too, but I really came to my voice through writing poetry, writing sometimes several poems a day. I was definitely more prolific in that than in cinema. But in making cinema, I've tried to apply that same creative momentum. There are a bunch of independent filmmakers in the Philippines who were quite big in the '80s and created an underground movement in Manila. But, ultimately, whether their goal was to make a feature film or some bigger commercial project, they never did. Something blocked them, and I attribute that to this idea of momentum. If you stop, somehow it's hard to start up again. In a way, Woody Allen practices this type of momentum by making one feature a year.

PC: He's also a filmmaker who's faithful to his own personal rhythm, or perhaps he can realize what's possible with the resources he's able to gather together in a year's time to do another movie.

K: Yes, you also might arrive at this rhythm because external forces are making it possible. But I believe that if there's this unfiltered energy, as you put it, a filmmaker can shoot every day. That's why I'm a bit lazy when I travel to festivals. I don't bring a camera with me because if I have my camera with me, I'll automatically start to shoot and make something. There's a risk of not doing anything else. One of my idols is Rumi, the Sufi poet. He stopped writing down his poetry at a certain point; he just spoke it and someone else wrote it down because he couldn't keep up with his own creative flood. I'm very impressed with that kind of energy flow.

PC: Can you explain what you're reacting to in the environment where you work? You make everything where you live.

K: My father was always sort of against the idea of travel. When I was young, I wanted to go places, "find myself" and all that, you know? But he told me that I didn't have to go anywhere. He told me that I could just go deep right in my own little space, right where I was. Half of my films were shot in one neighborhood but you'd never know that. My cinema is also a reaction to most mainstream movies made in the Philippines that are very much influenced by Hollywood, and a reaction to Hollywood itself, which dominates most movie screens there. I have this manifesto called Day Old Flicks. It's coined after "one-day-old chicks," a type of street food you find there. [These are, literally, one-day-old male chicks batter-fried and dipped in red chili sauce eaten whole, bones and all.] I've made feature films in a day. Shooting a short film over the course of several days is a luxury for me.

PC: There are pieces you work on solo and then there are pieces where you have a full crew working with you. How do those collaborations play out for you?

K: It's definitely all about the alchemy. Each soul in the crew and the cast should connect in some way, for better or for worse. Of course, if it's for the worse I don't work with that person anymore. [*Laughs.*] But what comes out of that, I value. I've been working with the same cinematographer and editor for about five or six years. It's a matter of trust. That's why I brought them in in the first place. You can't help but just learn from mistakes and you don't know if people are trustworthy until you work together, so that's necessary. When your life develops, your art develops. You can't separate one from the other.

I once was making a parody of a Hollywood action movie and the hero, the actor that was playing the main protagonist, backed out after one day of shooting. There was the option of scrapping everything and starting again and getting another actor to replace him. So I did that. But I cast seven different actors to play the same character, all wearing the same outfit. I wanted to make a comment on the "thousand faces of a hero." This is the prerogative of cinema versus let's say writing. Literature on paper is static; it lives there like that forever. But cinema cannot be limited to the screenplay or to the actual production, or the shooting. It's about everything that happens. That's what makes the film.

PC: And when there's an expensive apparatus engulfing you? What happens then when there's not a whole lot of space, time, or money for experimentation?

K: I worked with a really large cast and crew for one of my first short films, a very expensive endeavor. After that I decided to make films differently—not less quality, but definitely cheaper. A more expensive piece doesn't mean it's better. I remember trying to practice "real" filmmaking the usual way people do it and I fell flat on my face and my pockets were full of holes. I really rely more on alchemy and if the project fails at least I can fail proudly. Filmmaking is crisis management most of the time so you do value each moment that works.

PC: Would you be a different filmmaker if you lived or worked somewhere other than Manila?

K: Yes, probably. It's like some plants, you know, or some animals, some cockroaches, that might adapt or might die when their environment changes. But that's a "what if" question so I really don't know. I only can guess about what I would have become if I had lived in a different culture, been brought up in a different family. I'm very much a product of my surroundings, my history. I've also done a few films

outside Manila but only just because I happened to be there. Those times when I wasn't lazy and did something. Or I've been forced to do something. I do rely a lot on external imperatives. It's great to have an internal imperative and want to do certain things because your soul will die if you don't do those things, perhaps. But external imperatives like deadlines for commissioned work are essential to grow as an artist, I think. In some way it unleashes dormant ideas or impulses.

My first writing was done as an exercise in class, to compare writing poetry to flying a kite. I would never have done that on my own, thinking it was a stupid or mundane exercise. I wrote that assignment because I was a student and the teacher told us to do it. After I wrote it, the teacher was very pleased, and the editor of the university journal was very pleased so I became a poet. Okay, now I'm a poet! I must write more poems! It's like a tap on the shoulder. It is encouraging. It gives you a foundation of confidence that, maybe, helps you go through all the blocks, the negativity, along the way. You're able to get the job done. There are many schools of thought. One is, "You either have it or you don't." I also believe, though, that anyone is capable of being an artist or of expressing a passion in an artistic way.

PC: What stops people, do you think? Can we really be a world of artists? Would that work? Why aren't we all making art every day?

K: Well, it's valid if you're just not into that. But also I think a lot of people are just discouraged. Maybe it was just a bite that set them back and that was enough. Or maybe it was a real bulldozer. But whatever it was, it was enough to discourage them. I just met a friend here in Kosovo who was discouraged to become a painter because her father bought her a canvas. That might seem like encouragement but she interpreted it as pressure, as something negative. *Fuck painting!* Even though now she realizes she really loves painting. It's tricky.

When I started playing music my teacher told me I had talent. I thought that was bullshit and that he said that to every student to make them practice more. And it *was* kind of drudgery, the daily practice and all—until the day I was really inspired to be a musician. That wasn't based on his praise or encouragement. I think it stemmed from envy. A high school classmate of mine got an award in a music competition. That was it. I was playing music day in and day out like crazy. I always have a really long list of things to do before I die. And the list changes all the time. And some things remain. It keeps me going. When I was deep into writing poetry I was so impressed by Pablo Neruda. He wrote until the day he died in

his own Isla Negra. Maybe that's the kind of life for me with music and cinema, maybe something else.

PC: I've just recently started to get the opportunity to jury at festivals. You jury quite a bit. How is it for you to judge other people's work?

K: I like it. I think the premise here, as we've stated, is that I'm lazy.

PC: Yes, we keep coming back to that.

K: Yeah, I'm the lazy brown fox. I'm forced—yeah, back to the forced thing, too—to watch these films that I wouldn't watch unless I'm in this situation. Some things you like, some things you don't like, but it definitely effects and adds to my cinema, my views, my life. Judging other people's work also becomes about discovering myself. Among an array of elements I discover that I'm attracted to this one; I don't like that one. And, of course, the other jury members think differently because we're all unique individuals. It's a discovery that I like certain things that I never thought about before. You fine-tune your aesthetic, as well, on a conscious level. I'm usually subconscious, unconscious, intuitive. I do things just because I'm compelled to do them. In his poem "A Ritual to Read to Each Other," William Stafford said it's important for awake people to be awake and that it's also important for dreamers to sleep.

PC: So besides your laziness, what do you consider your most valuable asset?

K: I'm not a very religious person, but I do love the prayer of St. Francis of Assisi. "Make me an instrument of your peace." I believe that an artist is a vessel. You can be an instrument of peace. You can also be one of destruction. Life is manifesting itself and passing through you, reflecting your interpretation back to your audience.

PC: What do you get out of it?

K: The privilege of being that instrument. But, as I said, I really value the momentum that's built from this outpouring of work. The dynamics of it can certainly change. It's just really important to not ignore the muse.

PC: It also takes a really strong person to encounter that muse every day. Many artists' instruments just get busted and they never recover from that. You seem like a very healthy artist, if that doesn't sound too presumptuous.

K: Well, there are some of my films where you see the contrary, my distinctly unhealthy side.

PC: But it's unleashed in your work; it's not eating you from the inside.

K: My films are varied in style, subject matter, and tone. But most of my songs are sad love songs. Pop culture as it's expressed in the Philippines is *very* hopeless.

[*Laughs.*] I write a lot of songs when I'm brokenhearted, depressed, and I use song-writing as catharsis, as therapy. One way not to implode is to explode on a regular basis. Not just a simple explosion but a productive one, while following your bliss. An explosion in which you're being negative, criticizing other people, utilizes that energy in a bad way. If you just go about creating your body of work, nurturing your life, then your life becomes your statement. That's it. You can't be everywhere your work is, but that work can speak for you and represent your presence even when you're not there.

ROBERTO MINERVINI

Twenty years ago, Roberto Minervini moved to New York City from his native Italy. After some time spent working and going to school there, he and his family moved to Houston, Texas. Since becoming a southerner, Roberto has established himself in the local community. When he started making feature films in 2011 after making a handful of shorts, he continued to be inspired by the people of the Gulf Coast. The topography of the region is mostly marshland, with many barrier islands, peninsulas, hidden bays and inlets. One could get lost—or hide—in that landscape quite easily. It's also a region hard-hit by forces of nature that have left great swaths of Texas and Louisiana barren and de-populated. In 2005, Hurricane Katrina struck the Coast causing billions of dollars of damage. Thousands of people—specifically, the poor of that region—died, went missing, were severely debilitated, and became homeless. Three years later, Hurricane Ike caused further devastation from the Louisiana coastline to Corpus Christi on the southern coast of Texas.

Roberto has connected so deeply with the people in this landscape because he, too, went through troubled times and upheavals of his own, finding solace and camaraderie with others who were burdened by economic struggles, drug addiction, and loneliness, existing in an almost constant miasma of uncertainty and fear. The inhabitants of this region became his close friends, as well as the subjects of his films. Together they created customized portraiture combining observational filmmaking with dramatization, transforming the material into raw and urgent stories. In the span of only half a dozen years, the same small team would produce, write, shoot, and edit five feature films, some of the most riveting cinema of the last decade.

The Passage was Roberto's first feature, written by him and his wife and producing partner Denise Lee and edited by Marie-Hélène Dozo, who has cut all of Roberto's feature films. In this film, we meet the Carlson family, the cast a mix of actors and non-actors. *The Passage* would be the first of three films that came to be known as The Texas Trilogy. In *Bassa Marea* (*Low Tide*) (2012), Roberto's main protagonist is a boy of twelve. His signature style of directing young people in naturalistic performances would become emblematic of his work. The following year, Roberto would make his breakout film, one that garnered a lot of attention, titled *Stop the Pounding Heart,* the third film in the trilogy. It features the Carlson family once again, the story centering on the eldest daughter Sara, a young woman from a deeply fundamentalist Christian family, living in a seemingly isolated rural community, struggling with her faith. Roberto extracted astonishing performances from his cast who played versions of themselves, real life and fiction seamlessly conjoined.

Roberto's follow-up *The Other Side* débuted at the Cannes Film Festival in 2015 as a selection of Un Certain Regard, the festival's curated showcase for directors working outside of defined genres or forms. The film centers on the lives of two drug addicts—again, people Roberto knew intimately—living deep in the bayous of Louisiana, home to destitution, desperation, and a landscape roamed by anti-government right-wing militias who train there. Even though he started to be celebrated with retrospectives and spotlights at this point in his career, Roberto remained a very private and fairly elusive man, an intellectual from an Italian working class background who happened to be completely at home in an unexpected pocket of the American South. He cherishes his anonymity there.

His latest film *What You Gonna Do When the World's On Fire?* is a bit of a departure, but only in subtle ways since his means and methods of working with those appearing before his camera are very similar to his previous work. Four stories dovetail to create a portrait of the inhabitants of poor Black neighborhoods in New Orleans, as well as a rare glimpse into the inner workings of the local chapter of the New Black Panther Party for Self-Defense, a beleaguered, deeply-divided and, since its founding, persistently controversial organization. The film is as politically and socially complex and fraught with contradiction as Roberto's other films, and took him out of his comfort zone more than ever before.

In early autumn 2018 when we spoke on the telephone about the new film, Roberto was convalescing at his home in Houston after one of his lungs had collapsed. I'm not sure if it was a combination of this physical vulnerability, being in the

comfort of his own home with his children playing in the background, or his current state of mind, but I was so gratified and enchanted by our conversation because of how open and unguarded Roberto chose to be. He spoke passionately and at length in his Italo-Texan accent from a profoundly personal place about fear, trust, white supremacy, and the odd disappointments of being a celebrated filmmaker.

PC: In *What You Gonna Do When the World's On Fire?*, you introduce us to stepbrothers Titus and Ronaldo. Titus, at only nine years of age, is a petrified little boy. He's afraid of everything around him. His half-brother Ronaldo is his foil and also his protector. He's a pretty centered young man in many ways, wise beyond his years, as one would be if raised in a war zone like that, having to act as the man of the house. His dad's been in prison most of Ronaldo's life. How did you meet them?

RM: While I was hanging out and doing research in the neighborhood, there was always a lot of music playing. We all played guitar together and listened to jazz and we gathered some of the children in the neighborhood to talk about music and the history of the Black musicians in New Orleans. Ronaldo was one of those kids. I noticed him with this proud look he has, with his chin up all the time. This is body language the boys inherited and learned from their mother and from the streets and from school. A lot of the African-Americans I met told me they were raised to stand tall and look proud.

I went to their home to get to know the family and that was the day that the street was blocked because there had been a murder. I remember that Ronaldo opened the door and came out and I asked him what happened. He said, "Mom, what happened?" She said she thought somebody had gotten shot. And they went back and forth with him asking questions and her answering him about this murder. I mean, it wasn't a normal conversation. You don't get used to that kind of violence and you don't get used to that fear. But the tone of the conversation was pretty matter of fact, nonetheless. That wasn't the first time that happened. It was terrifying for us, though. It was a very raw introduction to the lives of these children. And they see it over and over again, this kind of violence. You constantly hear gunshots in that neighborhood.

So I started hanging out with them more and observing their behavior. Titus has his own way of dealing with constant fear of the dangers out on the streets. They're educated to be very watchful, to watch their backs at all times—in school, in the streets, when they play basketball, when they go around the corner, when

they open the door. Because he's a child, Titus copes in a way that's childish but he's very aware of what's going on. But he also wants to experience moments of joy, to experience being a child, to not be dealing with that all the time. So he responds to things often with joy and frivolousness and a lot of affection. He always wanted to be hugged and was constantly asking me, and everyone around him for hugs. We would have sleepovers with my kids. I have a boy and a girl who are eight and six. But then there are times when Titus shuts down completely and gets this very proud look on his face and ceases to talk at all. You can see this in the scene by the river and in the boxing scene. That's what he would do when he had to go back home, when he had to separate from us. He would go silent, go all serious. This fear and anger is all inside and he shuts down. On the other hand, Ronaldo is very guarded most of the time. He's also a very young boy but protects himself and weighs his words carefully before talking. They're products of this teaching from their mother and their environment.

PC: You always have very strong women at the center of your films. Here, there is the boys' mother Ashlei; Krystal Muhammad, the national chair of the New Black Panther Party for Self-Defense; and Judy Hill, the de facto mayor of sorts for the neighborhood, a community leader. So many aspects of being a Black woman in the South are portrayed. These are women who have no problem at all revealing their deepest fears and thoughts and encouraging those around them to learn how to do the same. The men are shuttered but the women bond over their shared pain.

RM: All of the people I spend time with and get to know and decide to make a film with are able to articulate all these issues—the bigger social issues that each one has experienced firsthand and can talk about very well. All of these people have something in common despite the differences of their stories and that is the wisdom that's accumulated during their lifetimes. Their conditions are not extraordinary. We find many times that the woman is the head of the family, carrying the burden of raising the children, keeping the ship afloat. This is because thirty percent of the Black male population is in prison in this country or moving in and out of jail. That's a statistical truth in America.

So my task is to find extraordinary people who tell ordinary stories. I don't mean ordinary in a derogatory way, obviously. It means it's a collective common story. Their individuality, for me, exemplifies a consciousness of this collective memory. Their stories tell a larger history and that's why I choose them, because they have this experiential wisdom.

Krystal as a natural leader has a different presence and then there's Miss Ashlei who for the first couple of months during shooting wouldn't speak to us at all. It was "good morning" and "good evening" and that was it. She was more interested in monitoring the kids and dealing with the situation of people coming from this other world as a protective mother would. She did open up eventually but only after she observed what was happening for several weeks and then she gave herself to the camera. Judy is the carrier of this collective consciousness and also plays a protective role. She refers to her own experience a lot, her time in the streets. She's very respected in the neighborhood because of that wisdom.

PC: The rhetoric at the heart of this film centers on the ongoing genocide of an entire culture. What, if anything, does all this have to do with your decision to shoot in black and white? Why is the film leached of color and how did you and your cinematographer Diego Romero discuss this?

RM: We were both aware that using black and white would trigger very impulsive and negative reactions and that there would be debate around that choice in terms of substance, form, and message. We talked about all that and felt that that was a very necessary debate. I mean it's nothing to do with black and white racial discourse. Maybe we could say the first layer of this debate is the timelessness of this issue, this continuum of the Black experience. For us, it was important to show this continuum. The push of the struggle somehow also can become dissipated in a context where we find ourselves talking about color blindness, the dissipation of collective memory for each race. The eras in which this struggle has taken place is not that far back in time. The fight for equal rights and the reality of the lack of equal rights hasn't changed.

A sub-point to that is that the continuum that exists in history is also within the film. It exists both outside it and inside it. There's also the continuum of these stories we hear. Despite the different geographical contexts where these micro-stories are taking place, there is also a continuum. For instance, what does it mean to be a woman in a household where there's no male figure? What does it mean to a child, a boy, when the father figure is lacking? What does it mean to be a Black person in a certain socio-economic condition? That has everything to do with class and of course there's next to no mobility between the classes in America. It's a continuum of situations and stories within the film as it is in society.

If I had presented this film in color, this would have immediately established a hierarchy of beauty among the stories, the very opposite of presenting this continuum

of related stories. When you move from one story to another, the attachment to the story would have changed if we had used color, the degree of attachment or the empathy one might feel. It would change. Beauty and ugliness affect audiences. Why didn't I want that? It's because color and the beauty of color is a white European concept. It is *our* cultural take on beauty, which has nothing to do with the Black experience and that's why I absolutely didn't want this hierarchy of beauty placed within the film, based on something that comes from white Europe. For all of these reasons we discussed, we felt that shooting in black and white was the right choice.

PC: Let's talk about the New Black Panther Party for Self-Defense and your negotiations and relationship with them as you filmed them on their perambulations around the communities where you were shooting. In the film, they're portrayed as an amalgam of neighborhood watch group, a sort of philanthropic band of people who bring food to the homeless and the destitute. They're also a radicalized political faction, as well as an extended family for many of its members.

One scene that was so affecting for me was when Krystal is literally yelling at a closed door at the police station with that mighty uncomfortable Black cop standing there letting people in and out of the door. However, there's no response whatsoever by the officers inside so that it feels like she's shouting into the void. How did you develop a relationship with the group and convince them to be in the film?

RM: It took a while before the Panthers and I decided to work together. There were deep concerns and so we talked and met several times informally. I spoke to officials of the organization behind closed doors where we dug really deep into our individual ideologies. We're dealing with a group of people that has been virtually ignored by the mainstream media for decades. But they refused to be portrayed in a way that was merely opportunistic on the part of whoever wanted to film them or do a story on them. Their distrust of the media went both ways. The media doesn't want them and they don't want certain media. So it took them a while to figure out why this white guy from Europe wanted to film them. Finally, Krystal Muhammad described it as a spiritual decision because spiritually she felt like I was the right person and so decided to trust me.

For my part of it, the fear I initially talked about made me hesitate. I first said yes and then I decided no and then ultimately yes again. I was scared. When we were ready to work together, we talked about going to the dark side and that terrified me. It was about gauging risk and opportunity and the fact that fear is exacerbated by these opportunities. You could say this was a high-risk, high-reward thing. It has a

lot to do with how I was operating within the film by getting to know all of these Black Americans living in these ghettos who also live in constant fear. But obviously it's a different kind than mine; it doesn't manifest the same way. They don't have a choice in facing the kind of fear they have to live with. Danger is part of the scenario of their condition whether as a Panther or as a guy living on the street totally unprotected. The fear I experience is kind of preparatory. I was so afraid of getting cancer. And then I got cancer. Once that happened, I wasn't scared anymore even though I might have died. So all these discussions were really good starting points.

If a decision is made in this spiritual way that means it's emotional and it's sentimental. I had a choice to do this or not do it and so I was always asking myself why I was there. The fear comes from my own condition, that of being a privileged white man. My beliefs lead me to walk through that fear. I share your feelings about that scene at the Capitol in Jackson, Mississippi where they're protesting the beheading of Jeremy Jackson and another man's lynching. They believed these crimes had been perpetrated by local members of the KKK and also understood that those people would go unpunished. The truth is, nobody really cares. To get rid of a small group of Black people is as easy as pushing a button so that's why the cops inside the station don't move or react in any way. That's how the riot we filmed ends, with the cops basically standing around. That's the truth of the situation. This symbiotic relationship with the community, and the love that was palpable for the Panthers from the local Black community was really touching. The people, in turn, protect them. Some said, "Oh, you're with white people. Be careful." And Krystal would tell them that we were there for the right cause. She'd say, "They're with us."

But it's also true that that scene of protesting outside a completely uninterested community of cops shows that they don't really have massive influence in the larger sphere. To defeat a system is their goal. One consideration regarding this is that in this country they were deemed public enemy number one by [J. Edgar] Hoover in 1969 and that was for purely political reasons, just to throw dirt on their name. But the Panthers have always been activists for good—they're there whenever there's a catastrophe like a hurricane. They're not just raising fists; they're holding hands. They've been politically ostracized for decades.

The second thing is that they operate at a regional level with chapters that don't congregate together all the time. They operate in smaller regional groups. And as we discussed before, many of the male members are in jail, causing a purposeful dilution of their power in numbers by incarceration. If members are not in prison then

they are regularly humiliated publicly and harassed by authorities—something like this happened at the airport in New York very recently. But in the film I didn't just want to show this idea of them screaming at walls and closed doors so that their own voices bounce right back at them. For me, it wouldn't matter if there were just one Panther left standing because what they do and what they stand for is heroic, risking their lives for a cause. There's a choice when encountered with a closed door—you could walk away or you can still stand there and scream at that closed door. If everyone screamed at these closed doors, maybe then they would finally open. Citizens don't do that anymore on a regular basis. Screaming into the void is a heroic act.

PC: Has the phrase "for self-defense" always been part of the organization's name?

RM: Yes it has. As I'm talking to you, I'm standing in front of a framed magazine cover published by the Black Panther Party from April 6, 1970 featuring Lil Bobby James Hutton who was murdered by the Oakland police. The party was reconstituted in 2014 as the New Black Panther Party because there had been a rift between a more extremist element of the organization where there was to be no dialogue at all with white counterparts. They also didn't want to have democratic elections for the national head anymore. Both sides of the split kept the New Black Panther Party name, so now there is the part run by Krystal Muhammad, the national chair who was elected democratically. They are not armed when they protest publicly and they only act in self-defense. They can be armed when they are there to protect people. They are also open to engage in dialogue with other people.

PC: What is it in your personal makeup and in your personal history that keeps you devoted to creating these kinds of portrayals in film? What about entering into these stories enables you to move through this fear you talk about? America is your adopted home. And you've chosen to live in Texas.

RM: I was raised in an environment where all my family members were active in the Communist Party in Italy. I was the leader of the Young Communist Party at the age of nineteen. The first picture featuring me with a raised fist was taken when I was two. My grandfather's name is Soviet. This is my background and it's one I'm proud of, one that defines me, and how I identify myself. I'm a fighter, the one who wants to be on the frontline and report. I grew up in a blue-collar environment in one of the most depressed regions of Italy called Le Marche in Umbria, among the working class poor. We were not supposed to go to high school because when you came of a certain age, you were supposed to go to work in the shoe factories.

My mom was working in the mayor's office as a secretary and my dad was doing non-profit work rehabilitating people in prison and working with at-risk youth. We were broke. I wanted to go to the big city; I wanted to make it! [*Laughs.*]

I studied computer programming. I couldn't really find a job so during college I worked as an insurance salesman while I was studying business. I then decided to go abroad. I went to Spain and ended up staying with the Red Cross because I had no money to eat. Finally I found an office job. After I lost my job there, I came to New York to follow my girlfriend who's now my wife. I got another office job and lost it during September 11th and using part of that settlement money, I pursued a master's degree in media studies. I graduated with a master's at the age of forty-four. I started teaching in the Philippines because I didn't want to teach in an Anglo-Saxon country. I wanted to go where people really needed an education and so I taught English. The Philippines, Ghana, and Nigeria had been my three choices. When I came back, I started filmmaking while also working in construction. This is my history up until now at the age of forty-eight.

It's not like I'm meant to be a champion of the underdogs of the world. It's not that at all. It's because these are my roots practically and ideologically and that's a fight that must not end, the fight for equality for people in need. So what happened when I came back to America? In New York City, I mingled with the intellectual liberal elite. At first I was very pleased that I had finally climbed that ladder. Then I realized that the liberal elite is the problem, really. I've never met a liberal person who would willingly put their kid in a class where that kid would be in the minority, in a class that wasn't almost totally white, in New York especially. There's this hypocrisy in saying that they want minority representation but in reality they are content with the status quo, which is the preservation of the dominant class, the white elite. This is white supremacy. The traditional white supremacists now call themselves white nationalists.

So basically I needed to get the hell out of New York City. I remember how people would react when I was considering moving to Texas. It's the South; there are cowboy reactionaries and right-wingers! But life for me has always been experiential so I came here to take a look around. My education about life has never come from academia; it comes from the streets. This is my country now and my family and I are Americans but I continue to feel uncomfortable with the contentedness, the indulgent satisfaction in the way the nation is going. That's something I can't take anymore. I need to sleep at night.

I'm not blind to what it's like here in the South—there are open carry gun laws and my vehicle has been vandalized because I have a sticker that says "Trump Is Not My President." But it's not the bubble of New York either. But again, I'm not interested in underdogs; I've lived most of my life as an underdog. I feel like a phony when I interact with the elite. But here I am as a filmmaker, being interviewed for books and it's for an audience of elites. I'm being heard. People consider me to be a prominent voice in some sort of cinema. I'm a product of a life that has nothing really to do with this. I wanted to make films because I wanted to hang out with people like Krystal Muhammad and Judy Hill, not people in the art business. You know what I mean.

PC: I do know what you mean. But we have to also appreciate the profound irony that the documentary community, for the most part, is the white liberal elite. Straddling two rather disjunctive worlds is what it's come down to. As well, in European eyes, America is an abstraction and I think your films provide the right entrée to a kind of exotic gaze for them.

RM: I think what we're talking about here is important. I do understand how people can perceive my films as a glimpse into something exotic or don't understand what kind of relationships I develop with the people in my films. But despite that, it's also the critics that seem to believe that they have a fuller understanding of racial and class dynamics. But the reality is that they've never experienced any of that firsthand. As I mentioned before, I'm a firm believer that knowledge is experiential—that's how I learn. I do have a problem with the contemporary documentary tradition. Putting a camera somewhere and depicting a reality is not documentary, it's reportage. Documentary, for me, and how I feel worthy of being called a documentarian implies full involvement of the author within the context of the project. I trained with David Turnley, a Pulitzer Prize-winning photojournalist who spent seven years with Nelson Mandela. That relationship transcended the photo-journalistic work he was able to produce—way beyond. He started his family in South Africa and raised his kids there. His personal and professional life became completely intertwined with Mandela's. The documentary work that stems from that is based on personal experience. Observation doesn't really mean anything. A full commitment is becoming one with the subject, whatever the reality you're depicting.

I think that's what throws people off within the industry. Many do not understand what's involved in reaching this level of intimacy to the point where if you have a preconceived idea of documentary in a binary way, it makes sense that it's

34

hard to understand. You can make documentary with this level of closeness only when the intimacy is real, when there's a relationship. There are some that just don't believe me, because they think that that's not how to operate. Everything is so compartmentalized so it's just not possible that I can become intimate with a group of right-wing militia. They don't understand how that's possible because it's not supposed to be that way. How could I not go and talk to those people? Am I supposed to just collect images that I suppose are going to touch people? Because I planted a camera in the right place, knowing that I'll never go back there again? Collecting information is not enough. These kinds of documentaries never change anything. They never sustain long-lasting debate. Nobody has taken much risk.

When I'm asked how I managed to bring the Panthers into this film, the question should be how did so many people manage not to? It's been thirty years! Am I so special? The assumption is that you shouldn't be able to do that. We go right back to white supremacy because the reality is that maybe you shouldn't be doing that at all. It creates problems. I can read between the lines of criticism, such as the guy from *Variety* who starts his review by saying, "Minervini tackles an easier topic with his new film." That's already a sentence that's telling. No matter what that journalist or pseudo-critic wanted to say, he just started by dismissing what I wanted to talk about with an audience. That's a political message and it's extremely serious. Is that supposed to be a liberal stance?

All this is just to ask, what has documentary become? People don't even die anymore to make a documentary. How lame is that? [*Laughs.*] People are making documentaries in war zones and come out without a scratch! Something's wrong. [*Laughs.*] How many times do we see murders and bullets going by and people getting shot and arrested? That's part of the game. When we were filming the protests with the Panthers, I was the one operating the camera. People from Georgia and Northern Louisiana and New Jersey gathered there acknowledged that we were the real deal because it's rare that a protest is filmed from the side of the protesters. They were deeply appreciative of that. To whom, exactly, are we speaking as filmmakers? I feel just fine to be in the minority when it comes to this way of making films. I feel fine being the underdog and an outsider. I think it's a really bourgeois platform where no one is taking any sort of risk.

I don't want to just point a camera, gather footage, and never connect again with the people I film. Why wouldn't I want to take risks? Yeah, you can get hurt. You can have emotional breakdowns. I've experienced all of that. I could use some

psychotherapy from this work all these years. These people are completely enmeshed in my life. Obviously it's hard. Do I just want to make a film? What am I trying to do? This is my legacy. These films are going to outlive me. My kids are going to know their dad through these films, my grandkids too.

There must be a sense of urgency in making films, otherwise you have films that are complacent and I couldn't care less about cinema anymore. The only way I want to make cinema is my way. I'm encountering more and more obstacles because I've been very stubborn about not writing anything or reviewing footage to prove my due diligence or doing anything the system is asking me to do to receive funds. Until now, I've survived. But I see that despite the fact that my films are doing better and better and my name is out there more, that somehow despite that, I'm struggling more. For funders, it's too much of a risk. For the first films it's fine, but to continue to work this way? That's somehow taking it too far. I raised my fist too soon. But now I don't feel like lowering it to make people more comfortable.

I struggled financially way more with this film than I did with *The Other Side*. I had some producers just abandon me. I had to return money. I've had health issues recently so maybe I wonder if they might not be a bit psychosomatic from absorbing this kind of energy. I'm at a higher level, hierarchically speaking, in the art world, right? So it's a given that I participate in festivals and have access to the prestigious film centers—it's already an assumption so this means losing touch with the fringe or the marginal. I'm sure that's where the really interesting voices are.

I remember when I started on my own and had to do all I had to do to elbow my way through everything and was so easily dismissed. But this position also cuts me off from other things because I don't find those marginal voices at BFI or Toronto or Venice. It's not really what I wanted. But I can still talk about this stuff publicly because the truth never hurt anybody, right?

KHALIK ALLAH

Antonyms of Beauty is the title of one of Khalik Allah's films, a 27-minute piece posted on YouTube in 2013. *Antonyms* is a precursor to the style and content he used in *Field Niggas* (2015), a work that brought him to the attention of the independent film establishment through its discovery by Columbia, Missouri-based programmer Chris Boeckmann. The resulting flurry of attention opened up substantial institutional and financial support for Khalik's second feature.

In *Field Niggas*, Khalik's style movingly illustrates his own ambiguities in portraying the nighttime denizens that inhabit the corner of Lexington and 125th Street in Harlem, New York. After extensively photographing on location, he felt he needed to expand these portraits of the indigent, homeless, drug-addicted, oft-arrested mostly African American men and women he encountered at three in the morning. Khalik's rapport with his subjects in this film reminds me very much of photographer William Eggleston's deeply visceral video work from the mid-1970s, particularly *Stranded in Canton* from 1974 in collaboration with filmmaker Robert Gordon. Similar in manner to the way Eggleston interacted with his subjects as he filmed them, Khalik documents the rarely- or barely-seen. As he's doing so, he is also engaging the people in front of his camera in conversation.

Up until *Field Niggas*, Khalik had been working with, photographing, and filming music videos for the group Wu-Tang Clan. He also made an hour-long documentary on Wu-Tang mentor and producer Popa Wu, which opened up into an exploration of the Five-Percent Nation, a cultural movement founded in 1964 by Harlem leader Clarence Edward Smith. Khalik was also brought up as a Five-Percenter and the practice informs much of how he sees the world, abiding by a personal philosophy

that involves maintaining optimum health for the mind and body and a dedication to expressing love and respect for anyone he encounters.

In 2018, his transcendent second feature about his maternal ancestral home of Jamaica was released. Shot with a mix of digital and analog cameras from different eras of the 34-year-old's life, *Black Mother* has been programmed internationally and is the first film of his to be released in cinemas in the US. A beautifully palimpsestic work that uses both black and white and color film stocks, along with Khalik's signature asynchronous soundtrack, *Black Mother* creates a kind of immediately visible personal and cultural history. While watching the work, something takes hold of the subconscious and closed-off synaptic impulses open and diffuse, creating a hypnotic state in response to this layering of memory, voice, image, and materiality.

The progeny of an Iranian father and a Jamaican mother, Khalik slowly exposes the traces of what concerns and fascinates him about his subjects through his camera lens, unfettering himself from linear time, linear thought, and straightforward conclusions. He is an artist that works in a free zone of imagination, intuition, musicality, and recognition of the grace in other human beings, no matter how ugly their circumstances or station in life appear to be. He is a gentle and incredibly friendly man with a coiled energy at his core. Khalik speaks in a deep basso voice and as articulate as he is, when you listen to him you realize this is a man still deeply rooted in the sensibilities and rhythms of his native Brookhaven, Long Island neighborhood. This conversation is a slightly edited version of a public talk I had with Khalik at the 17th edition of DokuFest in August 2018.

PC: What happened when you picked up a camera for the first time? How did that inform the way you encountered the world around you?

KA: By thirteen, I was begging my mother for a camera. In New York there was a place called The Wiz that sold all kinds of electronic equipment. For my fourteenth birthday, she finally bought me a camera. I filmed everything—skateboarding, breakdancing, everything going on in my neighborhood. When I went to community college, there was a course called Intro to Digital Filmmaking and that's where I learned to use Final Cut Pro, how to cut footage. That was an epiphany for me. I realized I could cut all this footage I'd been shooting for the last five years. I was getting an "F" in that class. But the final project was to make a short film so I put together a bunch of my images and got an "A" for it. So that enabled me to get a "C" in the class. In terms of working with Wu-Tang, I knew some of those brothers

and got a DVD to them and we started shooting videos together, not so much for TV but for this music video/hip-hop boom on YouTube.

PC: YouTube ultimately ended up being the platform where your work was discovered. In your earlier works there was something essential missing for you and that was the ability to build your own soundscape instead of using someone else's music. For *Field Niggas,* how did you convince the people hanging out on that corner in Harlem to let you film and record them?

KA: After working for Wu-Tang for some years and long before I made *Field Niggas,* I found I was a bit tired of the filmmaking process. I then started getting into working with still images and the still photograph was what really informed my filmmaking from then on. I came to it not thinking so much about sound, just the images. I always worked with sound separately so it works more like collage. But that corner there in Harlem was sort of like psychotherapy for me. I needed to be there for myself. At the time, I was working a straight job at a company with full benefits and a 401(k) plan. I missed the streets, that street life I had had in my childhood. Even though I was working full-time, I was awake at two or three in the morning and those hours were the ones in which I started shooting. Having been the kind of kid that was always held back in school, always behind, Harlem became a source of inspiration. There were all these esoteric books on metaphysics that I was reading as a kid and the Black history that was taught in school was just so limited. But this corner was also a corner I would try to avoid. At 125th and Lex there were too many drugs, too many police. It was only after a period of time spent there without a camera that I started to document the people.

PC: You mentioned that initially many of those people were resistant to being filmed, perhaps a bit afraid. How did you break down those barriers in order to convince them you meant no harm?

KA: Rightfully so, in the beginning people were suspicious. When you see someone you're not familiar with coming through with a camera at 2 a.m. or 3 a.m., your first reaction is going to be, "Yo, who the fuck are you, boy?" I got some threats. But when you're coming around during that time, there are one of two things that can happen: you're either going to get robbed or earn respect. I was not trying to get robbed, so I moved myself in as respectful a way as I possibly could. Some told me they'd just got out of jail and under no circumstances did they want me to take pictures of them. I respected that but that stance also changed through the consistency of my presence, showing up and showing up and showing up. The reason I ended up

making *Field Niggas* is because I eventually became frustrated with the still image. I was hearing things and seeing things outside of the frame that weren't being transmitted through the photographs.

It turned out to be a way to get back to my own roots. I was in corporate America and had stepped away from those people I had spent time with growing up. It was a mutual exchange. My subjects could then become co-creators when I was shooting. I know what it takes to gain somebody's trust in order to get permission to film. It's all about relationships for me, allowing whatever's coming through to come through. Putting it up on YouTube so people could access it for free meant I was ignorant, obviously. For all of the manifestations my work has ultimately brought to me, it all seems like a blessing, you know what I'm saying? *Black Mother* brought more expectations, naturally, and more consideration for the audiences that would see it.

PC: We see footage from all the trips you took to Jamaica as you were growing up, images taken way before *Black Mother* was conceived and that immersion was sporadic. A lot of the emotional heft of the film, for me, comes from getting to witness the evolution of your artistic eye.

When you played the very beginning of the film for the audience that came to see you speak today, you asked them not to judge the film from these beginning clips which feature not only "typical" sights and sounds of Jamaica, but also the portraits of the prostitutes you met there. Even though much of the film is expressed through a spiritual plane, through prayer and praise to god, you always remind us of the body. You always bring us back to the female body offered up and used as conduit for the deepest pleasures. There is also the deepest pain of childbirth, an experience distinctly not shared by anyone but that woman giving birth.

KA: There's this dichotomy that I felt I wanted to start with in this overture and that is the Jamaica that everyone is familiar with—I mean, really, the tourist version of what Jamaican society is. There's the woman dancing in the street seemingly happy-go-lucky with reggae music as the constant and only soundtrack. And then we're in the street at nighttime. It was my way of telling the audience that this will be a Jamaica you've not seen before, even if you've been there. The prostitutes were important to begin with because this movie, for me, represents the Earth, an earth that has been consistently raped and I don't want to hide those elements that are embedded in this place. Any place with a colonial history is going to have these complex layers and representations. Some are just more obvious than others. You can't omit those things from the story of Jamaica. But even though I'm half Jamaican,

again, people were suspicious at first and many said no when I asked to film them. While I'm part Jamaican by ancestry, I'm also American, born and raised in New York. But as a matter of fact, when Trump got elected, I got my Jamaican citizenship just in case I need an exit strategy. [*Laughs.*] I haven't been there since finishing the film. But I have my grandfather's house now that I'm going to use as my own private residency spot where I can write my next script.

But getting back to when I first started shooting people there: Jamaica is a really poor place and when someone shows up with a shiny Bolex camera, they want some money. I know there is a tradition of not paying subjects that appear before a documentarian's camera but I don't care about that. Still, I have them speak first so the money's not contingent on their performance. And we have discussions before I ever use the camera.

PC: Your audio recordings become a tapestry of stories and voices. This is the baseline of your narrative. What's that process like?

KA: I feel with the audio work I'm doing, I'm building a new film language for my content. The audio is the scaffolding I use to hang the images on. The audio is the space, and the images are the pictures I hang in that space as you would in a gallery. With both films, I found the story, the structure, as well as the rhythm from the audio recordings. Then I could organize it into themes. Once I decided I wanted to film a live birth for *Black Mother*, that instructed me to divide the film into three parts. Instead of chapters, I use the conceit of the trimester.

PC: How did you find the pregnant woman who agreed to have the birth of her child filmed? When did capturing that become essential to your story about Jamaica?

KA: It was essential from the beginning. But it was also difficult. It was really not easy at all to find someone who would give me permission. Jamaicans can be quite conservative and most people thought I was trippin' when I said I wanted to film a live birth. Initially I went through the Jamaican Midwives Association to find someone who was due in February. No one wrote me back. So I went the grassroots route and started asking people I met on the street. The man you hear negotiating with the prostitute at the beginning of the film had a niece who was pregnant and she ultimately agreed to do it. With the funeral of my grandfather in the film being, in a way, the finale—literally—I wanted to end not on a note of death, but on new life. Filming this birth was extremely important to me. There is a great spiritual uplift near the end of the film. A new birth could be looked at as a new choice. We see the

sacred and the profane in this film and the way they interact. They're not separated. What kind of path will this child travel?

PC: There is an elegiac quality to the footage with your grandfather that works to match his magnificent voice, a very tired voice but still a strong one. The same quality exists in the voice of the woman who recites a very long prayer. They are talking directly to God, but that god is the white Jesus they've learned to pray to. It's a personal relationship that culminates in that prayer that speaks to this unending and direct dialogue with God. How does dyed-in-the-wool spirituality exist in Jamaica today?

KA: Religion was something to keep the slaves docile. Before becoming slaves, most Jamaicans were from Ghana. The container of Christianity was given to them through colonialism, a way to instill the fear of God: "Be obedient to your Master." But there is a predilection to spirituality. So it really didn't matter whether you gave them Catholicism, Judaism, Islam or Christianity, because that's just the container through which they can express their spirituality. I left organized religion when I was about fourteen. I grew up with the Five-Percent Nation also known as the Nation of Gods and Earths and that's geared towards the youth. This speaks specifically to the young Black youth of America, to have a sense of where they come from and how they should be conducting their lives, a foundation of self-knowledge, history, and a relationship to what's going on around them in the larger world. The leaders put all of their practical knowledge in a catalogue called The 120 Lessons and we needed to memorize that. Christianity in this context was regarded as a shield. I don't want to shit on Christianity but I think it's been misused. But there are no Five-Percenters in Jamaica, they're Christians that pray to Jesus.

I knew that letting that woman pray on and on for seven full minutes might turn people off but I also feel like people are starving spiritually now. Whenever you include God in a film, it's a risk. God is unpopular. It's similar to the water you see throughout the film, the unceasing flow of it. She was flowing in her prayer. We're living in an era where it seems like family isn't as important as it used to be, so I wanted to come with the Good News a little bit. I can say that I put a lot into this film that I haven't seen anywhere else in film, to fill that void or lack of certain images and voices. It's a film that's so personal to me, which means it's also made to entice people to encounter their own thoughts while watching it.

PC: I want to go back to this birth in *Black Mother* and that genesis story you're playing with here, of a life beginning anew. There's also the end of your grandfather's

life. Besides the circularity of the life cycle, it's also tied back into the land of Jamaica itself. We see some renewal, but mostly we see the same tired exploitation of that land and the people who inhabit it. It's not meant to be metaphorical in its entirety, is it?

KA: I started my edit with six hours of recorded audio. I cut it to three hours and then spent some time puzzled as to how to find my film in those three hours. To get it down to its current seventy-seven minutes took a lot of listening to that material, over and over and over again. When I was getting ready to film the birth, I would talk on the phone with my mom a lot. She was a nurse and saw many births. She asked me if I might faint. She was interested to know what was going to happen to *me*. [*Laughs.*] I asked the doctor how long it takes for a woman to give birth. He told me it depended a lot on how much the "passage had been exercised." He thought I was the husband so he was asking me if I had been having sex with her. I guess that would determine whether the labor would be shorter. But no, I didn't faint; it was actually quite quick. I was in the room for only about twenty minutes during the actual birth. As the doctor was instructing her to push, he turned to me and said this is how babies can die. She wasn't pushing hard enough and you can hear that in the film. When I got back to my room after the baby had been born at 7:30 that morning, I backed up the footage right away to see if I had gotten what I wanted. But when I backed up the audio and heard the doctor saying that—about the possibility of the baby dying—I totally broke down. What it comes back to is that a woman has given birth to you—that's what it all comes back to. This film is like my daughter. *Field Niggas* is like my son. I'm planning on having many more children.

PC: Working through the structure of your soundscape, can you remember a eureka moment in the editing where this tension between image and sound was manifesting in the way you wanted it to?

KA: Going to Jamaica with a camera since the age of fourteen, I amassed so much material. So I could lean on that when it was time to edit this film. Much of that material was biography that has to do with my own family and I definitely didn't want to make a biographical film. I wanted to make a more universal film for all families so the parts that I included with my family were those segments I felt most families could relate to. The shooting itself directly represents my own growth. Sometimes I just had my Hi8. Another year I'd show up there with a Super 8 camera. Another year I'd come with a top-end digital camera. But in 2015, I consciously decided to make this film in Jamaica. And I had a budget. This film turned out to be

the equivalent of the film school experience I never had, to try shooting on cameras I'd never used before. I learned everything off of YouTube, starting with how to load a 16 mm camera. It was the same with the Bolex.

PC: Parents who've spent tens of thousands of dollars on tuition so their kid can go to film school are not going to like hearing this.

KA: I'm invited to talk to a lot of kids now in public speaking situations. My message to them is to believe in yourself first and foremost. Going to school doesn't guarantee anything. I'm the only one who doesn't have a degree in my family. But, in a way, since I don't come from that kind of disciplined learning environment, I could take the time to explore the endless possibilities of how I could use the audio and all the visual material and put it together. That was total freedom, only up to me to make it as bad as I could make it, or as good as I could make it. I like mismatched audio and video where what you're seeing and what you're hearing don't necessarily match. I trust people's capacity to obtain information in order to make associations that aren't obvious or aren't being made for them. But there is consciousness and reason behind every decision I've made. The hard work is having my own precise reason for putting things together in a certain way while also leaving it open enough for others to have their own experience, maybe something I didn't intend. I was editing and shooting simultaneously so I could easily see what I might still be missing and go back and get it on my next trip. There were lots of re-edits. It was kind of like playing Tetris where you try to see what's fitting together naturally.

PC: How did that inform the emerging portrait of the country and the various themes the film covers?

KA: Jamaica is smaller than Long Island, New York. But it's a huge place in its history and in its relationship to the rest of the world, especially through its music. Capturing all of that would have been impossible if I didn't work with montage since it's a way to condense all of that space, time, and information. There is a distillation process. The different camera formats helped to capture the different threads and fabrics and textures of Jamaica. But it's my own view, even though I'm including other voices, letting those voices express what they need to express in a very particular way. All this leads to a sort of truth, more than any other direct or traditional approach.

PC: How did you decide at which moments we would be able to hear you? In *Field Niggas* as well, there are these moments where we hear you address a subject or interject a question.

KA: There is definitely less of that in *Black Mother*. I felt it was more necessary to include my voice in *Field Niggas* because of the relationships I had developed with the people I was filming. The way I speak is familiar to them and it was fitting to hear my voice there. My voice is so inconsistent with the Jamaican patois, though, and I didn't want that to be jarring. So I chose those moments more carefully. An example is when you hear me say, "Grandpa, what do you think about death?" That sets it off. When you make a film built on montage and collage, it can be disorienting for viewers and I want to keep them with me. I'm taking you out there but I'm still holding your hand through the whole thing.

I also want to leave it up to my subjects to answer any question I'm asking. What does the person I'm documenting think? I'm not that interested in what anyone else thinks. So yes, in *Field Niggas*, those choices were freer. But there was more self-consciousness with *Black Mother* because I knew there would be more eyes on it. I didn't anticipate my first film playing at festivals. But after traveling with it and getting that exposure, I knew that *Black Mother* had a much higher chance for that kind of audience and so I was, admittedly, more careful with myself and more conscientious as to where I inserted my own voice. Part of that was stepping back to allow the film to breathe on its own.

PC: With your work so far, you're filling holes in the canon with these sublimated histories. Will you continue to do that in your narrative work?

KA: You do find the most unique stories from underrepresented points of view. But I don't know what those stories will be. It's all about opening up to receive information. That's how I operate most of the time. I don't go into anything I do with any answers. I go into it with an open mind and maybe one or two questions and things open up. I'm looking forward to it, whatever it is I'm going to do. I have the support now. I have people wanting to give me money for my projects, enabling me to be an artist who works at being an artist unlike most who have to split their time between the work and surviving. I feel like Andy Dufresne in *Shawshank Redemption*, digging myself out to freedom.

Our lives are so valuable and every day that you're getting to do your work is a blessing. It's important to do something that's going to add to the overall good. I say be like Johnny Appleseed—plant seeds. Fill things with your spirit—respiration, expiration. Putting breath into something then taking it out again. In the Book of Matthew, Christ speaks to the Apostles, telling them they are the light of the world. When you light a candle, you don't put it down on the ground. You put it in a high

place so it sheds light everywhere around you. When you deal with your inner light, you're raised up to a level where that light can be shared with many people. So don't search outside yourself for anything. All of the light is already there. It's there within you waiting to be received. The gifts increase by accepting them. When you start to accept those gifts, they start to multiply. That's how you know it's real.

SHENGZE ZHU

Shengze Zhu and her partner Zhengfan Yang have collaborated on several films together, dividing their personal and professional time between China and Chicago, Illinois. In 2016, Shengze released her second directorial feature centering on one family in her hometown of Wuhan. The film was shot over fourteen months, all the action taking place around shared evening meals. *Another Year*—with a running time of three hours—consists of thirteen dinners with a Chinese migrant worker's family: husband, wife, three kids, and a grandmother, all of them living together in one small room. The fourteen months Shengze and Zhengfan filmed with the Xu family in their Wuhan apartment, as well as in their small village home, is an expansive look into a rarely seen segment of modern-day China. Shengze had met the family while shooting her first feature film, a project she began after returning to Wuhan the summer before graduating from journalism school in the United States. The resulting film, *Out of Focus,* featured the eldest Xu daughter, Qin.

At the age of twenty-one, Shengze left Wuhan for the first time to attend the photojournalism school at the University of Missouri. She felt the need to escape the confines of a family with traditional expectations living amid the crowded, chaotic city of Wuhan, the largest urban center in central China. Columbia, Missouri, to be sure, held surprises for Shengze in the flatness and barrenness of the prairie, but she was certainly charmed by the locals she met there.

In the summer of 2012, most of Shengze's peers headed to media centers like New York or Washington, DC, to find internships. But she decided instead to return to Wuhan to make an independent project. She ran a photography workshop at the Lingzhi Elementary School on the outskirts of Wuhan. Most of the students were children of migrants who had come from the countryside to find work in the big

urban center. Hubei Province in Wuhan, where both *Out of Focus* and *Another Year* were shot, is a place of urban blight, economic instability, and displacement. After having spent half a year at the school, Shengze felt there was some good material for a documentary so she started to film the kids. After that, she returned to Missouri to graduate, then moved back to China and continued editing the documentary.

Just as Shengze's family wanted her to have a solid career and a stable life, Zhengfan's parents had plans for him to become a lawyer. But what he really wanted was to make films and, like Shengze, turned out to be a talented director and cinematographer. The couple trained with a retired professor from the Beijing Film Academy, Zhou Chuanji, a well-established teacher in film studies, although he'd never made any films himself. He offered private classes that didn't so much teach camera technique but provided instruction about the fundamentals of audio-visual language and how to use the camera to express thoughts instead of relying on narration, text or dialogue. *Another Year* was filmed with available light in long observational segments using a single locked-off frame. The only edits in the film move us from one month and one meal to the next. The Hubei dialect is rapid-fire and harsh-sounding. Much of the time it seems as if the family is fighting, giving the film a lot of its drama but also much of its humor. The claustrophobic existence in the one room flat in Wuhan is juxtaposed with the bucolic countryside of their home village, Hong-an, where there is clean air and more space but no opportunity to make a living or go to school.

In what ended up being a two-part conversation, I spoke to Shengze about the making of *Another Year* in late November 2018 when she was back home in Wuhan visiting her family. At that time, she was also finishing post-production on her third directorial feature called *Present.Perfect*. So Shengze and I decided to talk again a few months later when she was briefly back home in Chicago to discuss her latest film as well.

Wuhan, China:
PC: Did you have any cinematic influences besides those of Zhou Chuanji? I ask this because in many ways it's a really brave choice to work with a locked-off frame as your main storytelling device. You manage in the three-hour running time of *Another Year* to express so much of the economic circumstance of this family, their displacement as well as their status. Did the family understand what the presence of the camera meant?

SZ: They were curious about the camera and curious about how they looked on camera. In the beginning of this process when we started shooting with them for *Out of Focus,* every once in a while I would print out some stills from the scenes to give to them. They liked those a lot. During the shooting of *Another Year* they weren't really concerned about my presence or the presence of the camera except for Qin. Sometimes she would try to avoid it. None of the family members went to the cinema or the theater to watch a film except for Qin. She would ask me sometimes worriedly if I was going to put it online. I assured her I would never do that. I did tell them we were making a documentary and that we hoped it would be shown in theaters. In China, in general, people are not so aware of the power of cameras or don't really understand the potential impact of being filmed.

PC: When we first meet Yanhong and Qin, mother and daughter, their relationship is quite explosive. Maybe this is something about the Hubei dialect but they speak to one another very roughly, bordering on viciously. Yanhong speaks to the grandmother abusively as well. Is this a relatively normal way in which parents and children interact? Or does it stem from their living circumstance?

SZ: I don't think it's normal. It definitely stems from the fact that six family members share one room that's about twenty square meters in size [about 215 square feet]. That space is their living room, bedroom, and dining room. There's absolutely no privacy. So Qin just gets fed up; she really just wants to run away from this room and her family. During the shooting of *Out of Focus* she was thirteen, so she was rebellious. But no, that's not normal for family members to speak to one another that way. But I do want to be careful when I describe family dynamics because that's my interpretation. I never asked them why they yell at one another. In *Another Year,* part of the reason why I wanted to use these long takes was to capture the dynamic of the dinners because sometimes you saw them yelling at one another or there was a fight and things were intense. But just a few minutes later they were treating one another well. The family dynamic can radically shift even in the time it takes to eat dinner. But most of the time it was quite intense. We could say that the dialect itself also reinforces the tension. Hubei dialect does sound really tough. We often hear the joke ourselves that this language isn't suitable for saying things like "I love you" because it sounds like you're starting an argument.

PC: I've often thought the same of German. [*Laughs.*] Describe the structure of Wuhan and how the city has changed to accommodate booming China, the explosion of these urban centers that have caused even more intense economic stratification?

SZ: Like many families, Qin's family is from a small village and one that's not that far away from Wuhan. The situation in China now is that there are many, many people like them who decide to move to the big cities to seek a better life, not wanting to remain in those villages and be farmers. There is a policy in mainland China called *Hukou*, a household registration policy, dividing residents into rural and urban residencies. When those originally from the countryside move to the city, they remain registered as rural residents. What that means is that they have very limited access to urban welfare programs such as free health care. The jobs they do manage to find are very hard physically and consist of odd jobs on construction sites, in factories, or in restaurants. They face tremendous economic pressure. They live at the margins of urban society, not just physically but also psychologically, and so they feel alienated.

For example, this family lives in a community that is often called an "urban village," a packed and very old community on the outskirts of Wuhan. Almost all the residents of this village are just like them, originally from the countryside. In the elementary school in *Out of Focus* almost all the students come from this background as well. I was interested in how they perceive city life because I could see them trying to become a part of it.

PC: Is the outcome of that then living this kind of split existence? Could they ever establish themselves fully in the city, for instance, if that's what they desired? Or is legal residence in the city just not an option at all?

SZ: For farmers or migrant workers, if you work hard, you can earn a good living but because of this household registration policy it's almost impossible to become a resident in the city. This is especially so in the case of Beijing. However, if someone from the countryside attends university in a city and then finds a job after graduating then it is possible—although still difficult—to register as an urban resident. In my hometown of Wuhan it's a bit different but with *Hukou* policy in a place like Beijing, you can't even buy an apartment there or a car because you are not a registered resident even though you might live and work there. The workers build all the skyscrapers there but still do not belong to the city. In the United States, if someone moves from a rural place to an urban one, he or she can register as a resident of that city even without a job. Not in China—it's a completely different case. The migrant workers try to earn as much money as possible in the city because it's easier to get paid well compared to subsistence farming. But when they reach the age of fifty or sixty they go back to the village or country and settle there to enjoy rural life.

PC: When filming in the one room apartment and also in the country house, how did you decide when you would have a wider or narrower frame or from which angle you wanted to view the action? The film plays as a series of short stories about this family and I'm curious to know how you chose your start and end points for these long uninterrupted scenes.

SZ: Zhengfan and I decided beforehand where we would place the camera. We had many discussions about this and how we would frame things. The Wuhan apartment was easy in some sense because we knew that room so well but it was a bit difficult at the same time because it means you don't have a lot of choices. The overall principle was that in the beginning as we introduce the family members we would use wider shots. Towards the end of the film I really wanted to show faces more clearly so as a viewer, as you spent more time with them, you would get to know them better. We started with medium shots, moving closer to the family throughout the year. For every scene we would set up the camera and film until they finished dinner, so the takes were sometimes quite long, over an hour, but sometimes quite short.

In terms of the editing, I didn't have to make decisions about sequence for the shots obviously, since we shot chronologically. But I did have to choose the beginning and end points of each scene and that was the most difficult part of the edit. It took me almost a whole year to choose the beginning and the end of each scene. We didn't have an editing principle but allowed the internal rhythm of the shots to speak for themselves. The editing of this film is more about the rhythm as well as the relationships between the shots. One shot has to more or less resonate with the others, particularly with the shots that come right before and right after.

PC: The conversations most times in these scenes center on mundane or practical things the family is facing, or their worries or concerns, or idle gossip. But in the month of August when they're all together in the village, a neighbor comes in while they're eating and they all start to gossip and talk about various people they know. It starts with the pressures they feel having three children and then they bring up the Family Planning Commission and how they and other people they know circumvent all the rules about having only one child. They proceed to have a pretty expansive conversation about this issue. The desire is to have more than one child even though it's economically difficult, but it's even more important, of course, to have a male child. We notice almost immediately that little Kangyi is pretty much

treated like a king, and the middle girl Manqin for the most part is ignored much of the time.

SZ: I had similar feelings like the ones you just described. I was astounded by the whole situation of the three children. Not just because they have three, but Manqin didn't even have *Hukou* for a very long time, meaning she wasn't registered at all in the system. The reason families like this want male children is to inherit the bloodline, so that's part of the reason they keep having children despite the one-child policy. However, rural residents are allowed to have two if the first one is a girl and that's part of the reason they didn't register Manqin, the middle child and the second girl, for a long time. It's not really common to do that. It's also distinctly unfair. I was glad this discussion took place because it provides a really good reference point to explain the situation not only of this family but also of other rural residents. It's a bit different for rural versus urban residents because my parents didn't dare to have a second child even though they might have hoped to. But if they had had a second child, they would have lost their company jobs. We were middle-class so they both had stable jobs. Their generation worried about this because there were strict penalties. Also, in the cities, people of my parents' generation don't really care about this continuation of the bloodline. But for the rural residents it's a tradition they still believe in. The one-child policy no longer exists in China; now everyone can have more than one child. In fact, the authorities now encourage people to have more than one child since Chinese society is facing a serious aging issue.

PC: The act of cooking for one another, and the taste of the food, is so important. Even though Westerners also eat communally, a lot of the time it's actually quite a private act. In China, eating is very definitely communal and people eat anywhere they can find a spot to stop and pay attention to that act of eating. At these dinners, the quantity is also really bountiful. They eat until they're stuffed. Do most of the household expenses go towards food?

SZ: People have always commented on the meals, of course, but no one has ever asked about the food itself and the fact that they had a lot of it. But the food they had during the dinners when we were shooting was actually not good quality. Sometimes, I would bring them good meat so they could have better food. Except for the New Year meal, the food they had wasn't so great actually compared to other Chinese families. But Qin went to a boarding school throughout that year so I would always film them during the weekend when she was home. And when she was home,

her mom and dad wanted to take care of her and treat her well and that's why they'd prepare all these various kinds of dishes.

But the Chinese do like to eat and food is quite an important part of our lives no matter our background. It's not just about eating but it's also about gathering. Qin was away at school during the week and the father Jiasong worked every day from seven in the morning until seven at night so dinnertime, especially on the weekend, is the only family time when the six family members can gather together and relax or fight or do whatever. They can talk to each other and connect with one another even if it's just through rambling conversations they get to learn about one another's lives outside the home.

Chicago, Illinois:

Shengze's third feature, titled *Present.Perfect.*, is as different stylistically and narratively from *Another Year* as could be. In her latest feature, she weaves together footage that was self-recorded and simultaneously broadcast by every-day Chinese citizens who have joined the deluge of live-streaming anchors in China. Otherwise isolated individuals film their daily lives on their own devices, talking to their subscribers in sometimes deeply intimate ways. Many of the protagonists that Shengze chose to portray struggle with real-life face-to-face social interaction for various reasons, and this cinematic collage—presented in black and white—explores how individuals satisfy their cravings for human connection through virtual portals.

At the beginning of the film, we learn that the year 2016 has become known as "Year Zero" of China's live streaming craze. On December 1st of that year, the Provisions on the Administration of Internet Live-Streaming Services came into effect. In 2017, the number of live-streaming users in China reached 422 million people. On June 1, 2017, the Cybersecurity Law of the People's Republic of China was formed. Shengze opens the film with a quote from an excerpt of a document on the Cyberspace Administration website:

> *The Internet is the common homeland for all humanity. Building a Cybersecurity community with a shared future requires our collaboration. Nowadays the boundary between reality and virtuality is becoming more and more ambiguous. Cybersecurity is not only related to the security of our country and the society but more importantly it is related to the personal interests of every netizen.*

PC: *Present.Perfect.* is quite a departure from the methods with which you made *Another Year,* particularly regarding your relationship with your protagonists. However, you still use a formal and rigorous approach to the material. Stylistically, what were you after with this film? How did you swim through this massive archive and what were you looking for, specifically, in your chosen subjects?

SZ: There are millions and millions of users involved in the live streaming industry in China, in all its diversity. From the beginning, I knew I didn't want to focus on a certain group of people but rather to create a portrayal of as many different people and perspectives as I could. I don't focus just on one family as I did in *Another Year,* but I did find a similarity among the people in this film in that they struggle with real-life issues as well as social interaction. They have very limited access for connection with other people. Live streaming is a way to attain that connection and interact with people they would never meet offline.

PC: Why did you use black and white? It gives the whole film an almost other-worldly aspect as if the people are broadcasting literally from another planet or from outer space. Was that an important part of the film's aesthetic or did you do that for more practical reasons?

SZ: Those who do live streaming are, in essence, the DoP's of their own shows. Some are very skilled. That's why I chose not to use a professional cameraperson or propose my own perspective. The black and white also provides consistency for the images so that the tones, contrasts, and white balance look similar. But another important reason is that you're not going to see black and white in real life or in virtual life on the Internet. So it gives the film itself its own subjectivity and distinguishes it as the film I made about this topic. I like that. At the beginning stages of making this, Zhengfan and I discussed the reasons why people would want to watch a film like this instead of just watching the live streaming directly, go to the websites and platforms and watch the shows. My subjectivity or my intention for the film has to create a world that's different from the world of the community. The decision to make it black and white was one of the solutions. But it's presenting much more of a perspective rather than a method of storytelling.

PC: How did they react once they realized you wanted to use their shows and their presences in your film, that it would be seen in a cinema by another type of audience?

SZ: As long as I could still find them, I continued to talk to them and that included getting approval. Some individuals didn't care much because for them there was

not much of a difference so they were open to the idea. They didn't ask too many questions, really. Some individuals were more curious about it and wanted me to send the clips I was planning on using. Others had doubts so we had to have further discussions. The thing is they don't remember what they might have said during the shows. But what they said is very interesting *to me* and so I told them why it was interesting. They were appreciative of that kind of documentation. They lose their own archives of streamed footage. It's not stored on those platforms.

PC: So your film contains archival material that doesn't exist anymore. That's really fascinating. This live streaming phenomenon exists in various forms all over the world, but in China it has its own official administrative arm. Is there some kind of search engine where you can look for specific content, like you can on YouTube for instance?

SZ: I wouldn't say there's a search engine. On each platform, it's possible to use keywords to search for specific kinds of shows, but in most cases you won't get what you're looking for because the keywords are only linked to the title of the show, while the content is constantly changing and there's a lot of improvisation. So I never used this function to collect footage. Also, the shows are not stored on the Internet so you can't really search for them. That's why I don't consider this film constructed with found footage. The process of making it didn't involve facing an archive or a collection of footage. Live streaming is ephemeral, composed of fleeting moments. So it's a film like other documentaries, just shot by different people instead of a professional DoP.

PC: You focus briefly on this guy who cuts himself. In one of the clips we see of him, he mentions that he'd been contacted by the Cybersecurity organization. I guess the supposition is that if he continues, he risks losing his connection?

SZ: The system is like this: If you have a lot of fans then you will probably have an agent. The agencies train you how to perform or present yourself so that you can grow your fan base. They also tell you what you can do and what you can't, or what you should not do. The anchors in my film for the most part don't have agents because they don't have a lot of fans. But they still have to follow the regulations. There are managers on those platforms but you don't know who they are. So if one of these managers sees you doing something they think is not appropriate, they can shut down your showroom temporarily. If you do it again, they penalize you, or they can also just delete your account so you have to register another one.

The anchors have Internet names, but they have to register by using the name that's on their ID card. The community knows that they can be tracked. So they're careful. As well, the regulations are constantly changing so something that's allowed today can be banned tomorrow. For example, there was a man who wore a woman's outfit and danced. When he filmed that, it was okay but it's since been banned so they shut him down. What the viewers can or can't see on a streaming platform is not just about official censorship by the authority. It has more to do with self-censorship.

PC: You feature this young man who travels around his city to various public places and sings and dances or just talks to the camera. There's a scene with him very late in the film where the people surrounding him are not watching him at all even though he's inches away from where they're standing. Instead, their eyes are focused on him—and on themselves—on the screen in front of them. It was discomfiting and also so evocative of this phenomenon, this intense relationship people have with devices, way more intense than the ones they have with other people.

SZ: For him, the most important audience is the one on his screens, way more than the actual people around him on the street. He's very interesting, and from watching some other people who knew him well or followed him for a long time, I learned that he has more than ten phones that each do live streaming simultaneously for more than ten different platforms. He has this electronic motorbike that he uses as a hub. [*Laughs.*] He designed that himself. When he'd sing and dance and do his own concerts, he'd do it for days, from early morning to very late at night without a break. So he would occasionally sleep on the street during the shows but he would continue broadcasting. He wants to be a star, so he doesn't interact much with the people that are around him physically. Many of those people think he's mad, singing and dancing so strangely on the street.

PC: There are more and more restrictions being imposed on Chinese citizens, whether rural or urban. You work very close to the bone, in enclosed spaces, you and Zhengfan producing for one another and shooting and editing together with just a few other people involved, most of them outside China. Do you work in this way because of any risks inherent in what you're doing? How do you work around issues of censorship in China?

SZ: What both Zhengfan and I are interested in is cinema itself, how to tell a story or share an experience with others through image and sound, and how to construct or reconstruct the time and space in cinema. It has nothing to do with politics. But especially in the case of my work where I'm dealing with real people and

not actors, then yes, their lives are connected to the society and the social issues in China. What is important for me is to figure out how to represent these social issues by allowing people to tell their own stories in a creative way. In China, in general, the situation is definitely getting worse for filmmakers.

For example, there's a law that came into effect in 2017 that filmmakers cannot exhibit their work both internationally and domestically without government approval. Our work has to be shown first to a censorship board before we can present at festivals. We don't accept that at all because I don't want my work to go through a censorship board. So we now try to find other ways to work around this, for example, by finding a co-production country to work with. It's also almost impossible for filmmakers like us to get any kind of financial support in China. It's very sad and very tough.

There is almost no national support and those Chinese production companies and investors have very little interest in art house or experimental cinema. They are also unwilling to risk supporting films that would be challenged by the censorship boards. For commercial work, it's different, of course. We want to make films in the United States and other places, but China is still the place where I want to make most of my work. I'm so emotionally connected with that place and my experience of living in another country really gave me a different perspective in the way I look at China. I have this kind of distance and this chance to experience my own country that continues to really inspire me.

Still from *Hacked Circuit*, © 2014 Deborah Stratman.

Still from *Onward Lossless Follows,* © 2017 Michael Robinson.

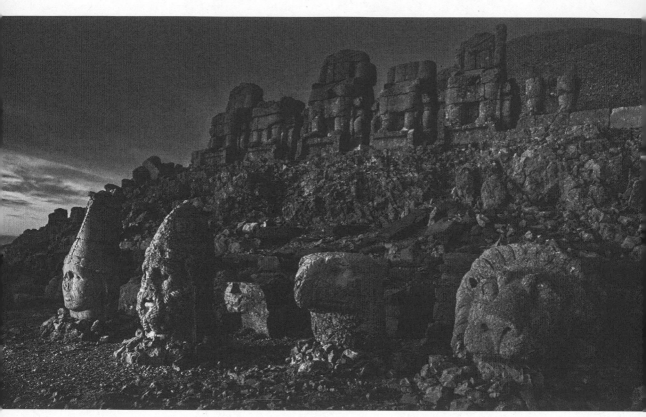

Still from *Meteorlar* (*Meteors*), © 2017 Gürcan Keltek.

Still from *Motherland*, © 2017 CineDiaz, Inc.

Still from *Did You Wonder Who Fired the Gun?*, © 2017 Travis Wilkerson.

PART TWO

SONIC TRUTH: VISIONING WITH SOUND

Each artist featured in this section grapples with sonic resonances in his or her film and video work, meticulously building soundscapes to accompany visuals almost as an architect might—a creative process of endless experimentation in order to construct a physical framework for stories otherwise difficult to tether. Deborah Stratman, Michael Robinson, Gürcan Keltek, and Dónal Foreman are makers in a constant state of inquiry as they build landscapes with audio-visual montages that exist between the spaces of physical environment and human imagination. While some collaborate with accomplished sound designers and talented musicians, their initial explorations are usually done solo, traversing the inner landscapes of their own fixations, anxieties, and quandaries into complex, cogent, and eloquent statements on modern life, geopolitics, sexuality, trauma (both personal and collective), loss, and memory.

DEBORAH STRATMAN

Deborah Stratman displays great mastery at subtly interpreting the subconscious frequencies and amplitudes that give shape to our common experiences, illuminating the viewer through her distinctive representations of systems of power, control, and belief. Working within a multiplicity of media—from film, video, and audio work to drawing, architecture, and sculptural projects—she has received Fulbright, Guggenheim, and Creative Capital fellowships over the course of her career. For the last decade, she has taught in a multi-disciplinary arts program at the University of Illinois in Chicago.

Deborah was one of five artists to receive the 2014 Herb Alpert Award in the Arts, an unrestricted prize of $75,000 given annually to innovative mid-career artists. She makes work to engage her perpetually inquisitive mind, a mind that asks a lot of complicated questions to which she really never expects to receive answers. And if she does receive answers with too much facility, it's likely she'll decide it's not worth pursuing after all.

The editing of her film and video work is distinctive. It reminds me of the work of Armenian director, Artavazd Pelešjan, also a brilliant essayist and theorist who created highly poetic views of life on celluloid. Pelešjan is also known for developing a style of cinematographic perspective known as "distance montage," and this is something that Deborah does, as well, particularly with sound, combining perceptions of depth with various visual entities on screen to sometimes uncanny, but always mysteriously moving, effect.

I met with Deborah most recently in October 2014 in the Czech Republic at the 18th edition of the Jihlava International Documentary Film Festival where she was to give a master class and also serve on one of the juries. We managed to carve out a bit

of time between her screenings for a quick bite of lunch at a deafeningly noisy café in the foyer of one of the cinemas. Deborah's latest film, *Hacked Circuit*, was also in competition in the Fascinations Section at Jihlava. It is dedicated to both Walter Murch and Edward Snowden and, out of thirty-three other films in its category, ended up winning the prize.

Hacked Circuit, a title that beautifully plays upon many ideas presented in the film, is a fifteen-minute piece shot in one take with superbly realized camerawork by Norbert Shieh. The film makes immediate allusion to a scene in Francis Ford Coppola's 1974 film *The Conversation*, in which surveillance expert Harry Caul frantically searches for a bug he is convinced has been recording his telephone calls. Deborah uses a real Foley studio in the back streets of Burbank in Los Angeles as her set, exploring violations of privacy by political powers while simultaneously illustrating the power inherent in the various illusions and conflations of our perceptions of sight and sound.

PC: Your various artistic explorations move through so many doorways. Can you talk a bit about the process of how pieces coalesce?

DS: I can't say I know ahead of time what the entry points will be. I also don't have preconceptions about what various levels of egress might present themselves. It's more that I'm conscious about not providing one single diagnosis to whatever question the film puts forth since I'm never attempting to diagnose anything in the first place. I want to come at things from a place of unknowing. I make because I *don't* know. I get really frustrated watching films with a pedantic attitude stating: "Now I'm going to show you what I know." I don't want to experience a work of art just to be lectured to.

I want the forms of my pieces to be open enough to accommodate the very different ways people take things in and that's why there tends not to be any specific methodology when I begin a project. I'm asking questions, trusting my audience to experience visual poetry and different audio-visual structures that say as much as spoken language can. I want the registers of the film to be multiple, to accommodate the different ways people pay attention via story or landscape or performance in order to watch somebody move with agency through the world. I am very conscious about when I want to shift filmic modes. Cutting from a section that's causal to one that's more sculptural is a way to choreograph the mental distance from which a viewer experiences the film, how closely or vaguely they're paying attention. I like

controlling all of that. In classical cinema or whatever kind of cinema you might be making, the point is to utilize this aspect of surprise and suspense, to utilize ambiguity, to use conviction as well as doubt. It's as much about the experience of reception as it is about cinema.

PC: What sorts of questions were you proposing while making *Hacked Circuit*? Your homage to sound in cinema is executed in very explicit and powerful ways. You use a Foley studio, an actual—meaning not virtual—space where reproduction of sounds is created and recorded to add to a film's soundscape. You unmask this sort of clandestine art form since the best Foley artists' work should be so well integrated as to go unnoticed. This is offset by the ways in which you also play with the trickery of surveillance and eavesdropping, where sounds can also be misinterpreted because we can't see or identify their source.

DS: Once production started, *Hacked Circuit* was a pretty succinct film to make because it epitomized a lot of the thinking I'd previously done around sound and that is that sound is half of a film and that it also functions as a strong mode of social control. This is something I've explored in my recent installations, the way sound is used subversively, sometimes militarily, as surveillance or camouflage. But while sound may be half of a film, we don't come to it with the same critical faculties as we do images. Sound is all around us in a 360-degree way. We rely on it to cue us as to what kind of physical environment we're in. When you're hearing something, you're *in* it. You're not in front of it, right? You're inside the sonic environment. Whereas when you're looking at something it's there in front of you, especially in a cinematic encounter. When you're listening you're in the middle of sound, so you're deeply connected to the here and now.

Consequently, there are many belief structures that emerge out of information sound gives us that we take for granted. We don't tend to pick it apart or analyze it as carefully as we might something visual because we lean on it subconsciously and we're easily fooled by it. That's why sound is so subversive and so well suited as a mode of control. As someone who wants to have complete control over my audiences, sound is an appealing zone to master. Yet I'm also attentive to manipulation. When I am in a really quiet environment, I notice how much lower my anxiety level is because of that missing layer of white noise. We're sitting in this incredibly noisy place and when we first walked in, you had immediate anxiety when you saw all the babies around us starting to cry, that your recorder would pick up all the ambient noise around us and possibly drown out our conversation.

PC: Physiologically then what kind of effect are you after, or how do you orchestrate a purposeful sonic design where you have those moments of silence, a total ceasing of any noise, manmade or otherwise? You have moments in some of your work where the sound is sucked out completely and we are in a sonic vacuum of sorts.

DS: In some of my longer films, I particularly like the operatic aspects of noise. I love the drama of a swell and then the literal dropping out of sound. An example of that is in *O'er the Land*. There's a shot of a distant fighter jet and its sound slowly drops away to nothing, and then we cut to a man stepping off a bridge, still in silence, before a third cut to a very loud scene of men with flamethrowers. There are times when there is a vacuum I want to create, a collapsing of space from something huge to something internal, in essence a sonic vertigo. Walter Murch and sound theorist Michel Chion talk about this, how sound allows you to play with physical scale very efficiently. *Hacked Circuit*'s manipulation of space via sound is more like a Matryoshka doll. It's meant to be nested so that with each layer there's another order of control, another order of manufacture that's revealed. The viewer should keep having realizations about what's constructed and what's not. By the end, you should start to distrust everything just a little bit. But it should still be accessible in the sense that, if you've never seen the film *The Conversation*, or don't know anything about the NSA surveillance scandal, you can still have a complete experience. I want my films to work even if you don't have "insider" knowledge. *Hacked Circuit* might function simply as a portrait of a Foley artist.

I'm interested in the loop as a form that evokes a feeling of paranoia, where you're stuck in a pattern, always returning to where you've already been. I think a loop reflects the anxious thinking that we're experiencing culturally. Feeling nervous about whom we can trust and, consequently, how we communicate with one another, the infrastructure for how we know one another, or what we lose when we're using these networks. I also like loops because they ritualize form. I was interested in the poetics of simple objects having double identities, a latent sonic one and an obvious utilitarian one. Foley artists have things in their studio because of what they sound like when manipulated. The objects have double identities, as do the political implications of communication. There's a lot of mirroring that goes on in the film. For instance, I like that an active Foley stage looks so much like Gene Hackman's apartment in *The Conversation*. They're both chaotic environments, strewn with oddball stuff.

PC: How did you find this particular place or did you already know about it?

DS: It took two years to find this studio because I needed a space that was relatively small with both a front door and a back door that was near a street corner so that going around the block didn't take very long. In other words, I had very specific geographical needs. There are a lot of beautiful, huge sound studios in LA. But often when you go outside those spaces you're on a studio lot instead of in a neighborhood. The location we found was perfect. The two neighboring businesses were Ham Radio Outlet and Guns Direct. It was too good!

PC: It's also so evocative of Hollywood's backstreets, where a lot of the most creative and innovative work is done away from all the supposed glamour of the studio lots. The best auto-body shops happen to be around that section of Magnolia Boulevard—parts strewn everywhere but the workers who know what goes where have a particular kind of genius in how all this junk can be used to build something that functions. This film represents a similar build.

DS: I don't generally work with a script for my films but with *Hacked Circuit* there was a conceptual shape I had in mind from the beginning, and that's fairly rare. I knew I wanted it to be a loop and I wanted it staged. I wanted this literal Foleying in a film that allows you to think about surveillance and construction, about how we believe in what's around us, the systems of belief by which we navigate our lives. Other times when I start a project I'm following a group of people or one person and they are the ones dictating how I will shoot and what I'll look at. So those pieces are conceived more in the edit. You could say they're more in a documentary style, though to me documentary just means you're willing to cede some control either to fate or to other participants—to anything besides your own agency.

PC: I think documentary just connotes an openness that perhaps isn't conducive to other kinds of work. As a maker you want to have some kind of correspondence with your viewers through your work. Who do you correspond with in your creative process and does that impact your decision at all in deciding on form? How do you know if something is meant to be an installation or a drawing or a film?

DS: I get a lot from the correspondences I have with my students, in particular, since they challenge me to think in a way that's outside of myself. I teach within a cross-disciplinary program where there are sculptors and painters, filmmakers and photographers. The critiques are done together in a big group and the conversations are so illuminating, especially when they fall outside my wheelhouse. There's a generosity to being a good critic. It's the difficulty of it that keeps me excited, the push

to keep learning about artists and histories and techniques. There's so much I don't know! As I said before, that's probably my overriding reason for making art, my not knowing. It's a way to think through something without language. I'll write after the fact but I don't like to write beforehand. I'd rather think about orchestrating rhythm, framing, determining pressure. I like thinking via the more haptic, emotional work.

PC: Do you think art has an imperative to be useful?

DS: The usefulness should be making something that will help you or society get past things, stubborn problems that nag. I make some projects to help me get unstuck. But the work is not always coming from a place of philosophical troubles. Sometimes I just want to work with what delights me.

PC: What's delighting you lately?

DS: Well, there are three things I'm working on now. One project involves jumping in and starting to film without any questions in mind. I hadn't done that in twenty years. I just wanted to observe and be conscious of what makes me want to turn on my camera. I shot half the footage in Brazil and half in Jordan. Who knows what it will be! The other delight project is something I shot a couple of years ago when my partner Steve Badgett and I were working on some public sculptures in the Yukon. I shot some Super 8 while I was there and I just haven't had time to sit with it yet but it will be fun to edit.

The third project I've been working on for five or six years now. I would *not* call it delightful, actually. It's been a stubborn, painful film. It's about faith, interestingly enough, and also about technology. It sort of came out of *O'er the Land* when I was thinking about the myths we construct around freedom and the stories people have written about why we came to America. To have religious freedom was why many people journeyed there. The film is meant to be episodic, the episodes all set in the state of Illinois. It's called *The Illinois Parables* and I've been working on it a long time, digging and digging and digging, but it's resisting me. It's a historical film because history allows us to see the present. But then I ask myself, should it be more topical, more observational?

PC: Trusting the work you're making to find its form is a kind of faith, fully knowing that the organic elements and those that are intentional might intersect.

DS: Yes, but deliberations like that don't have to be prescriptive. It is really about listening. Maybe something isn't going to work itself out in a film, but it's well suited as an object in a landscape. Sometimes the desire to change mediums comes less from what the concept dictates than an interest in a change of speed or pace. It's more

of a reactionary impulse because I need respite from a mode of working. Maybe it's something I can do in an hour instead of it taking five years. Changing soothes the part of my brain or body that's overtaxed. Like when you sit for too long at your desk and your body starts to ache. Steve calls it, "Taking care of the chair." I will sometimes deliberately put something in my path to trip on by working in a medium I've never tried before. I get nervous when I know a system too well. The expectations of trying something new are different because there's no mastery there. It's wide open. It's in the accidents and the messiness that the most enlightening situations arise.

MICHAEL ROBINSON

Every time I've seen a work by Michael Robinson over the years I'm left thrilled, puzzled, and ultimately moved, provided with an emotional reaction that sometimes sneaks up on me several days later or just makes me weep outright while I'm watching.

The first time I met Michael was at a late-night festival party in Oberhausen, Germany in 2013 where his then-latest tragicomedy, *The Dark, Krystle,* was in competition. The ten-minute piece is constructed with footage from the television nighttime soap *Dynasty.* The ABC-network series ran from 1981 to 1989, putting jackets with enormous line-backer shoulder pads, hysterical women bitch-slapping one another in every way possible, and endless episodes of serial binge-drinking on the map. It was a bizarre decade and the majority of Michael's work is deeply influenced by the campy American TV soaps and (mostly god-awful) sitcoms of the Reagan era.

His early 16mm silent film dedicated to his mother called *Tidal* (2001)—a piece he made as a twenty-year-old undergraduate at Ithaca College—shows characteristics of the artist he is today: the use of cross-fades, dream logic, and an ineffable, eerie mood to describe a specific place, time, and state of mind; his way of processing memories of romantic love and familial relationships; and visual and aural flickering, a stuttering effect that accelerates and moves into frenetic rhythm. His works at first blush seem to be delicate and beautiful, staged odes to the bucolic. But underlying this dream-like atmosphere is a lingering unseen menace that's usually introduced via the soundscapes Michael creates. Filled with caustics of sound and light, there is a coded language perhaps not really meant to be interpreted, at least not in any logical way. The soundscapes add another element of reverb, chthonic and nightmarish, oftentimes layered over a sing-along pop song. Watching Michael's

videos feels as though you might have had a little something dropped in your drink when you weren't looking, making your vision and hearing go all woo-woo. Not surprisingly, an early influence for Michael is the master of delirious unease, Mr. David Lynch.

Michael often tells stories of heartbreak, his own or an entire country's—the contemporary American psyche in a collapsing world.

Now living in Los Angeles, he's currently raising production money for his first feature-length narrative script titled *I'll Be Thunder*. He and I had a leisurely Sunday coffee klatsch just before the December 2018 holidays, he at his home in LA, me in the sleepy seaside village of Berwick-upon-Tweed, UK.

PC: It feels like the pieces you make must have a really long percolation period. Do you have a system for housing elements you might want to use for works you haven't even conceived?

MR: It's never very organized, but I do gather a massive amount of stuff—notes on my phone, notes on my computer, different folders on my computer, lists in notebooks. I'll forget about something for a while but I'm often struck when I do go back and look at all these lists of things. They could have been noted a decade ago—loose ideas or bits and pieces of potential projects that I internalize. And, oddly, somehow they do eventually get checked off the list, even if I don't remember that they're on a list to begin with. I do feel confident about the kind of abstract narratives I put together and, yes, it does take a percolation period for me to sort them out, to feel like I know what a certain element is going to mean for a piece or mean for me, personally. It's different with a scripted project. I'll keep coming back to the script and changing it over and over again, aware that the creation—the shooting and editing—will be a whole other layer to it with room to change things from the page to the screen. It definitely doesn't feel much like the collage process I've become accustomed to.

PC: Nonetheless, there is a very cohesive vision to your work. One of the first pieces you sent me you made while you were still in college. I was so captivated by *Tidal* because I could see the creative markers and tools you've continued to reference. What was it about working with both film stock and video—and their innate and particular manipulative qualities—that excited you?

MR: Those first films I made were all heavily influenced by my studies of the history of avant-garde film. I was a real sucker for '60s and '70s-era American work

that was landscape-oriented. I fell in love with that history and felt this kind of second-hand nostalgia for this era of American art and landscape. So as a student, I wanted to mimic that. The reasons I wanted to go to film school were probably a bit more transgressive than I was aware at the time. I'd been deeply affected by David Lynch's work as a kid. I watched *Twin Peaks* at around the age of ten. There was something about wanting to mimic and be a part of this history of avant-garde film but also feeling like that wasn't really an okay place to be anymore, that there needed to be this darker response around the state of the world mixed with my own interest in wanting things to feel a little bit off.

In terms of the family films I made in college and the landscape-centric stuff I was making in grad school, I wanted to create this sense that they were perhaps from a different era. Though what actually happens in the films and the way they move towards something stranger came from a desire to evoke this feeling that something from the past was coming back to take revenge or to have new stock in the present. That was the language of filmmaking that I was sitting in front of and appreciating. Mixing that with my own predilection towards doom and gloom as well as my sense of humor was the general approach. All that said, however, so much of it was intuitive.

PC: You often reference constellations and other extra-planetary elements both in your films and in your collage work, patterns that emerge from other spheres of existence. Your own self-portraiture is quite hidden or even buried but there is a sense of emotional autobiography. Even the titles of your pieces are enigmatic and incomprehensible, meaning they have private meanings for you. I really envy this readily available access you have to very personal coded language. But then I think that too much explication would actually cloud one's visceral connection to the work.

MR: It's true that I do transfer a lot of my emotional life into these works but I don't always do it consciously at the time. In *Onward Lossless Follows* there was definitely all this stuff going on in the world and that all went into the film in a way that's clearer to me than it has been in other pieces—not so much when they're done, but when I'm in the midst of making them. I think it varies piece to piece because for the more emotionally intensive ones I do go into a kind of fugue state to sort them out. But then the editing of any given piece involves a process of sitting down with it and discovering some inkling of how everything is related. Through trial and error I start to put things together.

In something like *Chiquitita and the Soft Escape,* which I made back in 2003, it's funny to think about that as a coded message. The ABBA song *Chiquitita* was a favorite of my sister's and mine, and the two of us had this whole dance routine to it. [*Laughs.*] I usually have some permission from myself for every little bit of what's there. That piece was made during my last year of college and I wanted it to feel like a love letter to the places and the people that I was about to say good-bye to. I'd also just had my first romantic relationship breakup and he and I had bonded over ABBA, too. The figures in the second half are my mom and my sister and Lucas, my college boyfriend. I mean at the time I wasn't thinking about it as a breakup film. But it is a film about lovers as family. Here are the people in my life—let's put them through the optical printer and then rationalize it. Those kinds of choices often feel more emotionally clear some years later when I can think of them as personal reactions to the things and people that were or are important in my life. I'm just putting them through some abstract pageantry. They felt more open-ended to me when I was working with them. It's only later that I recognize any kind of self-portraiture.

Recently when I've had the chance to do solo shows it's been much heavier for me to watch pieces made over the course of many years. In general, I'm pretty okay watching my films because I work on them until I feel stupidly pleased with them. Having this amount of time pass and realizing that I'm still doing this, I start to wonder what might be wrong with me. [*Laughs.*] Each film does feel like a time capsule of what I was thinking about and feeling at a certain point, and given the darkness and wacko-ness of a lot of it, it does make me question whether I'm okay or not, especially my more aggressively deranged films. People have expressed concern and my response is to say I meant it to be funny. But seeing them all in a row…

PC: Almost every piece you've made has had a robust exhibition life—at festivals, galleries, as part of special curations. So something is resonating with a lot of other people on a consistent basis, even with more than one generation of critic or curator. The derangement, as you call it, has a deeply human perspective. Many of the speakers in your works are seers, prophets, self-proclaimed or otherwise, empaths, psychics, visionaries, and mystics who can see other worlds beyond this one. Your work pays homage to these different states of consciousness. You use pop culture as a spot-on conduit for that, a collective pressure point used to shift everything into an altered state.

MR: I am definitely interested in transference of experience. All the films have a somewhat disparate relationship between image, text, and sound. The text could be that of a TV show or voiceover or a written text. I'm always looking to separate those things just enough so that the connections feel both extra-tenuous and somehow all the more vital and the reason for that is precisely because they're coming from some outside logic. The emotional core lies somewhere in between all these things so that only in the movement or in the projection between image, sound, and text can it emerge.

The banality of the media we ingest, particularly the stuff that I gorged on as a kid, is a pretty weird thing to reflect upon. It is a dark thing to imagine millions and millions of people also being raised both creatively and emotionally on something like these sitcoms or soap operas. I watched a gross amount of TV growing up and I think I gained a lot of my sense of humor from TV. I also learned about love and cinema through TV and there's a weird way in which we learn a lot of our own humanity through this kind of media. That's changing somewhat now. Since I'm not a kid anymore, it doesn't feel as porous to think about social media or the kind of online media that's currently forming people's brains.

It seems terrifying to me so I still veer towards the stuff I grew up with as my test subject. I gravitate towards pop culture media that seems squeaky clean or glamorous on the outside but has a pretty dark underbelly. This is something I play with in *The Dark, Krystle. Dynasty* seems to represent so many problems of the '80s, while also being this campy fun thing. Or a show like *Full House* [*Light Is Waiting*, 2007] that seemed so banal as to be offensive, making you want to look away. I *hated* that show as a kid. But I also loved it and watched hours and hours and hours of it. I'm fascinated that as a culture we submit to these giant machines of entertainment that for better or worse end up shaping parts of our brains and getting lodged in our psyches.

PC: Let's talk about this forty-five minute piece you did in 2012 called *Circle in the Sand*. It's the longest piece you've done thus far. It's a piece that I found more discomfiting than a lot of your other films. I'm not sure why but it could have been the way in which you used actors here versus stock footage or archive. It was surreal in a whole other way and it also seemed like it could have come out of a moment when you felt as you did when you made *Onward Lossless Follows*. It felt like something universal had let you down.

MR: Starting with the films I made in the mid-2000s, apocalypse and a broken future have worked their way into a lot of my work. I remember that at the time, I was inspired by the town hall debates that President Obama set up around the Affordable Care Act. I guess that would have been 2009. Having all the hope and satisfaction and promise of Obama, I felt the future was going to be okay and that things were potentially back on some track that didn't feel awful. And then seeing those debates go so weirdly wrong, I realized that humanity is maybe just too flawed to properly take care of itself. [*Laughs.*] This all seems somehow quaint in Trump times.

Circle in the Sand is a less emotional film for me than some others, maybe only because it was a more collaborative process. Editing a quasi-narrative gave me a chance to focus more on the humor and magic of it more than the darker emotional ramifications hovering over the entire thing. I wanted to make a longer piece because I needed to. I was interested in how the kinds of atmospheric zones I tend to set up would work over a longer duration. I did imagine it as a work for the cinema but I showed it as an installation and I felt that it worked better as something a viewer could wander in and out of. Most of my films have more of a song structure, like longer power ballads that run seven to ten minutes. This one was a taller order.

PC: Like *Bohemian Rhapsody*?

MR: I consider *Lossless* more like a *Bohemian Rhapsody*.

PC: *Lossless* won a Best Sound Award at Cinema do Recife in Brazil the year it came out. The soundscapes you create are what usually tip things over tonally—in a literal way but also in an ineffable sense. It's the way you switch gears into this disturbing dissonance between what's being heard and what's being seen.

MR: The reality of that process is that it involves a lot of trial and error in terms of figuring out how the sound is working. I can usually get a rough visual edit together pretty quickly but then the sound takes much longer. I'm looking for this transference of meaning between sound and image in the way I'm warping sounds or letting them come in and out in layers. It's about keeping that balance between the sound and the image on the edge of falling apart. But also they should be motivating each other. If there are worlds upon worlds opening up in the image, the sound should have a way of pushing those through or working like the emotional or atmospheric glue between things. The sound is definitely the guiding force in my films since it can tell you what to do with that more open-ended imagery, casting a darker or more troubled tone onto something that otherwise would be banal or familiar. The trial and error occurs in figuring out how to skew the image away from itself or

towards a more abstract narrative. It's safe to say that I use a lot of the same tricks over and over again. I don't know, for instance, what my attachment to reverb is but it works for me in achieving this porousness of the image, having sounds that open themselves up and echo out.

PC: I appreciated what you wrote about this encounter with your collage work. It's become part of your practice, the ability to exhibit in this more multidimensional or multidisciplinary way. You said that you began making collages in 2009 as "a means to relieve the tedium of editing on a computer, and generate something fast, direct and physical." [Michael's collage works are represented through Carrie Secrist Gallery in Chicago.] But then you go on to say that as these works became more sophisticated, they've taken more time to make. You've become even more proud of them because they express visually what you achieve in the sound work of your moving image pieces.

You literally make collage with the text in *The General Returns From One Place to Another* from 2006, one of my favorite pieces of yours, where the ominous beauty and slippage from reality to the supernatural is incredibly sly.

MR: That piece and the other works I made around that time, *You Don't Bring Me Flowers* and *And We All Shine On,* were a reaction to both having had my heart broken and Bush being reelected. [*Laughs.*] Those were the main motivating personal forces. There had also been this saturation of avant-garde film I talked about earlier and that's where you see my interest in mimicking this somewhat nostalgic landscape, this 16 mm film aesthetic and then having it fall apart or devour itself. The nostalgia these works are tapping into ultimately poisons them. I made the *General* piece in the middle of my two years of grad school at University of Illinois. That was the first piece where I really paid attention to complex sound. Deborah Stratman was my advisor at UIC and she's incredibly wise regarding sound and opened me up to things like tonal separation and bass and letting things breathe. In that piece more than any other, I feel like I tapped into a pattern I would then go on to embrace as a way of letting the various parts of a film be in conversation with each other while also being at odds.

I wanted the darkness and damnation of the text to build against what felt like an increasingly floral or beautiful background, though the images are sort of dark and mechanical too. The weight of that damnation collapses the text and then you have to reckon with how the various parts continue. I wanted this tug-of-war between beautiful image, ominous sound and fatalistic text to finally collapse. That film more

than any other fell into place in a way that was terrifying to me. I had had a totally different idea. I had wanted to use some of [German filmmaker Rainer Werner] Fassbinder's plays, just using the stage directions as text. That didn't work because it wasn't doing anything emotional. That monologue from the Frank O'Hara play appears in the film just how it's written and it just paced out so perfectly with what I'd arranged with the image and sound. It ended up doing this whole other thing that emotionally was exactly what I wanted to do but I didn't have the wherewithal to write something like that myself or even recognize that that's what I was up to. That helped me a bit with *Onward Lossless Follows* because like with *The General*, I sat down to make it with all these various pieces I had gathered and a pretty troubled heart to try to figure out what was going on. It, too, fell into place in a way that seemed like it knew more about me than I knew about myself.

PC: The conceit of using this child safety VHS tape from 1994 called "Never Talk to Strangers" for your ill-crossed love story in *Lossless* is, again, something that resonates with all of us who grew up with this ABC After School Special style of cautionary tale—the feeling that something insidious and potentially fatal could be right under your nose and the danger will probably come from someone you know. This film feels so fraught with personal peril on some other level that surpasses your previous work.

MR: It is. So many of the people around me and I felt like our emotional and romantic realities had just been flipped on their heads by the 2016 election. The instability of the current political climate has brought out this notion of our world not being what we think it is and that does have some drastically damaging effects on people's romantic lives too. I saw a number of couples breaking up or having serious problems around that time. There were also a number of women I'm close with who were having babies at about the same time I finished the film. Tracing it back, they had all gotten pregnant somewhere around the time of the election. It just all felt like an existential crisis unlike anything I'd ever experienced before.

I wanted to think about this era through a warped love story, relying on the excitement and sweetness of new love—as grafted onto Mrs. Smith and Karmi's ill-fated text exchange—as a vital response to a world that feels like it's about to fall apart. The short film I'm starting to piece together now feels like a follow-up to that and I'm thinking I might want to make a handful of these warped love stories for Trump times. The irrational nature of falling in love feels analogous to the irrational nature of having a comic book villain be in charge of the world.

PC: As I've told you, I weep like a baby when I watch that scene of that blinkered horse being airlifted out of a dangerous situation. What touches me, I think, is the man dangling underneath that creature, hanging on and spinning through the air with the animal. There's so much to project upon there and the choice of using the America song "A Horse with No Name" sung by a children's choir goes way beyond any safe baseline of emotional places we can explain away.

MR: The more I do this the more I realize that the thing I always come back to is emotional abstraction. Not in the sense of abstracting emotions to be something other than what they are but achieving deeply felt or resonant emotions through abstract means. It feels infinitely exciting and curious to me. It points to both the strangeness of emotions in general and then tries to pick apart what they are and how we allow ourselves to think and feel. I just like big emotions in art film. It's exciting to push things into points of almost absurd emotional saturation or bombast. It feels personally cathartic and I hope that that's the case for spectators, too.

GÜRCAN KELTEK

The cinematic worlds that Turkish filmmaker Gürcan Keltek creates are meant to disorient, even when he provides the spectator with very explicit compass points. The evocation of unsettledness is the entire point. Because if one is filming in a landscape that is unmoored from reliable mileposts altogether, this makes it possible to acutely experience what it might feel like to be trapped in a war zone where certain passages of ingress and egress are blocked or open, depending on the season; or, what it feels like to be bombarded by things indeterminately man-made or atmospheric hailing down from the sky. Perhaps there is a woman—a fictional amalgam of a real person—speaking barely above a whisper about what she's able to see and hear, a clairvoyant able to insert herself into different zones of space and time, and even as she's dying, able to remember the past and conjure events yet to come. Filmically, Gürcan revitalizes hellish experiences by starting with long static frames of empty, sere landscapes. Only upon patient observation are the incorporeal scars of displacement and disappearance revealed.

The first work I saw of Gürcan's was the 50-minute *Koloni* (*The Colony*) (2015). The film was in the Balkan competition at DokuFest that year. The jury awarded it with the Best Balkan Newcomer Prize, even though Gürcan is in his mid-40s and has been making films since 2011. As with *Meteorlar* (*Meteors*) (2017), his follow up feature, *The Colony* is shot in black and white. Gürcan recounts military coups, ethnic slaughters, unearthing of mass graves, and states of being amidst perpetual warfare and boundary shifting.

Around the colony to the east there is Vretsia, Theletra, Greece. Simultaneously it is also Afania / Gazikoy, Turkey. To the west, 200,000 Greek Cypriot refugees just want to return to their homes. In Strovolos there is an archeological dig for bones.

Families have had to grieve for loved ones without a body. At Lysi/Akdogan there has been a construction of a new road. As the bones are found by an autonomous Missing Persons Committee, they are buried one at a time until hopefully a whole skeleton might form and a family can be notified that remains have been reconstituted just enough in order to be identified. In 1964, mass graves were robbed, leaving bones and other personal effects scattered—a giant jigsaw puzzle with so many pieces to put together so that it can make some kind of sense, to make a picture one can understand about what happened there. Disembodied voices float in the air trying to describe massacres, statistics of missing persons, how many Greek Cypriots died, how many Turkish Cypriots died, a divided Cyprus. By *The Colony's* end, we are left with the staggering statistic that since 1974, 951 mass graves have been discovered and opened.

Gürcan is a maker able to extrapolate images into story by figuring out what they should sound like. Death and destruction can come out of nowhere. A meteor shower can appear to be an attack of bombs and shells. Any place can stand in for so many others because after a while war becomes unending noise, an invasion and ambush of sound, especially in ditch warfare where even the identity of the enemy is not always clear. The sound takes center stage because the images cannot hold— they literally disintegrate into pixels, blurred and smeary. The echoes and reverberations of sound are what we're left with when the lights come up.

We spoke about his exhilarating and haunting work in November 2018. He called me from Istanbul having just returned from a retrospective of all of his film works at the Viennale, the annual international film festival in Vienna, Austria. He said it was really wonderful to encounter such appreciative audiences and joked that it had felt a bit ironic to have a retrospective at a festival that up until then had rejected every single one of his films.

PC: When we enter the worlds of your films, we always encounter life forms embedded in the landscape. But first we're allowed to have a very long look at that landscape and what's in that landscape emerges quite slowly. We see these frames of vistas accompanied by ambient sounds but even that doesn't give us any idea as to where we are. Why do you like to begin your stories with such disorienting perspectives?

GK: The decision to film this way comes completely unconsciously. I start to imagine a series of wide-shot landscapes connected to one another so it is the geography that leads me forward. Then the story and all the elements come. This decision

has to come first for me because it's the most important part of the spirit of the film itself. It doesn't matter if it's Istanbul or the southeast of the country or some island in the Mediterranean. The relationships we have with landscapes help build us as human beings. It has to do with where we come from and how we see things. That identification with geography in modern terms is key to what we are and why we move ourselves from one landscape to another, whether they're cityscapes or rural areas or wherever it is. When I decided to make films, I concentrated on that and the atmosphere that those landscapes evoked in me. The story or the immediacy of the subject came together from there.

When I decided to make *Meteors,* a film about this conflict in the Kurdish regions of Eastern Anatolia, I also wanted to make a series of shots in those mountains because this mountain territory was so important. Most of the guerillas were hiding in those mountains, coming down in the summer just as the goats do in the beginning section. In Turkey the winters are usually quiet; there's not much happening. But when the snow starts to melt the soldiers can cross the borders through these very tight passages so they can get to the territory where the Turkish army is. Even the conflict itself is affected by the landscape and how it shapes timelines and schedules. All of these elements are important. The animals and plants and the skin of the landscape help to inform these storytelling decisions.

PC: But to shoot in black and white can also be loaded with questions. The texture of everything is more enhanced somehow—mountains, skin, hair, plant and animal life. You often use a macro lens in order to come just as close to something as these vistas are far, creating an astounding sense of mystery that works to sublimate the intellect.

GK: I used to work in the film development industry and all the things I used to work with related to getting these highly polished, clean, pristine color images. It started to make me kind of sick. The presentation of beauty in the industry and how people deal with those images made me feel that there's something inaccurate built into how we perceive things, in general. I shoot in black and white not for some nostalgic effect since that's also completely superficial. Some filmmakers use black and white and they really have no idea why. It can be kind of lazy. I shoot all of these films in my country or related places that I would traditionally see in the French or British archives. The camera arrived in the Ottoman Empire a bit late and images from Anatolia were all black and white. However, as a person who came from a

formal film school education, I learned very early on that I should not be too overly analytical because then it is so easy to suck the spirit out of the film you're shooting.

Simply those landscapes speak to me. In the case of *The Colony*, all the locations you see in the film are mass graves. The places where we shot and the places where we walked, where we had fun, where we ate lunch—all these places were waiting for the missing persons committee to plan excavation procedures. In *Meteors*, all the places up until we arrive on Nemrut Mountain at the end of the film is Kurdish territory and there's been a conflict going on there for the past fifty years, maybe more. So in one case, these are landscapes where people were but are there no longer. They died there. And those places are completely anonymous. There are also very personal reasons for all this. Something might be happening in my life that has nothing to do with the content of the film. Those grays and blacks and whites feel like paintings to me that express something personal even though I also know that's been done before many times. I think that's why when people see these films and have no idea of the political or practical context, they could still have a relationship with those images. I'm trying to create that possibility when I film in these spaces.

PC: Aside from the slow reveal of the spaces we look at and what they mean, we also hear disembodied voices floating in that atmosphere. This also supplies a sense of import, but more than that, great mystery and suspense. In *The Colony*, you use a compass orientation of east, west, south, north, but if one's never been to Cyprus, one still doesn't have an accurate concept of its geography. But you do name those places just the same. And if you bother to name something, is there something being stated in that act of naming?

GK: Yes, there you are actually, in a real place. Space is generally disorienting, it doesn't matter how you present it visually or what's happening with the sound because you can begin to speculate within your own space and within your own experiences. The conceit of splitting *The Colony* into four chapters in that way was a way to get the spectator to think about the territory, the word "territory" itself and what it is and what that means and how that affects the landscape. As we've talked about before, everything is so manipulated in cinema and I sometimes have a problem with that too since I don't like to be manipulated all the time. I also don't like it when a film presents beauty or ugliness or whatever it's presenting in a telling way. I like the feeling of disorientation too because, again, that can cause us to have a

relationship to the film itself or to the filmmaker in trying to discover what he or she is up to. I believe in that.

But as the maker, when you're recording those images, you're also learning from them. My films have this documentary language and I really like this process of having space to discover and learn something. When we were shooting *The Colony* we saw this worm slithering around us so we shot it with these macro lenses and somehow that became the final scene of the film. As an image, it echoed these themes of life and death as well as the territory itself. That decision was not really talked about too much; we just shot it. Disorientation is important in cinema because that means that there isn't anyone telling us how to feel about anything.

PC: Can you talk a bit about your relationship with Ebru Ojen Şahin and the role she plays in *Meteors*?

GK: I wanted to make a feminine film. Everything related to war is very male-oriented. It was one of the first decisions I made about this film, to have a female narrator. In the first scene you spoke of about the mountain goats we see that they are females and the hunters talk about that because they are only allowed to shoot males. So they had to give up. And specifically choosing an actress did speak to the documentary elements of this because even though Ebru is an actress who studied opera and is also a novelist, at the same time she can provide testimony of these events in an authentic way because she comes from one of those Kurdish cities in the east. Her father used to be a beekeeper but right now he's a member of this Kurdish party, the members of which are targeted and arrested on a regular basis. He just got arrested this past week actually for the third time. When we were nearly done with the Kurdish translations of the film, he went to jail as well.

Ebru has experienced this cruelty against civilians firsthand. We see a shot of one of her novels in the film very briefly. It's part of the underground literature that describes the Kurdish community in the '90s when she was growing up. She can also speak Kurdish in five different dialects and she's also my writing partner so there's closeness there. We've worked together for a long time. So it felt very right to use her as the narrator. In this space, there was no room to put conventional talking heads commentating on what's going on. I wanted someone with an authentic experience to tell me as well as the audience about what she sees. Her beauty was a concern because it's always dangerous to shoot beautiful people in cinema. I don't believe in it. [*Laughs.*] She's a known person here not because of her acting but for her books and her public persona related to politics. She's an important figure for

me. She also helped me record sound and assisted the camera crew. It is definitely a sharp contrast in the film when we see her but when I first conceived of the film, Ebru was the first person I turned to.

PC: The soundscapes are incredibly complex and always surprising. The way you use and incorporate musical selections is also unexpected and serves to lift even the most transcendent imagery so much higher, this use of an unexpected crescendo that circles back to some previously sublimated emotion. The penultimate act of the film speaks about the literal disintegration of the image. All we have left is sound.

GK: I'm a sound designer as well and I sometimes edit sound even before I shoot the images. I then give the files to my editor Fazilet Onat to see if these sounds we've captured somewhere else work for the edit. The sonic aspects of the films are really important; I don't agree with the notion that images are more important than sound. When you watch *Gulyabani*, for instance, that's a psychedelic documentary. We recorded sounds from *all* different kinds of objects and places and then manipulated them. This is how the main character hears things because she resides between two worlds. She's in a bed in a hospital dying and is seeing things from the past but also seeing things in the future because she's clairvoyant. It was the same for *Meteors* in that I started to listen to recordings of the sounds of the meteors captured by NASA as they entered the stratosphere. I loved those sounds when I heard them. They were really beautiful. It wasn't very loud but it was enough that you could hear that they must have been really big. So the sounds match the character's experience or the landscape itself, natural and unnatural phenomena intertwined.

In one scene we look down on the protests but we can't really hear anything. We just hear some deep rumbles. In one particular instance, this very young boy died during the time we were shooting. The public went mental after that happened; they were in pain and they were grieving. But we don't hear what they say or their prayers and cries. What we hear are these deep rumbles because the killing of that boy created deep rumbles within the society. I have this very small and simple Zoom recorder and I'm constantly picking up sounds that I will later use in my films. All of the sounds in *The Colony* and *Gulyabani* came from these strange field recordings over the course of a couple of years. It's a similar method one might use to construct a fiction film. I think of a film like [Werner] Herzog's *Fata Morgana* where we're looking at a desert somewhere in Africa but hearing something very otherworldly. I like this kind of contrast. I don't believe in "realism" in documentary because then

you're flirting with some kind of journalism or video activism if you ask me. I don't want to move in that direction.

Even though these events are important, I am making something to be seen on a big screen so I want to stay away from works that seem too contemporary where you're given this flat, raw information accompanied by diegetic sound. The images I can show the audience in a pretty straightforward way, but the sound helps me unhinge that. With music I like to use a lot of guitar reverbs or guitars that have been manipulated by various devices. The ending of *Meteors* has a lot of really loud guitars, a kind of sonic coda. It steps away from any kind of quiet or peaceful ending because I didn't want that. These play over the images of the intertwined snakes and the goats clashing horns. All that helped me create a picture of what it feels like to live in Turkey right now. There is music in *Gulyabani* that comes from banging on these big Chinese woks. Friends in London who work as an audio collective created that sound.

PC: This footage from the decimated village does very much feel like reportage since the men and women speak to the cameras as they would to a curious news reporter who wants to know the facts of the situation. But as they're edited, each of these video pieces is abruptly cut off, sometimes even when someone is in mid-sentence.

GK: Some of these images are from the Women's Peace Initiative in Turkey. Literally no one was allowed to enter that zone. We tried to enter those ruined neighborhoods and got thrown right out by the Special Forces the first time, by the police the second time, and we also tried a third time. But this group of women is made up of writers, scientists, news reporters, and other professions and they were successful in entering that zone, allowing them to get eyewitness accounts, to talk to the people there. They made that material public but they kept themselves anonymous. They allowed me to use some of that material. Those cuts were sometimes because someone was approaching or some danger was coming. We needed to protect ourselves but more importantly the people we spoke with. Sometimes they don't complete their sentences because they don't need to. They were extremely traumatized.

There was this case where a young girl was shot and she had to lie there dead in the street right in front of the door to her house with the rest of the family watching from inside. They couldn't collect her body for a couple of days. There were snipers shooting everyone. When they did manage to get the body they had to put her in the refrigerator because they were not allowed to go to the cemeteries. There were so

many horrific stories such as this. That's part of the reason why these interviews are so fragmented. I decided to edit in that way because you can't tell something like this in any linear way. It's all there in the faces of the children or some of the older women. You can see something is really wrong but then you see shots of the children playing in the ruins, which for me had these reverberations from pieces of old World War II footage where you also saw children playing in these complete ruins having fun, being children. The shooting period then as well was extremely fragmented so I wanted to reflect that. Those people had been held captive inside their houses for something like ten days, sometimes without water or food. When someone was shot, there was no way to get him to a hospital. Ebru also experienced this.

I don't like to edit my films as if they were on the BBC. When someone is saying something really interesting, then yes, I want to hear what is said and learn from that but most of the time, I find using footage like that in a reportorial style inappropriate. In this instance it was important to show the people talking to the camera. But those are now only memories because all those images are gone. They shot down journalists and independent reporters. The police confiscated that footage. So it was essential to show this documentation. There are a few images in *Meteors* that literally don't exist anymore. They only exist in the filmmaking universe.

PC: What's it like working in Turkey today?

GK: I will say that documentaries, traditional ones, are the number one enemy of the government right now. If you make a film about the Kurdish resistance as a fiction film you get away with it. But if you make a documentary or some kind of hybrid film related to that subject then you may be in trouble, to be honest. That's the situation we're in right now. I decided not to release *Meteors* in Turkey not because of the current regime, because this atmosphere existed quite a long time before it, but as a way to protest the state of the film industry here and the environment we're living in. Everyone acknowledges the censorship here and that bothers me because it makes things extremely hard for us. But at the same time, I have it a lot easier than other filmmakers because my approach is something that they don't understand. For instance, *Meteors* contains poetic elements and when you use those, the censors just can't do anything with it. With concrete stuff, they can charge you with something. But if you're implying things with poetic language or by the way you construct the story, it's difficult for them to figure out what it is.

There are things in my films that could make them furious and that's why I didn't release the film here. I just don't want to deal with a court case. There are a

few bills that have been passed in Turkey over the past couple of years that are very Kafka-esque. You can be put in jail for two years but you never learn what you've been charged with. It's very strange. But, I will say that I don't like to complain about this. I don't, in general, like when artists complain about working in repressive conditions. You are always hitting some walls as a filmmaker. I'm shooting something right now that has nothing to do with any political situation but I'm still hitting walls. I don't have a big network; I work with very few people because I want to protect the essential feelings of what I'm shooting. I don't want unnecessary distractions. I mean we're already in some troubled geography—like Cyprus for instance, at the Nicosia Airport in *The Colony*. It was and still is impossible to get in there with a proper film crew. You have to bribe the soldiers protecting it or you have to talk with the regular people who live around there to get in.

So no, it's not easy in Turkey but I'm always well aware of the fact that I'm not making cinema for a mass audience. You have to make peace with that. No one understands what I want to do—no producers were listening. Here, most of them just cannot imagine a film that is based on real events but at the same time much of it is fictionalized. This approach is new in Turkey and the mentality here makes you lonely, not people's behavior necessarily. But there are ways to deal with it and so that's what I'm doing. I mean it's getting pretty scary everywhere—Eastern Europe, the US, Britain. The things we were complaining about in Turkey a few years back are quite common now. You see different versions of the same mentality. But it's the film industry, not the politicians, that makes it so difficult for me to produce these films here.

The thing I'm trying to do, really, is make the films I want to see on the big screen. I made *Meteors* because no one was making a film about that place and the conflict there and that pissed me off. There's something extraordinary happening there. In that time as well I had just lost my mother and was in this grieving phase that made me relate quite deeply to those people in that place. When you lose someone there is this horrible grief that is as powerful as intense love or hate, I think. And in the midst of that grief, I decided to go and make this film.

DÓNAL FOREMAN

Writer and director Dónal Foreman splits his time between his native Dublin, Ireland and his home for the last ten years, Brooklyn, New York. His first feature documentary *The Image You Missed* (2018) is a fictional memoir of Dónal's complex relationship with his filmmaker father, Arthur MacCaig. MacCaig, the son of Irish immigrants, was a documentary filmmaker who made his home in Paris most of his adult life but centered much of his work on the ethno-nationalist Troubles in Northern Ireland. MacCaig made over twenty films between 1979 and 2003 and died in Belfast in 2008 at the age of sixty.

After his father's death, Dónal went to Paris and sorted through Arthur's apartment where he discovered a vast, disorganized collection of tapes, film reels, photos, and notebooks. All of this would eventually form the basis for *The Image You Missed*, a film in which a reverberant dialogue takes hold in Dónal's imagination about the legacy of an archive that spanned thirty years of Irish history. Aside from a handful of early encounters, Dónal had virtually no contact with his father throughout his childhood. *The Image You Missed* is a meticulously handmade, achingly redolent film about a son coming to terms with who his father was as a man and as an artist, his father's elusiveness throughout most of his life, and their common choice of profession.

The 34-year-old filmmaker is as prolific as his father was. He's been making films since he was eleven. In 2013, he wrote and directed his first fiction feature called *Out of Here* about a young man in his twenties returning home to Dublin after traveling the world for a year. Dónal has made over fifty short films, both fiction and documentary while also writing film criticism for such publications as *Cahiers du Cinema*, *The Brooklyn Rail*, and *Filmmaker Magazine*. Since Arthur MacCaig's death,

Dónal manages the rights to most of his father's film work. Owing to his own film's recent success, he's begun curating and presenting screenings of Arthur's work alongside his own and that of other filmmakers engaged in the Northern Ireland conflict.

As he was editing the film over the course of two years, Dónal wove in his own audio-visual commentary together with Arthur's film material, continuing to investigate his own relationship to, and points of view about, polemical filmmaking. Addressing his father at one point, Dónal says: "Your camera always looked out at other worlds—never your own . . . I'm piecing together a fiction of who you might have been." One of the most captivating aspects among many is the film's soundscape, one that consists of constant interference, static noise, ghostly voices layered one atop the other, and carefully curated musical selections, creating a vivid orchestral landscape.

PC: I'd like to start this conversation with a line that comes towards the end of the film: "Reality isn't given—you have to take it." What's the source for that?

DF: That line comes from a piece of dialogue from *Maeve*, a Northern Irish film from 1981 by Pat Murphy. I use several scenes of dialogue from it in my film. *Maeve* is a unique experimental feminist film about the North and Pat is also an old friend of my mother's that I've met over the years. I had seen it for the first time while I was researching this film and was really blown away by it. The main character is a stand-in for Pat, someone who grew up in Belfast during the conflict and then moved to London to go to art school. She was always alienated from the political culture of the North and in the film she returns home and reconnects with her ex-boyfriend who's in the IRA [Irish Republican Army]. They have these intense, polemical arguments about memory, history, and myth, him coming from a militant nationalist perspective, her from a more critical and intersectional feminist perspective.

It seemed to mirror a lot of the tensions I was exploring in my film, and when I talked to Pat about it, she told me part of her inspiration to make the film was actually seeing Arthur's film *The Patriot Game* when it screened in London in the early '80s. She really didn't like it; she had a lot of problems with it in the way it presented this didactic "master" narrative of what the situation was in Northern Ireland. I think part of the problem for her was the limitations of conventional documentary form, which The *Patriot Game*, for all its radical energy, basically adhered to. It didn't relate to Pat's lived experience of actually growing up in Belfast in the 1970s, so

she set about finding a cinematic form that would actually reflect that—partly as a counter-narrative to *The Patriot Game*. What she came up with was a collage of personal memories, intellectual debates, stories, songs—it's a much more multifaceted, rhizomatic kind of approach.

One of the things I loved about it is encapsulated in the line you quote, "Reality isn't given." There's this really exciting skepticism in the film towards the idea that our notions of nation or identity, or even resistance, are simply these "given" parts of who we are that we either accept or reject, rather than something that's being constantly invented and revised. And this kind of questioning is reflected in the form of the film itself, as opposed to the givens of a typical documentary approach. The problem that Pat encountered when the film was released was: How do you reconcile these kinds of critical questions with the immediate, material needs of a political movement? The film was released around the time of the Hunger Strikes in the early '80s and some saw it as irresponsible to be tackling these kinds of high-minded questions when the situation on the ground was so urgent and dire. So even her experience with the reception of the film seemed really relevant to the tensions and conflicts I was wrestling with in the making of my own film.

PC: It also feels a bit like a hidden homage to your mother who is also called Maeve. Her influence on you and your artistic life is quite profound, much more present in your life than any influence from your father.

DF: I did enjoy the fact that Pat's film shared my mother's name. That seemed apt, especially because throughout the making of the film I was considering this question of influence and generational connections. Where did I come from as a filmmaker? I play a lot with the idea of Arthur's influence on me. It's something people always assume when they hear my father is a filmmaker and it used to annoy me because I never believed there was a direct connection there. But for the purposes of the film, of course, it was much more interesting to suggest that there was. Yet at the same time I was aware I could as easily have made an argument that I became a filmmaker because of my mother. She knew so many filmmakers when I was growing up, including some really important ones. It was always something I was aware of. In earlier versions, I tried to delve into some of that more directly. There's a photo of Maeve and me when I was very young that's taken by Pat. Vivienne Dick, an important experimental filmmaker who was part of the No Wave scene in New York in the '70s is in the photo as well with her son, alongside Jane Gogan, who was a film

producer and someone really instrumental in setting up some of the institutions of film culture in Dublin in the '80s.

So there are all these lines of influence I could trace, and while the link between father and son is obviously at the core of the film, at the same time I also wanted to disrupt that and call it into question. That was why I chose to incorporate the home movies of my mother's uncle Seán as well, as another kind of cinematic ancestor along the maternal line. I think one of the resistances I have to a lot of typical first-person personal documentaries is I really value the idea that there are a lot of different voices moving through us that we need to try to recognize and respect. It's not just about how *I* feel or what *I* think. There are all these ghosts that are informing who we are and how we see things. I remember what Deleuze and Guattari said about writing *A Thousand Plateaus* together, that "since each of us was several, there was already quite a crowd," and I felt like that was very much the case with myself and Arthur in this film.

PC: There is this lovely evocation of riffling through a scrapbook and part of that is greatly enhanced by the soundscape of the film. I felt totally wrapped in these layers of sound and image that allowed me to go deeper into this material. Subliminally, it taps into very deep emotions.

DF: The approach to sound was really rooted in my experience of discovering and sorting through Arthur's archive in his apartment in Paris after he had died. Practically all of his material that I use in the film was found in that apartment, and I always returned to the emotional experience of that event while I was editing. That was the key reference point for what I wanted the film to feel like. In dealing with all the different materials, I didn't just want to get lost in the immediacy of that particular time and place. There should always be a certain distance, distance in the sense of mediation: you're always in the archive, buried in this world of images. There's something kind of deathly and ghostly about that. Obviously the varied and degraded textures of the images help with this, but I also wanted the sound to play a big part. The sense of being wrapped in it, as you said, is a good way to put it because I was also interested in a sense of overwhelm—there's too much to take in, whether it's hearing different voices layered over each other or different musical sources merged together. In the same way that the film's premised on a dialogue between images, I tried to think of the sound as something that spoke to and responded to the images, rather than just echoing them.

PC: Within the film, you also present this notion of failed activism—your own failed activism. That even though it might begin from a place of good intentions, when you're enmeshed in those activist situations, disillusionment can set in rather rapidly. Do you see your dad as an activist filmmaker? Do you see yourself as one?

DF: Some of his best films could be said to be pretty important and effective activist films. *The Patriot Game* in particular became an organizing tool for Irish nationalist groups and their supporters in the UK and the US, and was widely screened in activist contexts. I think that's a key point to appreciate. But that might be different than saying he was an activist himself. As far as I know, he wasn't directly participating in these struggles outside of his film work.

As far as my own activist involvement, since my late teens I'd been really interested in ideas about how art can transform consciousness and change the world. I started from a more romantic, poetic notion of transcendent experiences of art. The more I read and the more I saw, the more I became interested in explicitly political and collectivist approaches to filmmaking. When I was in film school, I did my graduate thesis on radical film collectives in the '60s and '70s, in particular on the Newsreel collective in New York and the Dziga Vertov Group in Paris. It was an interest that developed in parallel to my own filmmaking. In my films, I was playing around with approaches to improvisation and collaboration and thinking about ways filmmaking could be less hierarchical. But the films themselves didn't really extend themselves past my own personal experiences. There was a certain disconnect between what I was writing and thinking about and what I was making. That was one of the reasons why I made this film, to try and bring those disparate elements together.

I don't know if I could ever really claim I've been an activist in the world. I've always been on the periphery of those things. I've dabbled, helping friends with projects now and then, and going to lots of meetings and protests, but I never really felt totally comfortable in that world or able to find my place in it. I moved to New York eight years ago just a month before Occupy Wall Street. Getting involved in that was a pretty transformative experience for me, even with all its messiness and disappointments. I always feel ambivalent when people talk about the failure of these movements. In many ways, I'm a pessimist about the prospects of these things but I also feel like political projects can have a lot of knock-on effects that may be imperceptible for a long time yet can still be important. I always think about Jean-Pierre Gorin saying it was "too early to tell" what impact the Dziga Vertov Group had had. And that was thirty years after the fact!

Ultimately, outside of his filmmaking, I don't think Arthur was an activist. He wasn't part of these groups or part of any kind of collective action as far as I know. His contribution was making the films. His sacrifices were the same as most independent filmmakers make whether their work is political or not. It's a life of struggling to get the film made and scrambling for money and putting that before anything else. That's not very compatible with collective action. I could say that I'm envious of that kind of clarity of purpose and of analysis, that ability to say, "This is what the situation is; this is what's right about it; this is what's wrong about it and here's what you need to know." With social media, Twitter or Facebook, I very rarely put out political opinions, or any opinions on anything for that matter. Partly because in any way of phrasing things, I'll always think about what I *could* have said, or that what I'm saying is too simplistic; maybe I should also mention these other things, and "on the other hand. . ." I get tongue-tied in my head thinking of the nuances of everything.

When it came to Occupy, one of the bleaker assessments I have of the movement isn't at all fair to the whole thing. But I remember this aspect of it where you have a village of people and then this media circus, all these people roaming with cameras and phones, TV crews, every level of media presence. Then there are people who are there just to give their opinion, up on their soapboxes, holding signs, wearing costumes. The camera people are wandering up to them going, "Hey, what are you angry about? Why are you here?" It's like a real-life Twitter feed. Let's hear your few sentences and now let's hear yours! The same feeling I have about social media is similar to the one I had about Occupy. I didn't have that sense of confidence and certainty to make declarative statements like that. I did, coincidentally, do a series of twenty-five short online docs ten years ago that I titled *Declarations*. But of course they were all totally oblique and ambiguous. [*Laughs.*]

PC: What is it about collectivity that is successful or appealing to you through your course of research and writing? For instance, how does that differ from street activism?

DF: Godard said that the important thing is to make films politically, not political films. My research into collectives was largely driven by the idea that if you're thinking about making films politically the two main questions are: How do you relate to people in the making of a film, to your cast, crew, or subjects? And how do you relate to people in the distribution of your film, in other words, to your audiences? Every filmmaker has a lot of choices to make about how they structure those

relationships. I was fascinated by the diverse ways filmmakers have tried to grapple with that. But one of the disillusioning discoveries in my research was something that I've also come to see firsthand in political collectives. There can be an emphasis on the appearance of equality or a non-hierarchical structure that really just obscures the hierarchies that are in operation.

For example, some groups can insist that every meeting has to happen in a circle so no one's above anyone else. But sometimes that just means it takes you a little longer to figure out who's really running things and making the decisions. Why don't you just stand up in front of us and talk, if that's effectively what's happening anyway? The Newsreel film collective, for all its achievements, had a policy of anonymity—meaning there were no credits—that ultimately functioned a bit like this. I remember being at a screening of short films about Occupy Wall Street while the occupation was still going on. The filmmakers were doing a Q&A afterwards and someone in the audience said that they shouldn't be using microphones because it was creating this hierarchical power dynamic with the audience because their voices were louder than those sitting in the crowd. So they stopped using the microphones and we couldn't hear what they were saying at all. [*Laughs.*]

PC: I vividly remember the time I got to visit Belfast. My very first impression was how shockingly tiny it is and how close everything is, in a very claustrophobic way. In all of the portrayals and chronicles of the Troubles I've read, I just sort of imagined a much more expansive playing field there. In some ways, it feels like a living museum or art happening with the massive walls and gates and huge painted murals. These murals are also documentary depictions—real people in the midst of all that violence doing heroic things and dying for the cause. Your dad mentions Sinn Féin in a letter to your mom. She and you lived in Dublin and you had never been to Belfast when you were a kid. How aware were you of her involvement?

DF: Maeve was in Sinn Féin while living in London throughout most of the '70s. She was involved in activism in support of the nationalists in the North—the Troops Out Movement, for example. After I was born, she gradually drifted away from Sinn Féin but she still had a lot of friends in Belfast that she would visit. She just never took me with her because she didn't think it was safe. There's a new documentary that she and I saw together recently at the Galway Film Fleadh called *Unquiet Graves* directed by Seán Murray about the collusion between the British military and loyalist paramilitaries. When I met him at the screening, Seán told me that seeing Arthur's second film *Irish Ways* was the reason he became a filmmaker.

It's now been proven that the British army directly enlisted loyalist paramilitaries to carry out assassinations and massacres against the nationalists. There was a huge amount of blatant and illegal violence sponsored by the British state, including some of the bombings in the South. There are accounts in Murray's film about how if you drove through the wrong area in the North with a Southern license plate, you'd be done for. When we saw it, my mum said, "See? That's why you couldn't go with me." I certainly grew up aware of the situation, and I remember at some point in my childhood I was looking at the border on the map thinking: That's not right. That shouldn't be there.

But I also can't say I gave it a lot of thought because it was never a part of my lived reality. And Dublin is also, visually, completely depoliticized compared to Belfast where the terrain is so contested. The neighborhoods really have to declare in their murals and in their flags that this is where you are now; this is our identity and our history and our tradition. It's right there on the walls. In Dublin, it's just billboards and statues from a hundred years ago. If someone in Dublin has an Irish flag hanging off his house, it seems a bit redundant. There isn't that sense of identity being something that you have to keep alive and display and fight for. It's a totally different world in that way.

PC: And what about your own shifting sands in terms of homeland? You're living in the US and the tone and timbre of what's happening is very strange at this moment, maybe something you wouldn't have envisioned when you moved there. In the film you speak briefly about this reverse crossing. Your dad went from the US to Europe and is buried in Ireland and you moved from Ireland to America, as did your great-uncle Séan.

DF: I've been able to develop more of a sense of being from somewhere by not being there. I don't think that's unusual for a lot of emigrants, the fact that your nationality starts to feel like a more important part of you when you're away from home. I feel like I've been able to reflect a lot more on questions of Irishness that would have been totally uninteresting to me ten years ago. But I still feel very much allergic to any notion of nationalism. What I am fascinated by is landscape and geography and how that ties into political histories. I really like the work of essay filmmakers like Patrick Keiller who explore that a lot, the notion of psycho-geography and how we're navigating this whole history under our feet that's led to the streets and buildings we encounter today. And it's pretty much always a violent history. Every city is a traumatized landscape in that sense.

PART THREE

BORDER CROSSINGS

In nonfiction and experimental filmmaking circles the word "borders" is uttered almost constantly. It is a way to discuss traversing genres, to be sure, but in almost every discussion in this compilation, the topic of crossing or encountering hard geopolitical as well as sociopolitical borders comes up as well. Quite a few of the filmmakers profiled have a native home and an adopted one and often they travel between the two regularly. There is a mastery of one's mother tongue, and also mastery of a second one—in some instances, a third and a fourth. Some individuals have backgrounds that have encompassed other vocations or disciplines besides that of filmmaking and use one talent or set of skills to inform his or her art making. Quite a few have lived in places where political borders have been consistently fluid, or tectonically unstable. They've lived in environments where the idea of trying to maintain equilibrium on constantly shifting sands has become part of their artistic practice.

CHICO PEREIRA

Spanish filmmaker Chico Pereira's second nonfiction feature *Donkeyote* is, as its sly title suggests, a modern-day pastorale, at once an homage to the director's childhood hero, his Uncle Manolo, and Miguel de Cervantes' classic tale of a man who sets out to become a hero of his own imagination. The story, an inventive narrative, weaves together fragments of memory, dreams, and metaphysics, as well as a good dose of illusion. Playing the role of Sancho Panza is the elegant, stalwart and self-possessed donkey of the title, a burro called Gorrión ("sparrow" in Spanish). With his dog Zafrana and Gorrión as his traveling companions and support team, the 73-year-old Manuel Molera Aparicio attempts to journey from Spain to America, where he plans on traversing the Trail of Tears, the westward route on which over 20,000 members of the Cherokee Nation were forced to walk as part of a violent forced removal from their ancestral homelands in 1830.

In lieu of rehashed or revisionist personal histories, the film beautifully illustrates the way a life can be shaped and reconfigured by intrepidly putting one foot in front of the other in stubborn forward momentum, even through the most inhospitable of landscapes. Just as in his first film, *Pablo's Winter*, the director has introduced us to an old man that missed his calling as a movie star. Written by Pereira and his cousins Manuel Pereira and Gabriel Molera, and working, once again, with close friends Julian Schwanitz, Mark Deas, and Nick Gibbon (cinematographer, sound designer, and editor, respectively), the making of the film was truly a family affair.

Chico spoke to me from his current home in Santa Cruz, California where he is pursuing a doctorate at the University of California, a course of study melding anthropology and film.

PC: When you made *Pablo's Winter*, we talked about these compromises that are inherent in making a nonfiction piece. What kind of specific challenges did you have this time shooting with your uncle? Obviously, the intimacy you have with Manolo is built in since you've known him all your life. You're also working again within this macho culture that defines what a man is supposed to do and how he is to act at every stage of his life.

CP: An anthropology professor here at Santa Cruz asked me if I was making these films in order to learn how to be a man. [*Laughs.*] The male figures in my films are varied, though. With Pablo, this was much more about the worker, as well as the family and the women supporting him. But with Manolo, I don't think of him in those terms, as an element of the culture. Our connection was indeed deeply personal, but it was also a connection that had been broken. We took the opportunity of making this film together to rebuild the bond. Nonetheless, the film does capture the strong patriarchal system in Spain, where the man goes out to travel and see the world, to search for freedom, and the woman stays behind at home waiting for his return. But that wasn't really my main purpose behind this portrait.

PC: You chose to not reveal this close connection in any obvious way until the very last part of the film and only then does it become clear that Manolo is a close relation. The history of the family rift is handled quite subtly, as well. Manolo's journey is what illustrates the heart and soul of the man as we watch him negotiate this impossible dream of his. You make some captivating experiments with POV and mise-en-scène in how you frame him.

CP: When we were kids, we used to go with this man to the countryside, all the nephews. Manolo could turn the most mundane thing into a fantasy for us; he would make adventures for us constantly. When the family break took place, we were too little to understand what was going on and didn't have the agency ourselves to carry on any kind of relationship with him after that. Twenty-five years later, we come back to his house, and now we are filmmakers. And we told him, okay, now it's our turn to take you on an adventure. So in essence, we picked up where we left things, in the countryside. All the low-level shooting is meant to represent a child's point of view, seeing him once again as this larger-than-life person, caught in a child's gaze. During this process, we realized that the story of a man wanting to go somewhere was really not the point. It was not about leaving but about a return from this self-imposed exile. At the end, this tango he sings about *volver*—to come back, to return—the lyrics resonated for us in a somewhat different way than it might be

106

viewed in terms of the narrative of the film. The family issue was not something we set up to explore at all.

PC: When you were kids the donkey Gorrión was not around. At the time of filming, we learn that he's ten years old. Do donkeys tend to live long lives?

CP: I think he must be in his 40s in human terms. But I think they can live up to, perhaps, 25 years. More than anything, I think that Manolo's relationship with these animals is what the film is documenting. I think it's the most documentary aspect of the film. From the beginning, both Zafrana and Gorrión are in almost every shot, and we always see the three of them together. They eat together, they drink at the same time, they sleep at the same time, and of course, they walk together. To establish this sense of family was very important because of what happened in the past. It changed his relationship to animals. I think these relationships are a direct consequence of the solitude that arose in his life.

Obviously, we don't know what goes through the minds of these animals. But what we do know is that whatever happens, it effects all three of them and they each, in their own way, deal with whatever is happening. But they are together. And they communicate with one another in various ways—man to animal, and also between the animals. This is a way of understanding how humans and animals can enrich each other's lives, opening our own concepts of friendship and spending complex time with non-humans. We do it with our machines, our computers, with our phones. Why not with more responsive creatures who can give and receive love and friendship, another border we can cross if we want?

PC: As the only profound human relationship we see in the film, his scenes with Paca (Paquita), his beloved and adoring daughter, also have their own language, both verbal and non-verbal. We know that, perhaps, she has been the only member of the family that's always been loyal to him, despite the rift—or maybe because of it. They both are such deep romantics in the way they not only see the world, but about the shared memories they have when she was a little girl and her father created these beautiful fantasy worlds for her.

CP: Paquita really fears losing Manolo, as most of us do when faced with aging, fragile parents. He's been the biggest inspiration for her, and she admires him for everything that he is. After filming him for a week, it was time to tell Paquita what we were planning to do. She didn't know anything about this big walk. So in the scene where they're having lunch together, I told her before we started to film that whatever Manolo was going to say to her, she needed to take it seriously, take it as

something real. Normally, I wouldn't have said anything at all to her and let the scene play out, but I also knew that she could very likely turn to us and say, "Are you joking, guys?" At the same time, this is a reenactment of Manolo's life. He's always been considered a bit of an eccentric in the village. He was the first vegetarian in the '70s; he would run barefoot and naked through the countryside when there was a full moon, and there were other odd behaviors, so he's been dealing with this all his life, the fact that people think he's a bit crazy. His dream to get to America to walk the Trail of Tears is an extension of this. It was me that told him about these trails here in the US and encouraged him to come. He said, "Yes, I would like to come, but I would have to bring Gorrión." He would not dream of coming without the donkey. As a filmmaker, this sparked a light.

And we really were trying to make that happen, to bring him and the donkey here to do a long walk. Paquita knew it was a serious proposition. But we had to work at diminishing Paquita's concern because she wanted to be in support of her father's dreams, as always. We would be traveling for a month in unpredictable circumstances. Manolo has health issues; he needs to have his lunch and dinner at certain times. Being nomadic, everything is always open to any circumstance. She was very worried and I felt that pressure, so she and I talked a lot throughout it all. This is how the stress test scene came up and Manolo was all for it. It ended up being quite a dramatic scene. It put us all on edge, really.

In the scene towards the end where we see he's in a lot of pain, this is the first and only time you hear me addressing him, asking him if he's okay. These human negotiations were necessary for all of it, dealing with his past, the stress test, his health, Paquita's worry. The story was being told with this fictional approach; that was the goal. And by "breaking" the fiction at certain moments, this could very effectively show what these relationships consisted of between those who were behind the camera and those in front. There was a lot of play between the two going on. It was our idea for him to call the travel agency to ask for some help planning a transnational journey for a man and his donkey. He knew they were going to laugh at him. He was willing to expose himself in this comic way in these surreal moments. This is not filming some guy with this crazy idea. These moments were useful to show these negotiations and collaborations.

PC: I did feel this homage to a man that, even though he is frail now, is still larger than life to you and that was probably the most instrumental influence in why you

and your cousins became artists. He was the one who taught you how to unleash your imaginations.

CP: Yes! Of course there were moments when I asked myself if we were going to be able to continue the journey to whatever conclusion there would be. Those moments made it clear to me that I wasn't going to do anything in service to the film for the film's sake. If we had to return the day after we started for whatever reason, we would have done that. These gestures of breaking the fiction and entering "real life" were meant to illustrate the rules of the game, that we were in no way going to do this at any cost to someone's safety, health, well-being.

PC: The landscapes they walk through could be anywhere. There are no markers, guides, or signposts to help orientate us to where we are, or even how much distance the trio covers. The timelessness of any countryside landscape and the modern impositions made on the landscape reside side by side. The massive herd of sheep jockeying with automobiles on the road is a great illustration of this strange displacement.

Then there is the omnipresence of fences and other barriers absolutely everywhere they attempt to trek through. They appear in almost every shot. Perhaps because of what's happening globally, this is very much on my mind, but that really created huge resonances for me, a potent signifier of how quixotic and risky this journey really is in today's world. These are serious fences, not to be scaled or crossed.

CP: I'm so glad you noticed this because my thought, honestly, was that there might not be enough fences in the film to make this clear enough—because this limitation of movement from the physiological to the wider sense of the severe limitations of his dream journey is not meant to be subtle. This is a man who wants to roam freely in the world. But the world is made now for services and money. It's not for people. If individuals want to move about freely, then it fucks up the system. Even when we were trying to walk in the countryside, there were fences everywhere. We couldn't sleep here; we couldn't cross a piece of land there. These were public paths that are supposed to remain open and passable but were illegally fenced off by landowners. So Manolo turned out to be the most modern individual among a landscape of people and structures that felt it was fine to make fun of him, a silly old man.

These people show they have such narrow ideas of what it means to live and be in this world as a human being. From the macro to the micro, these restrictions were everywhere. The shepherds you mentioned have the same problem. These are nomads that are also now dealing with restrictions that are not part of their history

or their lifestyle. The guys in the canteen are also on the margins of society, as is this anachronistic place of the canteen itself, frozen in time and doing its best to keep its distance from the contemporary world even though it sits right by the train tracks. It's the same with the truck drivers, another nomadic group of men whose mode of transport is also their home.

The ocean at the end is the Mediterranean—the body of water that separates Europe from Africa. We know now for certain how many people die on a daily basis in the effort to cross that sea. When Manolo arrives at the beach with the dog and the donkey, he says that it seems like it's going to swallow them. This is really exciting to me, to be able to offer what on the surface looks to be a whimsical story about a man on a journey with his animals.

PC: The final scene is one of the most hilarious and charming episodes as we listen to Manolo serenade Zafrana and Gorrión as they're leaving the beach. He immediately turns this failed journey into a ballad, into narrative.

CP: Exactly, all of it gets turned automatically into another fantastical story, part of the legend of Manolo. When he gets back home, he will regale his daughter and anyone who will listen about this amazing tale. He's also protecting himself from all the disappointments and the judgment he's experienced from other people through this kind of performative act.

PC: "We have been perfectly documented," he says at the end of the song—the most appropriately meta-comment of them all. I think of Pablo and all these solitary eccentrics we come across in documentary. Their lives are so circumscribed, for the most part, and yet they have this profound understanding of how the world works.

CP: That beach episode was fascinating for us. We spent the night there because it was the end of our journey, obviously. In the early morning hours, this policeman came and, shining his big flashlight in our faces, demanded to know what the fuck we were doing there with a donkey? Manolo genuinely did not understand the question. He was naïve to the fact that this spot holds scenes of human trafficking and drug trafficking. And to a cop, that donkey with the saddlebags was a big red flag. He thought Gorrión was part of a smuggling operation. [*Laughs.*] Since this happened in the middle of the night and took us by surprise, we didn't get to film it, but that episode is what builds in the song Manolo sings as they're leaving the beach. Expressing that they have been "perfectly documented" also signifies the requirement to have the right documentation when the cops show up; it has to do with the microchip that is implanted in Gorrión. It also describes the way in which people might ask if this is

a documentary or a fiction as this eccentric man is walking towards the windmills we see in the background. No matter the trappings of a fictional story, at the end of the film you know a lot about the real man, his relationship with animals, and the relationship he has with his daughter. In the second volume of *Don Quixote*, Quixote becomes very aware that his life has turned into a book. He's dreamed of becoming a hero in the cavalry novels and he references the book that tells his own story, the one in which he is featured.

In the end, the most difficult journey for my uncle, really, is to cross the street and go back to the family home where he hasn't set foot in thirty years. That's the real delicate negotiation. That's the big journey, not going to America. The lived experience of making the film took us all towards much more complex and exciting places.

KALTRINA KRASNIQI

I've loved the voice and spirit embodied in Kaltrina Krasniqi ever since meeting her. There are varying degrees of friendship and levels of intimacy with the makers in this book, but I did try to make a conscious decision not to include very close friends. I made an exception in Kaltrina's case. In this conversation from December 2018, we talked about the woman who raised Kaltrina and her sister Erëmire. Kaltrina was born in 1981 in Prishtina, the capital of Kosovo, and was among the first women in her country to graduate in film directing from the University of Prishtina. Being a temporary refugee was a childhood experience for almost everyone in Kaltrina's generation. She currently makes her home in Prishtina with her husband, Genc Salihu—who's rather a big music star there, as well as an actor—and their daughter, Margo. Together, she and Genc co-founded Dit' e Nat' (Day & Night), a bookshop that promotes film, literature and music and is a cultural beacon in the city.

In her film work, Kaltrina has always worked in a genre-free zone blurring notions of fiction, music video, and documentary, layering sound and vision in a way that connotes personal memory, but, more importantly, the collective memory and history of the Albanian culture and language. Ever since she was born, Kaltrina and her generation have dealt with the legacy of war and disruption on significant scales. We are just beginning to see what will prove to be a potent canon of art, film, music and literature from Kosovo, and Kaltrina is, and will continue to be, at the forefront of that.

Her first film was a short fiction *Kanarinët e dinë (The Canaries Know)* (2014), a beautifully rendered, restrained portrait of one Kosovar family caught in the jaws of war, one that lands, literally, on their doorstep. The year before, she directed the documentary *Seks (Sex)*, a deeply researched journalistic piece commissioned as

part of the SEX issue of the country's top cultural magazine, *Kosovo 2.0*. The editors—all in their late twenties and early thirties—wanted to explore contemporary intersectional issues on sex, including homosexuality and wider queer issues, in an extremely conservative, majority Muslim, society. Both the magazine issue and the film caused a sea of controversy in Kosovo, including a vicious physical attack on some of the staff members of the publication.

In 2016, as Kaltrina continued pre-production for her first fiction feature *Vera e andrron detin (Vera Dreams of the Sea)*, she and Erëmirë, an independent researcher and curator, wrote a concept paper with the vision of creating an interactive map of Prishtina based on the memories of its residents. In the past century, the city has changed radically more than once, so there are aspects of many urban spaces and entire neighborhoods that have disappeared completely. When Kaltrina and I spoke, a small team had begun the extensive task of interviewing people who had lived in certain neighborhoods in the city trying to extract stories through shared memories, photographs, and other personal documents. Oral History Kosovo took a while to realize adequate funding, but now it's in full swing.

PC: The Oral History project is a hugely ambitious and vital undertaking. How is it going?

KK: At the moment, we're in the midst of trying to create this massive photographic archive of the city. We'll still be doing oral history interviews through next year but now I'm trying to organize the interviews we've already done and all the pictures we've received. We're working with mainly personal archives. One of the bigger issues is that we have photographs where we really have no idea where they were taken. The people who could tell us aren't around anymore. In some ways, memory is very short-term.

Two years ago, we applied to UNDP [United Nations Development Programme] but they couldn't support the project at the time. Two years later, they came back to us to say that they really wanted to help us realize it. We started by creating a draft of an interactive map with the possibility that in coming years people could suggest and contribute data to it. Eventually it will be a phone app in three languages—Albanian, Serbian, and English—and will be thematic. You'll be able to take various paths through the city and the app will give you a map of that path. At each point you will receive information, pictures, sometimes audio or video files of people telling stories about that particular part of town. We're doing quite a lot of work but

there are going to be many other things we'll need to do in the future. It's impossible in ten months to record the entire memory of the city so we want to allow for a creative mechanism where people can add and edit information. Of course it will have to be with our moderation but we want people to be allowed to do that in order to enrich it further. It's massive. I was aware from the beginning that it was going to be massive but there came a point where we needed to narrow the scope a bit, which is difficult to do.

We're not only interested in the Albanian perspective even though Albanians have been the main inhabitants of the city. We want the participation of the Roma community, the Serbian community, as well as the Bosnians and the Turks. Of course we're having a lot of issues with the Serbian community. They're always hesitant in hearing other stories. [*Laughs.*] On the other hand, they're not hesitant in contributing to the archives so we're getting good access to their personal photographs. Let's face it—if you're living a good life and you have a bit of money, you're able to record your life more. What we're finding is that Albanian people have not documented their own lives so much photographically or on film. But the Serbs have so we're finding some interesting photographs from the turn of the century as well as from before each World War.

It's interesting as well as nostalgic to go through it all. I forget how much has disappeared even just within my own lifetime. I was struggling with this idea of disappearing for the past year, how easily a life or a person disappears from the city. I've realized it comes from this material disappearance that has been so aggressive, especially in the past two decades. It's crazy going through the past like that—oh, this is the building where my aunt or my mother used to work and today you either don't have access to the facility or layers of renovation and reconstruction have completely washed away any memory of it. Our own neighborhood where we grew up has changed so much. All the small working class houses have become restaurants or fast-food joints.

PC: The film project you're making this year has very much to do with the silence of women in the culture. You were talking about the histories we get to know because they were documented. In both your fiction and documentary work, you deal with situations and episodes that could very well disappear quite easily, sometimes forcibly. What appeals to you about the liminal spaces of form to describe this phenomenon of disappearance?

KK: I've always been attracted to this territory that lies between fiction and non-fiction because that's where I feel most comfortable. I don't believe in strict forms. I don't even think that's possible, especially in film. Even when you're shooting a documentary, there is a point where something is staged or is rearranged. Once you take that power, it's kind of impossible to believe that that could have been a straightforward, rigid document. The only way that can be possible is when you might be dealing with oral history interviews—you sit, you record and then you don't edit. You just technically put together pieces of narration. I never feel comfortable saying it's pure this or pure that. I don't believe in that.

The film that I'm going to be shooting next year is in some ways quite personal. Erëmirë and I were raised by a single mom because my parents divorced when I was six. For four years my mother Vera struggled for our share of the family property and she was defeated. That was a very turbulent time for the three of us. My mother grew up in a communist system and she believed in the values it propagated. She believed she was equal to anyone else in the eyes of the law. She was in her late thirties when this trial took place and discovered that that was all a farce, that she, as a woman, would not be treated equally in that system. There was and still is a parallel life in our society, the public and the private. Privately, men have certain beliefs in regards to the life of women and what does and doesn't belong to them. This issue of women and property is not specific to Albanian culture, by the way. Even today, we learn over and over that it's a universal phenomenon. Each culture finds its way to justify it. Women face this issue all over the world. It's a fact that only twenty percent of what's considered universal property belongs to women. So there must be something wrong universally about this issue of women and property and how that's treated.

Being faced with that situation, my sister and I have naturally been affected by that decision. We've always had to fight for our place in the world. Not having that economic independence made us quite vulnerable, especially in the society in which we lived. My mother is a highly educated woman and always worked. Even though she was defeated, she worked hard to enable us to live in the center of the city because we were born here. She still owns the apartment she found for us then, a state-given apartment. She also worked hard to see that we were extremely independent, including supporting us in getting a very good education. She wanted us to be able to do everything on our own. When I was six, she took me to the first day of

school and from then on I had to go by myself. She would take me to the dentist for the first time and from then on I would have to get there on my own. That shaped me because it gave me the strength to know that I could do all of these things on my own and take care of myself from a very early age. But it also made me aware of others coming from marginal places, not just women, but gay people, Roma people, populations I can easily identify with. I can see those stories and all their layers easily. That's home for me.

Now I'm preparing for my first feature and of course the closest story for me to tell is this one, a story of women and property and it's totally coincidental, in a way, how that story came to me. In 2014, I met up with a friend I grew up with. Doruntina Basha was someone I hadn't seen in fifteen years. She and I had both been traveling and educating ourselves both here and abroad and working over the course of those years. She shared this script she had written called *Vera Dreams of the Sea*. The first time I read it, I was really shocked because the main protagonist was very much like my mother and Doruntina doesn't really know my mother. But women of that generation led very similar lives. The character of Vera is sixty-three years old. She's a sign language interpreter who lives with her husband, a famous judge. They have a daughter who is completely out of the picture because of a fight between her and the father. Then the father commits suicide. Vera is told that he's willed the family property to a male family member that lives in a nearby village. So we see this struggle of a 63-year-old woman to claim what rightfully belongs to her but she's completely uncomfortable in claiming that at all because that's how she's been raised.

This woman very deeply moves me for several reasons. First of all, we never see that generation of women in film, almost never, especially not in a lead role. They are always peripheral and depicted stereotypically. The other moving thing about the story is her relationship with her daughter because it resonates with the relationship I have with my mother. I am very aware of the gigantic steps my mother took but still, there are grudges. From one generation to another there are these endless debates and there will always be certain discomfort with decisions that women of your mother's generation made. That relationship can also be quite intimate as mine is with my mother. I could see clearly how that dynamic needed to be in the film.

PC: *Sarabande*, which you started filming in 2014 but wasn't released until 2018, is also an extremely intimate portrait of an artist encountering his creative tasks—ones most people never see. We think of a virtuoso such as Petrit Çeku as someone able to articulate how it feels to be in service to something larger. In the film, Petrit

talks about Bach and his wife and co-creator Anna Magdalena in the same way. Petrit describes how they wrote music together and it didn't matter who the author was. Petrit talks about the fact that he will play these suites for the rest of his life and that the recording in Spain you capture is just one step in his growth as a musician. There will be infinite amount of times that he will attempt to grasp the complexities of this music and each time it will be interpreted differently. I think this might be one of the reasons you and Petrit are such great friends, you constantly push yourselves to grow in this way.

KK: *Sarabande* is exactly about growth. And about growing up. Both of these experiences are very personal. Growth is a very individual journey. However, what's unique about the particular growth I'm talking about is that it can be so invested in a world that doesn't exist anymore. We want to grow in relation to the world we're living in now and we want the recognition of that world. We want that world to see that growth and understand that it's happening *in the now*.

When people think about classical music, the perception is that these pieces are rigid or can only be interpreted in a rigid way because they are written notes. But that's not true. What I learned making this film was that every performer has this space of interpretation and as they grow, not only as performers, but also as people, they will interpret this material differently. The truth is that those Bach suites that Petrit recorded five or ten years ago—you can literally hear this when you listen to them—sound different. And it feels different whether it's the speed at which they're played or the contemplation. There is improvisation there. Music is always open to improvisation.

I always wanted to make that film. I always wanted to be able to be close to someone who is so invested in what they do. While making this film, I had to make a very difficult decision because I wanted to involve the outside world and the outside reality of our lives. That's why it took me three years to make it. There were all these other things happening! We were going to Spain and I'm not allowed to go to Spain. We had to take a kind of a fifteenth-century route there. [*Laughs.*] And I had to think really hard about pulling in that issue. And I decided that yes, I did need to because it is about the time and the space we're in as well as the music. It's also about desire. We can organize any kind of border but we can't organize desire. Petrit is very much into what is considered Western music but he comes from Prizren, a very Ottoman town in Kosovo. So he's well acquainted culturally with the Orient, but the Occident is his world. I was grateful to have that access to him because I'm not sure I would

be comfortable having a person film me while I'm making a film. We all go crazy. It's not easy recording yourself or being recorded while you're in the midst of making what you love. The act of loving itself is crazy.

PC: The film is also about dreams. This is apparent from one of the first scenes where Petrit is sitting in the house where he grew up, in the place where he found the perfect acoustical spot to practice his guitar. You imagine him as the boy who, while he was practicing, was perhaps fantasizing about playing in a huge concert hall somewhere in the wider world and here he is today doing just that. But I was also taken with the notion that for Petrit performing is only one percent of what's meaningful for him about playing classical guitar. It's much more about his personal relationship to the music.

There are these oddly transcendent moments when we hear you and your mother speaking over the phone when you've finally reached your destination. They feel like dreams or elliptical conversations you made up in your head on your journey. So much is left unsaid and also unseen.

KK: You're always allowed the space to be loud in filmmaking. And that can be nice. But that's not me. In today's world all of us in one way or another end up documenting so much, making our own movies with all the technology we have at hand. We understand visual language much more than we think we do. When I leave those so-called *loose ends* I'm convinced that the viewer will be able to penetrate all the spaces left to interpret. I want the viewer to relive some of my experiences visually, sometimes even just with sound. When I'm editing, I'm trying to relive those moments and create a space for other people to live them with me again and again.

When you say these phone conversations might be something coming from my head, I love the idea that I created the space for you to have that kind of perception because those conversations with Mom sounded surreal to me at the time as well. It's about time we can be a bit freer in our storytelling. The layers of our understanding are much more complex nowadays. I want to be comfortable with the films I make, films that don't necessarily make sense in the rational world and in the traditional film industry. It's a very engaging art form that offers a lot of space to re-interpret our thoughts, memories and emotions. All of these aspects of who we are aren't linear; therefore, I'm not concerned with that. I am concerned with form or rather the ways to break it.

PC: Going back to your encounter with Doruntina's script, you could say you encountered it as documentary, even though it's presented as a fictional story.

KK: When you go to art or film school, they want to teach you form. And then it takes a long time to release oneself from the prison of that. Right now, I don't really care if it's a fictional piece or documentary, as long as it serves the story I need to tell. There are particular simple stories that I need to tell and I'm not choosing the means. I'm grabbing whatever serves me to tell it. To come to this point is very freeing for me because it's a much more inspiring and complex process. And it has also given me strength to pursue various kinds of stories. I like this place where I am because I still haven't made the films I want to make. But I'm on my way.

BRETT STORY

Brett Story's second feature, *The Prison in Twelve Landscapes*, is a delicately drawn, contemplative essay film about systems of incarceration. Yet during the course of the documentary, we never enter an actual penitentiary. Brett is a trained geographer, and her meditative landscape portraits show how certain topographies contain varying degrees of meaning regarding class and race.

Brett is active in the contemporary prison abolition movement. North American prison industries continue to boom, structurally, economically, and socially. Much of Brett's film work prior to making this feature has centered around issues of the national prison systems in both the US and her native Canada, extrapolating the ways in which those systems impact almost all other aspects of society. In 2019, Brett published a book, an academic companion to the film, called *Prison Land: Mapping Carceral Power Across Neoliberal America*.

The Hottest August, Brett's third feature film, was released in 2019. Currently on a robust international film festival tour, it will be broadcast on PBS' *Independent Lens* documentary series in 2020. Like *Prison*, *The Hottest August* is constructed by threading together disparate vignettes. Here Brett presents a universal portrait of collective anxiety about climate change. The overarching conceit to illustrate this looming issue is through the portraiture of one place, New York City (and its outer boroughs), and the collective consciousness of its inhabitants over the course of the month of August 2017.

At the end of summer 2018, Brett spoke to me from Brooklyn about the organic process of discovering the ways in which sweeping statements always reside in the smallest of details.

PC: *The Prison in Twelve Landscapes* has an elegiac quality with much attention paid to the artfulness of presenting these various places and the people who inhabit them. But despite its rigor, it also contains a sense of drift where you allow us to see your process of stumbling upon stories you ultimately use in the film. The particular geographies you present have much to do with the story, but sometimes they are the story itself.

BS: All of what you mention is very close to my heart because as a trained geographer I think a lot about space. Most people connote the word landscape with this kind of expansive vista with a horizon line. But I think of it more broadly as the spaces we inhabit and how we make those spaces by living and working in them and how those spaces impact us. Especially within the medium of film, there's a great opportunity to use the language of cinema as a mode to describe that relationship and then extrapolate that into a bigger social statement.

PC: How did you map your journey geographically and why was it important to never actually take us inside a prison?

BS: In many ways, this film began with a conceit but also a prompt in the form of a question. I've thought a lot about the prison space or system as something that's actively "disappeared." It's unseen by the rest of society. Prisons work to keep people in as well as to keep people out. If you can't get in or you can't see what's inside, then how is change supposed to occur? That interests me as a political problem, as well as a creative one. I mean we can sort of trouble this idea of access in the world of documentary where access is supposedly the linchpin of a project. What if the question of access isn't about getting inside but rather reconfiguring what it means to see the prison within our midst? That became my motivating prompt. Where else can we see the prison expansively within other societal systems? How is it operating and how is it affecting lives outside the physical structure of a penitentiary? I find that when you hold and carry a question in your mind, the world will start sending you answers almost right away. I find that really gratifying.

The scene in Washington Square Park with the guys playing chess is a great example of that. As I was playing with someone there, he started telling me that there are so many guys that are setting up boards to teach and play for money and all of them were coming out of the New York prison system. It never occurred to me that the men playing chess in the park had been incarcerated individuals. This becomes their livelihood because of course as former prisoners they're often shut out of the labor market. I had an experience of seeing that space completely

differently and that's an experience I wanted to bring to viewers. I've been working with prison issues for a long time and that background informed what kind of links I wanted to be able to make, to evoke rural industrial areas, for instance, as places with no job prospects that really desired to become prison towns. That's something that's happening all over the United States so that was an important story to tell. I had a conversation with someone who lived in Appalachia and that was exactly what's happening there. These prisons are being built on top of former coal mines and that was fascinating to me because it's no longer just an academic or theoretical link—the exchange of one industry for another is literal, and built into the landscape. That relationship has a visual and visceral quality since the coalmine is also a very particular space. If that space was then being turned into a prison, well, that seemed so haunting to me in a way. I wanted the film to haunt all of us in just this way, as well as tell us the ways in which the US prison system operates today.

PC: All of these refracted elements seem ripe for exploration, particularly in the US.

BS: I think I could have also made the film in Canada and Canadian audiences have asked me what a film might look like in a Canadian context. There are very similar dynamics, the main one being that our prison system has also been expanding over the same period of time as the one in the US and our prisons are also filled mostly with poor people of color. I think there's something pretty spectacular about the fact that the US is engaged in the largest prison-building project in the world. At no other time or place in history have we conducted this experiment of locking up so many human beings. That's an opportunity to ponder the fact that if the prison is so monumental in the landscape of American life, it shouldn't be treated as exceptional to or apart from a whole set of ordinary spaces and institutions on the outside. I wanted to explore how deeply imbricated the prison is in the organization of society as a whole, and this conceit of having the film take place entirely in "non-prison" spaces seemed like a useful way to go about that.

PC: You talked about this desire to have an overriding haunting or evocative mood where the viewer has lots of space to think. There's also lots of space to really listen. The soundscape holds us aloft as we gaze upon a frame that may last several minutes.

BS: Before I started making films, I worked in radio and made radio documentaries. I've always been interested in the possibilities of sound. It might have to do with the fact that I've always secretly wished I were a musician but have no musical

talent. The way in which sound works on the body and how it can evoke this sense of the uncanny, a mood, a sense of atmosphere—this can be incredibly underappreciated in the context of film. It's precisely in this relationship between the image and sound where we can create all sorts of complexity and dissonance. In many ways, the film presents as quite a conceptual one and asks people to do a lot of thinking, so I knew how important it would be to use sound to build spaces for feelings and emotions.

I met the sound designer, Simon Gervais who is French Canadian, at the Berlinale Talent Campus. I was right at the very beginning of this project. He had worked on a film called *Guidelines* by Jean-François Caissy, which is a tremendous film, one in which I was so captivated by what was going on sonically. The conversations between us once we decided to work together really had to do with thinking about how to create space in this film for the images and the sound to operate in a kind of dance with one another. Sometimes the visuals would lead and the sound would follow, but also there could be moments where the presence of the soundscape sits in front of the image producing a different kind of experience.

PC: Like the scene with the prison firefighter.

BS: Yes. There are limitations that one has to work with quite often and this woman was incarcerated and so I wasn't able to get her on camera, or get a good audio recording. So I created a transcript out of interviews in which what's expressed included some really important but subtle and complex ideas and experiences. It was important that the audience be able to listen carefully to her words. We created a series of images of fire footage. I said to Simon that I wanted these images to sort of cast a spell so that we can listen more deeply to her voice. When you're sitting in front of a fire, your optical attention is taken up by something beautiful but not informational and that just allows you to sink into the substance of what you're hearing. The sound design here ratchets up the intensity and creates this kind of mood.

PC: That woman's articulation of the training experience and working as a firefighter connotes a kind of freedom for her that is very moving. At the end, she says, "I think of myself as a hero," but we know that this heroism sits in a very specific aspect in relation to the rest of her life. At the very beginning of this section, you kept in the audio portion when she's asking you if she should just go ahead and talk. Many makers would have chosen to cut that out and start the scene with her storytelling. The filming is mentioned several times, in fact. I always find that kind of transparency to be a compelling choice.

BS: There's a kind of double reassurance that I'm trying to convey as well as allowing the spectator more knowledge about what the encounter consisted of. But I can also say that I don't really love the pristine. I like to work within an aesthetic framework, certainly, and I do use formalist techniques. So I like rigor and try to use rigor, but I also love the messy tactility of documentary as a mode. It's a messy process and its messiness includes feeling uncomfortable, having to look at people who may not want to be looked at, having to negotiate talking to strangers. I don't think it's necessary to convey all of that to an audience because it can devolve into a narcissistic space or into being too "meta" about it all when you show too much of the process.

But I don't care for that kind of pretense of making it seem as though the camera and the filmmaker weren't actually present. Everybody knows there's a camera there so why would you try and make it seem as if there isn't? And sometimes that interaction between the crew and the people appearing in front of the camera can say more than the actual content of the scene. There's a scene in the film that my editor Avril Jacobson and I had a lot of debate about. It's the scene in St. Louis where we're driving in the car with this Black man who says, "I know you're all Canadian, so you might not understand that you can kill a nigger anytime you feel like it here in America." I thought that the fact of me being Canadian was not a really important issue or that it might be distracting, but what he said was so powerful, how could I not include it?

In another scene, there's a long line of people waiting outside the courtroom to pay fines. There's a tradition in documentary that involves close looking and that tradition too often involves white people observing nonwhite people or poor people, or what have you. It's a loaded thing to do. But that's not an excuse not to look. Looking is really important. Those moments when some people in the lineup stare right into the camera was, again, a way of acknowledging to the audience that we are not hiding ourselves or sneaking up on people. When people look into the camera, we don't know what they're thinking. They're not looking at the camera in acquiescence to my film. Their looks could be interpreted as defiance, perhaps, but what they're also conveying there is an acknowledgment of our presence. It's quite complicated.

PC: On the flip side of that you have this really long segment filmed in Detroit at the Quicken Loans campus. It's a really wild and bizarre segment and tonally it's so different from everything else in the film. The tour guide says, "Our culture is everywhere" and that this casino/real estate/venture capital company is scooping up the entire downtown and making it white again.

BS: The original idea of that scene came out of a newspaper article I read about Dan Gilbert and his Quicken Loans empire and how it was buying up all of Detroit. The article talked about this kind of war room where there were wall-to-wall security monitors where live feeds from the real estate bought up by this company came into this room. Local police were hired in as security guards to surveil the streets and act as an apparatus that would keep "undesirables" out. The idea was just to get into that room and film it. I just wanted one beautiful locked-off shot and so I contacted the PR people at Quicken Loans to request access to this room and they promptly told me no. So that idea was thwarted. But then they told me that they did these PR tours every day and we were more than welcome to do one of those. My process can be kind of scrappy, working with a very small team, most of the time without a producer, and so I said yes to going on the tour because I still thought I might be able to get into that room and get my shot.

Quicken Loans is an online mortgage lender and Dan Gilbert is one of the country's richest men. This was 2014, a few years after the nation-wide mortgage default crisis. Massive evictions all over the city had taken place and water lines had been shut off, leaving people without running water—a true crisis. The mortgage and housing markets were very much a part of that.

It may seem like a far throw from talking about the US prison system, but I think it's not. When you think about a family refusing to be evicted, we know that the sheriff will be called in to possibly arrest them. Or someone will be accused of "stealing" water because they won't pay their water bill. The ways in which things are decided in terms of what constitutes a crime has so much to do with resources or the lack of them. Anyway, I took this three-hour tour through all of their real estate holdings. It was very important to me to not just highlight the effects of the prison system, but also its causes. Where are the loci of power that are responsible, that have a vested interest in who gets arrested, criminalized, and/or displaced? Here was a center of power from which this company representative was *bragging* about rising rents, evictions, and hiring security companies that would work closely with the police. As you can see, the company is filled with young interns, many of them white in a majority-Black city.

What's on display and what connects all this to the prison system is capitalism. It was an opportunity to invite the audience to think about how capitalism works, how it transforms our cities, and how the prison system is intertwined with these

other systems of economic power. We never did get to sneak into the command center.

PC: Even though issues of race pervade each of the film's twelve segments, you have this more tangible discussion with the woman who has a job and pays her mortgage and works very hard to have what she has. She talks about her initial refusal of the fine for not having the trash can lid affixed properly to her trash can. She's ultimately defeated and pays a hefty fine for this ridiculous charge because she doesn't want to go to prison. We learn that because she refused to pay at first, they just threw her in jail. This scene is aesthetically different from anything else in the film and is directly emotional in a way that many of the other chapters are not.

BS: There was so much that was challenging in terms of structure. Despite the fragmented way in which the material is presented with this use of vignettes, I wanted the piece as a whole to earn its form as a film and not just a series of portraits. To figure out how it could build momentum was key. Avrïl and I worked really hard to figure out how to do that in the edit.

When we shot that scene where the woman shares her trash can story, I had an intuitive and immediate feeling that that was the heart of the film. Cinematically it's definitely not the most interesting segment. It's a straightforward interview in her home. But there's something about the way she tells that story and what that story consists of. We could say that everything reverberates out from there. It isn't just about serving thirty years in prison for a crime one didn't do. It's about serving fifteen days in prison for not securing a trash can lid correctly because you are a poor Black woman in St. Louis. I wanted to be able to earn a way of thinking about race by presenting the politics of racism and racialization in America while not separating it from these other issues touched upon elsewhere in the film. It needed to be emotionally affecting enough, certainly, but it also had to tie into all these other issues the film raises. Racism and classism in American society are played out in those people standing in line waiting to pay their fines. Or in a person waiting for three hours to get on a bus for a twelve-hour ride to a prison to visit a loved one only to be told upon arrival that her shirt violates the dress code. It's a daily slow violence that is deeply ingrained.

PC: These thoughts make me want to segue a bit into the project you're working on now, *The Hottest August*. I saw you pitch it in Copenhagen in 2018 and was immediately captivated by the way you're approaching the topic of climate change. Again, you're attempting to cinematize this pretty intangible mood of free-floating

collective anxiety and fear. What is it about making work for the cinema that holds itself together in such a fragile way—these glimpses into various aspects of our society—that challenges and captivates you?

BS: One really basic reason I'm drawn to making films is that the process makes me feel less alone. It's definitely also an excuse to go on a journey and meet people and have conversations. But sometimes it's also about getting a feeling that's trapping me *out* and holding it away from me in order to examine it. *The Hottest August* is about just that. Like a lot of us, I've been overwhelmed with feelings that consist of fear, dread, incredible amounts of anxiety. I've extracted all these feelings and am working, once again, to examine them within the framework of making a film. What's political about those feelings? How and why is this the emotional Zeitgeist of our age right now? So in a way, the motivation is quite selfish. But it morphs into the motivation to make a project. In this film, there is the overarching premise of making a film about the prison system in which we never see a prison. That was enough to begin asking, okay, what will we see and hear then?

In *The Hottest August* I wanted to make a film about the emotional life of climate change. Instead of imposing limitations, it's more about finding those parameters to work within an idea that might support that. In this case, the film was entirely shot over the course of one month in one city. That idea came directly from my love of Chris Marker's *Le joli mai,* which was shot entirely in Paris in May of 1962. What I want to explore is how and why we are living with this notion that there is no future. What are the social consequences of that? Some work really well with story but I don't necessarily get drawn into something through story but through a more prismatic approach where I just start collecting material and start to shoot— moments, ordinary events, conversations with people. I was motivated to create a kind of archive of the present, one that would offer a kind of mirror in which to look at ourselves right now, but also that might be useful in the future for people who are going to want to know what we were all doing during this time when we all knew our planet was in such peril. What does that look like? That tends to be evident in those spaces of ordinariness, not really in the more spectacular moments. That's what I really love, for instance, about Chantal Akerman's films. It's in those ordinary moments where those feelings reside, that everything, including the power structures we live within, can be discovered—if you can figure out how to look at them.

PC: I'd like to know more about your relationship with the DoP, Maya Bankovic. Was *Prison* the first time you worked together?

BS: Yes and I would have worked with her again on this latest film but she wasn't available. I'm used to shooting my own films but I'm not a professional cinematographer. I don't work with a shot list nor am I really all that interested in coverage per se, or these more traditional ways of thinking about the visual language of a film. What does interest me is the method of active looking and framing the spaces we inhabit. That can be very difficult to translate into directing and working with a cinematographer. Part of the reason we decided to work together was that I really liked the way she looked at the world and there was a symbiosis in the way we both looked at the world on a very literal level. The thing that might catch her eye, even in an optical corner of whatever it is she's seeing, would be something that was also interesting to me.

This is a film made up of images that aren't obviously informational. It was more about capturing a sense or an atmosphere but I also wanted much of it to be purposely destabilizing. This could manifest in compositions being just the slightest bit off in the beautiful way a Robert Frank photo can be just a little bit off. The world is not stable. Maya's an incredibly talented cinematographer but she also has this visual patience that is rare and that was very important to me.

PC: You bookend the film with people going to the prison on the night bus as we overhear various voices from a radio show titled *Calls From Home* conveying messages from people to their loved ones serving time. But in the final segment, once it's daylight again, you really slow things down to allow us to once again enter a more elegiac quality or mood. There's a beautiful score and bucolic scenery rolling by. And by the time the bus reaches Attica, the slow reveal of the structure and the light make it look like the bus could be parking in front of a castle in the countryside.

BS: I knew I wanted to begin on that bus. Overall, with this film I wanted to disturb our sense of what a viewer's expectations might be. I also wanted to blur that boundary of gazing on a prison structure and those other spaces that we show that are more familiar to us. The bus is an example of that. Riding on a night bus seems like a deeply universal experience. Almost everyone has taken a long journey on a bus, and there's something already so moody and sad about that space, but it's also a space of ambiguity. It's familiar but there's also a sense of disorientation as we realize it's a specific bus bringing visitors to prisons.

It was later in the process that I decided that I wanted to end the film with a shot of Attica Correctional Facility. Whenever I begin a project, I think a lot about the potential traps that I might fall into. I worried about presenting the prison as

metaphor—you know, everything is the prison and nothing is the prison. I absolutely did not want to do that. So that end shot almost contradicts the premise of the film in a way because it reminds the audience that the prison *is* also a building, and there are people locked in cages inside that building right now as we're gazing at it. That's a reality that's too important to let people forget or take as mere metaphor. I wanted that to feel devastating because I'm devastated by that reality. I knew I wanted to end with that kind of rejoinder around the premise of the film as a whole.

That slow motion ride on that road felt right because as someone wrote about this segment, by the time you're on that road you realize you've been on that road the whole way through. All these scenes are roads that lead to the prison. A film comes into being only once viewers have inhabited it. In order for that to happen, room needs to be made. Those slow moments are those invitations to enter the film but to also, perhaps, drift away with your own thoughts, perhaps reviewing or looking back at all the places the film has taken you and all the stories you've heard. It's an opportunity, as well, to be entranced by the beauty of the trees floating by just as those people on the bus might be despite—or perhaps even because of—the bus's final destination.

PART FOUR

POWER PLAYS: DISRUPTION

Can filmmaking be an act of political disruption?

Everything the makers presented in this section think about and act upon has much to do with private or personal reckoning. They are wise in the ways of cinematic political discourse, as well as the retribution this kind of trenchant, and oftentimes devastating, portraiture can provide.

ORWA NYRABIA

Toward the end of his film *Eau argentée, Syrie autoportrait* (*Silvered Water, Syria Self-Portrait*), director Ossama Mohammed states that his country has made history's longest film and that the 1001 filmmakers whose images he has used to craft it have recorded and participated in Syria's longest funeral. Through an ongoing dialogue, both verbal and written, Mohammed and co-director Wiam Bedirxan—a young Kurdish woman whose name in her native language is Simav, which means "silvered water"—create a poetic lamentation for their disintegrating country caught in a brutal civil war between factions entrenched in regime-, ISIS-, and opposition-controlled zones. Over 170,000 civilians and counting have been killed, and there continues to be a mass exodus of refugees. The war has destroyed their homeland, making the landscape of one of the most ancient civilizations on the planet unrecognizable.

Sixty-year-old Ossama is a renowned filmmaker whom elementary school teacher Bedirxan contacted online. She asked the exiled Ossama what he would film if he were there. *Silvered Water* documents the destruction and atrocities of the civil war through a combination of footage shot on mobile phones or small cameras and posted to the internet; footage shot by Bedirxan during the siege of Homs; and, pensive, sad missives from Ossama from Paris where he lives as a political dissident. Ossama relates his tormented feelings of cowardice as he watches what's happening in his country from afar and how haunted he still is by images of a boy shot to death for snatching his camera on the street.

Producer Orwa Nyrabia was Ossama Mohammed's assistant while Nyrabia was still a student in Damascus. He and his business partner and wife Diana El Jeiroudi are filmmakers as well. They've made their mark on the international stage

as producers and run their own company called ProAction Film. Orwa and Diana started a documentary festival in Damascus in 2008, the first ever in the country. The last edition was in 2011, ending just a few days before the revolution and subsequent massacre began.

In 2012, Nyrabia was arrested and detained by the Syrian Military Intelligence at the Damascus International Airport. His family lost contact with him shortly before he was supposed to board a flight to Cairo. Orwa was eventually released without charges and he and Diana relocated to Cairo. Also facing problems in Egypt, the couple sought asylum in Berlin, Germany being one of the very few European countries to grant them refuge.

Orwa and I have been friends for quite a few years and now live in the same neighborhood in Berlin. On the day after the announcement of American airstrikes against ISIS, we met at a local café to continue a long-running conversation.

PC: I've watched a lot of Syrian films, both fiction and documentary over the years I've known you. So watching *Return to Homs* and *Silvered Water* was not the first time I paid attention to, and began to further understand, the modern Syrian sense of humor and perspective. But because these pieces are shot in real time, the ability to have this kind of footage creates a whole new "canon" of tragi-comedy. What's even more shocking than the violence is the humor amidst the tragedy.

Now you have audiences asking you, Ossama, and Talal Derki, director of *Return to Homs*, this very modern and deeply disturbing question: "But what can we *do* about this terrible situation?" These are people who come to these films as mere calls to action of some sort, which I find ludicrous. Then there's the follow-up question that seems to negate the former: "Do we really need to see this? Is it *necessary* to show us the most sadistic, the most violent and bloody footage you can find and linger there?" Because watching *Silvered Water* is just short of unbearable.

ON: Do we make this for everybody, for those who are forced to ask if it's necessary to see it? Is a film defined by the violent moments in it? Or is it the overall outcome, the overall feeling you leave the theater with at the end? With *Silvered Water*, I was so very scared before the release of the film. I didn't know what would happen. How will people perceive this violence? Is it going to be perceived in the same way as Pasolini's *Salò*, for example, which is much worse in its portrayals of violence? I didn't know. In my experience this film does not leave a very bitter taste when it is watched in theaters in contrast to when it is watched on a laptop. It becomes

a different mode. This film manages to speak to many people's subconscious. It doesn't try to convince, nor does it lay down any rational kind of logic or context. What it does manage to do is move people on a very deep level—it takes hours, sometimes days, before they can even discuss it. That's a special experience. None of us are really adept or experienced in making films during massacres, are we?

The thing that moved and shocked me was this note from Rithy Panh. He said, "Well, what can we do? It's too much pain; we have to give just a few parts of it." I have no answers. But I can tell you that I'm willing to die in this profession defending the right not to censor, the right to experiment with what is usually considered unusable, un-viewable. It's all un-viewable.

PC: You are repurposing footage of the Armageddon-like war that's happening in Syria for a cinematic work. You've learned how to go in and out of there safely, how to get cameras smuggled in, how to keep filmmakers as safe as possible while they're shooting, and then how to get the footage out. You yourself shot a lot of *Return to Homs*, at least the first part.

ON: That is one aspect of how it needs to work. But in *Silvered Water* there was also the task of searching for the best quality of footage from YouTube or contacting the activists who shot it, if they were still alive. The visual identity of the film is that it consists of this very bad-quality footage. That developed organically in the making of the film. We would try to find the original footage, not the uploaded footage. We discovered gradually that it is only on YouTube because either the person who filmed it died or their hard drives were destroyed in explosions. Everything is gone. All that is left are these missives left in virtual space. When we get to the second half of the film with Ossama encountering Simav in the siege of Homs it's kind of the same problem. I think there are at least four good-quality cameras spread around different places in Homs that did not manage to get to her. She was always working with a very small, low-quality camera. The only way she could work was to compress her footage into small files and upload them to Ossama on Google Drive.

PC: This ongoing dialogue Ossama has between massacre and cinema within the film is staggering. He declares a new cinema of the murderer, a new cinema of the victim, a new cinema of the marvelous and the poetic, a whole litany of different types of cinema that he interprets for us as we watch one instance of live-action brutality after another, contextualizing this low-quality, pixelated, blurry footage. This is placed in juxtaposition with his more thoughtful, artful ponderings from Paris as

we listen to Simav report what she's seen and felt. He also implores her to write and write and write, never stop writing.

ON: It's Ossama's advice to everybody. That's his answer to various things in life. That's how you survive it—write it. It's profoundly embedded in who he is, this relationship with writing, which he still does with pen and paper. What's strange is that he is one of the pickiest filmmakers I have ever met about aesthetics. So even those bad-quality videos, he deals with the editing, the post-production, the color correction, as well as the sound in an extremely demanding way. That's how this co-directorship came about. Simav did not follow instructions. What she sent was coming from a different world. Her footage was very difficult to edit, for example. I remember when Ossama needed very short cuts to continue. He never told her what to shoot but he was trying to establish a rhythm and a connection. But then she would upload a fifteen-minute shot. That created a different dynamic in the relation-ship and in the film itself. That's why she was named a co-director in the end. One day Ossama asked Diana and me about it and we acknowledged that this was more than being just a protagonist, more than doing some of the camera work. She was a partner in authorship.

PC: Can you talk a bit about the structure of this in regards to the edit, because if anything needs structuring, it's this kind of interstitial material that becomes ensconced in the film's overall narrative. The editing of each segment is meticulous, as are the bigger choices of how to present the whole cycle. In addition, we are wit-nessing someone emerging as a filmmaker. Ossama, even though he realized that Simav was not following instructions, as you put it, decided to leave these long takes in just the way she shot them.

ON: You have to understand that that was Ossama's working synopsis of the film before we even knew of Simav. He saw it coming and was totally right about it. The synopsis in 2011, way before she sent him a message, was about the activists discovering cinema. Watching the terrible YouTube videos, he saw these young peo-ple trying to document atrocities. He was waiting. They had the camera; they had the emotion. Ossama knew that they would discover cinema. They would find it between their souls and the lens. We argued a lot about the structure and he stayed with what he had in this extremely stubborn way and that was a four-act structure. As you watch the acts now, this is how they were originally written. He didn't know what those four acts would contain but the structure never wavered. It was a very long process figuring out how the film could work with the second main protagonist

being introduced halfway through the film. It was like knitting something from a huge pile of hay. There was a point where the cut was around 110 minutes and the level of approval and acceptance was very high. We all thought it was finished. After much discussion, we decided that it wasn't done and this was after nine months of editing. So we continued for two more and the film became ninety minutes. I think it's the best thing that ever happened to it.

As a producer I am pragmatic in my belief in Ossama and his way of working. I trust the caliber of the work and his instincts and talent. But that also speaks to this very particular relationship I have with him. For this very reason, I was adamant about not pitching the film to anyone until I had a full rough cut in hand. That was my way of defending the film. There was a beautiful text, definitely. But at the same time, if I didn't know him and wasn't ready to take this bet on this filmmaker, I would read the text and decide that it just wasn't possible. A film like this cannot be made. Out of this first cut, he and I selected thirty minutes and that's what we showed to financiers. It was non-filmic, the text. I was not willing to limit the filmmaker's freedom by somehow guaranteeing some kind of proposal for it. That results in a lot of risk and very little money.

PC: Are you going to continue to make films in Syria?

ON: Definitely. But not only in Syria. We produced a film from Yemen called *The Mulberry House* by Sara Ishaq, and we're starting a project in Egypt. I'm also very interested in producing a film out of Bahrain. When we say the region of Syria or the "Syrian issue," well, that might be anywhere in the world. This is the time to "do" Syria, but it doesn't necessarily mean inside the country itself. Some projects are inside, are very close to the skins of the people living there; others are investigating stories around the world, but they connect back to what's happening in our country today. There's an amazing level of risk to all of these things we're doing. It's the way we used to work in Damascus. It's our Syrian revolution form of insurance where someone comes to you and says, "Boss, if I die, will you take care of my son?" And I say, "Yeah." And that's it. You wouldn't think it would really happen this way, but it does. That's the pact. I don't think anyone can do better or do more in such times. The other day, I had the strangest thing happen regarding a newspaper interview that I had in the morning in Helsinki. That afternoon, something I said but probably shouldn't have, ended up being the headline. "It's not enough that Super Obama flies over Syria and kills the bad guys."

PC: Oddly, this city we're in seems to be a haven for exiled documentary filmmakers.

ON: For Diana and me, it was simply a political issue. We didn't exactly have a menu of places to choose from. We talked to the authorities in a few places and the Germans were the ones to welcome us. It took three to four months until the paperwork was done. Other countries did not extend an invitation. And here we are not as challenged, economically speaking, as we would have been in other European cities. If I were in my twenties, the best thing would be New York or Paris, but for the past few years I've had so much noise that I cannot tolerate it on a constant basis. It's been that way for years now. At the moment it's only stand-up comedy that saves my life. It's the only answer possible, that profound irony. There's no other way to survive this huge mess of violence and pain and at the same time the challenge of coping with money and time.

PC: How does it work when you enter and exit Syria?

ON: I cannot go to any regime-controlled areas. I am clearly wanted in those zones. I cannot go to ISIS-controlled areas because I am wanted there as well. I can go to opposition areas but there are all kinds of opposition areas and some are riskier than others. It depends on the faction in control. I still have a few ideas for projects I would like to explore.

PC: Are the stories also focused on the siege of Homs?

ON: No, not at all. I have absolutely no sense of patriotism about that.

PC: Your hometown is gone.

ON: I never liked it.

PC: Okay, but I'm sure you didn't want to see it decimated.

ON: No. It was an amazingly moving experience to have these films take me back to my hometown. That city for me was so extremely boring; I spent my teenage years waiting to get the hell out. After I left, I hated going to visit. But then, during the first year of the revolution, it was beautiful to be in that city. On Syrian IDs, it is written where you come from. At the army checkpoints in Damascus, when they see that I am from that neighborhood in Homs they become very hostile immediately. And you start to get this realization about your hometown neighborhood again because it means a lot to those soldiers trying to look for their enemy. The singing and dancing and demonstrating—all of that was really beautiful. It kind of mended this relationship with my hometown. But it's not about Homs. There is this country now, Syria, that really needs everybody, not only Syrians. I need to feel I'm doing what I can do about what's happening there. That doesn't mean I'm a Syrianist and that I need to go live there and defend it forever. That's the place I know best, but

ultimately it doesn't matter where I am at this point. This is something special about our profession. We reside within this widespread film community much more than in our local communities, at least those of us whose work is international. When we moved to Cairo, then to Berlin, we didn't become Egyptians or Germans.

PC: Life in the indies.

ON: I love your country, but there's a major, major issue with the US indie understanding of cinema. It's all about competing with this invented mainstream in many ways. But then what does that leave us with—the last wonderful manifesto of Michael Moore? It cannot be as simple as that. Changing people's minds about something requires a much more complex process. At heart, one needs to really challenge the audience with the form and content of film.

What we see most of the time are films that address a pre-set audience that already agrees with the statement in the film and films that already take a very aggressive position towards those who do not agree. All of these kinds of subject-based, investigation-based, look-for-the-truth-based films are bound to that. They cannot escape being built on prejudice through pre-set ideas and convictions. What this will lead to is not the death of documentation, but the death of cinema. If we're not for free individual expression that challenges the world, if the imperative of authorship and personal interpretation of the world is lost, then everything else is way beyond competition, that means that Hollywood wins.

RAMONA DIAZ

Ramona Diaz was born in Manila, the capital of the Philippines, into an upper-middle-class family. She came to the United States as a student, first studying at Emerson College in Boston and then doing graduate work at Stanford University in California after deciding she wanted to pursue documentary filmmaking. Ramona came of age during the regime of Ferdinand Marcos. Her first post-graduate feature film was on his wife Imelda after Imelda had returned to the Philippines in the years following her exile and that of her dictator husband. The making of *Imelda* (2003) saw the emerging maker acquiring unmitigated access to the former First Lady of the Philippines, the notorious "Iron Butterfly," whose propensity for haute couture fashion led her to collect over a thousand pairs of shoes.

The films Ramona has made since have dealt with the legacy of the martial law period under Marcos. Her first film, made while she was still a student at Stanford, centers on the 1986 People Power revolution in the Philippines. *Spirits Rising* is an hour-long film about the role middle-class women played in the overthrow of the Marcos regime. From that point on, Ramona knew that she wanted to tell stories from the Philippines centered on the female experience and the various power struggles inherent in a corrupt and unstable society. Her second feature, *The Learning*, is an intimate film that follows a group of Filipina teachers who come to Baltimore and end up assigned to the city's poorest districts with overwhelmingly African-American student bodies. The film sensitively chronicles the women getting hired through a recruitment agency in Manila, coming to the US, and then returning home after they've completed their two-year teaching commitment. It's a deeply effecting portrait and ever since first seeing it, the film has been a personal favorite of mine.

Her film on the mega-rock band Journey, *Don't Stop Believin': Everyman's Journey* (2013) documented the group's first tour with a young Filipino man named Arnel Pineda whose apocryphal story saw him plucked from obscurity on the streets of Manila to become the band's new lead singer. After making the Journey film, in 2016 she returned to the Philippines to make *Motherland,* a stylistic departure from her previous work. Ramona and cinematographer Nadia Hallgren situated themselves in the largest maternity ward in Manila for several weeks and made an immersive observational piece.

When Ramona and I spoke in mid-December 2018, she had just returned to the US from a research and development trip to the Philippines in preparation for her latest feature documentary. Once again portraying highly controversial public figures in Manila, she was in the midst of negotiating the delicate permissions needed for access to a story she wants to tell surrounding the mid-term elections taking place in the capital, the elections themselves a jumping off point for wider themes her film will tackle. *A Thousand Cuts* world premiered as a selection of the US Documentary Competition at Sundance 2020.

PC: You've returned again and again to the Philippines throughout a period that has seen so many different eras of power and control over its citizenry. How old were you when you first left?

RD: I didn't leave Manila until I went to university in the US. I came of age there so was pretty much formed by that culture. At eighteen, I thought I knew a lot like you do when you're eighteen. But I truly didn't learn about my country until I left it. It was a real eye-opener. There was no freedom of the press so we only got the national newspapers. I also grew up in a very middle-class family so we lived in a bubble. Very few things touched me until I left the Philippines and only then did I have any kind of political awakening. And then, ironically, that's when I became *obsessed* with that place. I wasn't interested in documentary at that time. I wanted to make fiction films—that's why I went to film school. Then I went to Los Angeles after graduation to work in television and I thought that was the life—LA, working in TV fresh out of college. But it got old for me pretty quickly. The end of the TV show I was working on coincided with the end of the Marcos era and so I decided to go back in 1987, a year after Mr. and Mrs. Marcos had left. There were so many stories to tell and people were so hungry to share. They had been repressed for so long. That's when the documentary form took root for me. There was still no infrastructure to

get those stories told publicly on TV because making documentaries was not part of the Zeitgeist there. They just wanted to talk.

After returning to the US, I decided to go to grad school to learn how to make documentaries. My thesis film at Stanford, *Spirits Rising*, was about the Philippines. I took a couple of my fellow students and we shot there for about three weeks. I wasn't there for the 1986 People Power Revolution and I really regretted that. I missed out on one of the biggest political events of my lifetime. But I made a film about it. It centered on the middle-class women, the women I knew. I wanted to know what their role had been in the revolution that had finally ousted Marcos. This class of people had a lot to lose standing up in opposition to him but the wrongness of it all took them over. Something snapped and they moved out of the comforts of their homes and went to the streets. I was so fascinated by this thing that can turn you.

When I went back there in 1993 I met Mrs. Marcos. I asked for an interview with her—and got it. That really surprised me! I was with a student crew in Manila and got a letter to her and waited and waited and waited. The very last day we were there, I got a call from her assistant who told me that she had been in the hospital. She would grant me only five minutes—and I couldn't ask about the revolution. We ended up being there for nine hours. She kept talking and talking and eventually started talking about the revolution. I felt that was fair game because she was the one who brought it up. I was just amazed that I was meeting this figure that loomed so large from my childhood. Everywhere she went, everything she did, was covered by the press. So I told her right then and there that I really wanted to make a film about her. She thought it was a *great* idea! I told her, okay, I need to finish school; please wait for me. [*Laughs.*] They had been exiled in 1986 and returned from exile in '91. But she had been allowed to come back a couple years later to accompany the body of the dictator who had died in exile in Hawaii. She was in the midst of campaigning for her children and so we filmed the bulk of the documentary during that campaign. Three years later, I brought up the idea of making the documentary with Mrs. Marcos. I finished school and I had to figure out how to raise money to do the film.

In screenings for my thesis film about the middle-class female revolutionaries, people were most fascinated, of course, by the presence of Mrs. Marcos. During a Q&A someone asked me what my next film was going to be and brazenly I said that it would be about Imelda Marcos and I'd be starting production soon. I mean it wasn't total BS—I had gotten her permission, but I had no money. Luckily, this

was the mid-'90s and it just was an easier time to raise money. It felt more abundant to me; maybe fewer people were making these kinds of feature documentaries. The Center for Asian American Media, then called the National Asian American Telecommunications Association, had a fund then headed by the late Janice Sakamoto. She came up to me right after that screening and asked me: "Are you really making a film about Imelda Marcos?" I said yes. I just need money. She told me to write up something, supply a budget, gave me the deadline for the open call, and then I had money. I think I got $50k for research and development! After I shot my sample, things started happening.

PC: What was it specifically that attracted you to Imelda Marcos? What did she represent in terms of what you could say in a film about this notorious public figure?

RD: Generally, what fascinates me are stories of power—those who have it and those who don't, those who take it from other people and how people eventually break free from a charismatic person of power, that moment when they've had enough and figure out how to break the hold. I'm also interested in women who are powerful and disempowered, cornered by circumstance, like the women in *Motherland,* as well as the situation of the women in my film *The Learning.*

PC: I love *The Learning.* I hadn't watched it since 2011. It's such a fascinating glimpse at this trajectory of women's liberation, particularly in the midst of a repressive regime. You captured this moment and made a multi-faceted and complex portrait of Filipina women not just in their home country, but coming to live and work abroad in the US. At the same time there is also servitude on the home front precisely because they become the breadwinners for their families.

RD: Exactly, and what they must do in order to save themselves. It's so tough on both sides. These women just had no idea about what it meant to come to America, an America that they could never have imagined because they did buy into this picket fence white suburban existence and ended up in urban Baltimore with a poor working class African-American population of students. How they navigated that became the heart of the film. The fact that these women left *everything* they had to come here was incredible, especially to see one of these women leaving her infant child in the care of her sister. They were not given long to decide whether to take these jobs once they were hired. They basically had to decide right then and there, pack up a few things, and leave a couple of weeks later. And then the pull of home takes hold. The youngest of the women I featured, Angel, had so many financial responsibilities to her entire family.

PC: What is it about the culture there that breeds this kind of expectation that others should take care of you? There's such a divide between what was promised during the Marcos regime and the reality of getting absolutely nothing in return for one's acquiescence to a dictator, an entire country still craving that unattainable promise.

RD: First of all, it's not the entire culture to be sure. It's a certain segment of the population that is dispossessed and is reduced to a kind of infancy because there's such scarcity amongst the people who really have nothing. Also, the idea of family members taking care of one another, especially kids taking care of aging parents, results in a family bond that is very strong and that does cross socio-economic lines. But it manifests differently, as you can imagine. The poorer you are, the less agency you possess, especially if you're a woman. It's a patriarchy, although they like to say it's a matriarchy. There've been two female presidents but one of them, Corazon Aquino, was an accident of history when her husband was assassinated. And Gloria Macapagal Arroyo was the daughter of a president so she was part of a political dynasty and has also become this symbol of a corrupt politician. As if there aren't so many male politicians that are corrupt but she's always held up as an example of corruption. In the Philippines there are so many female entrepreneurs, CEOs, et cetera. It's one of the leading countries in Southeast Asia in its high numbers of female leaders. Most of the Filipinos working overseas are women and they are responsible for the billions of dollars that come into the country from outside. It's a big part of how that economy stays afloat. They work as nurses and teachers, still predominantly female professions.

PC: Your portrait of Imelda speaks to that mythical way of building a personal story since she's far from being a cardboard figure or just a puppet of her husband.

RD: My family was on the opposition side during the Marcos regime so all my life I had heard how bad they were for the country. When I asked her to make the film with me, she had already connected me to my family and where we stood politically. Yet, to her credit, she granted the access anyway. And I was ready to not like her. But I liked her quite a bit. She was charming and funny and that made me really uncomfortable. I knew that was not how I was supposed to react to her. I wanted to illustrate that discomfort in the film. She was well-liked by many people. Why? People who have done so much against the country's best interests can still be nice people, can't they? The thing is they have *so much power*. I believe she believed everything she said and stood for. If someone says something long enough, it becomes her truth.

I do think in the beginning she had good intentions. I think what really did her in was her lack of education. She also has an astounding lack of critical thinking skills. She saw Lincoln Center in New York when she was invited there and decided to copy it for Manila, and to this day that Cultural Center is still used. Because of the success of that building she built so many other things that were useless, like the Coconut Palace built for the Pope. And the Film Center was a total disaster. She also supported certain artists during Martial Law, the ones she favored, although, of course, the ones she didn't favor were censored. Ultimately, there was a cost for taking that money.

Imelda Marcos was also a great game-player. When we finally went into production on the feature film, we were in the midst of filming in her backyard. She was standing under a tree telling a story and then excused herself because she had to do something. Twenty minutes later, we're still waiting. I asked one of the guards if she was coming back and he told me she had left to go to lunch. And then he told us the name of the restaurant so of course we packed up and went there. When we arrived, my crew and I walked into the restaurant and she tittered when she saw us and introduced us to whomever she was lunching with: "This is my crew!" [*Laughs.*] So then I thought, Okay I'll play this. Now I know what the rules are. Game on. That was really mind-opening. I mean she had told the guard where she was lunching just as her assistant would let us know that she would be coming back to Manila on the five o'clock plane from this destination, and there we'd be. We have this shot where she deplanes waving. Yes, Mrs. Marcos, we're here filming you just like you want us to be.

PC: After making *The Learning* in 2011 and then *Don't Stop Believin': Everyman's Journey* in 2012, cinematographically and narratively you made a real leap in *Motherland*. Was there a larger political statement you wanted to make, or, like *The Learning*, was your focus on spotlighting Filipinas of a certain socio-economic level?

RD: My job as a filmmaker is to give the audience a full experience of what it's like to be in other people's shoes, people they will probably never meet. If they get some kind of political insight, that's great. But the hope is that there might be some empathy and understanding. That's what I'm after. The reason I ended up making *Motherland* was because I was interested in a reproductive health bill that was coursing through the Philippine Congress at the time. It was a little known bill that was gaining momentum. It was in the news because people were saying it was about time that a bill like that got passed. What that meant was cutting the ties to the

Catholic Church, an untethering from its power over that aspect of women's lives. I wanted to make a film about this bill and the social drama around it, not necessarily what the bill contained but how people were thinking about it. When I got there it just wasn't happening—I couldn't find the story. I couldn't wrap my head around how to structure the film. But then someone told me I should visit the Fabella hospital and maybe something I saw there would inspire me.

And sure enough, the minute I got there I knew immediately that's where my film was. I entered with no permission and I got to the fourth floor where the maternity ward was and just walked around. No one bothered me. I was sitting on the beds and just listening to the conversations around me. I felt like a ghost. Of course, getting permission and carte blanche access to the hospital was another matter. But something else also took over when I visited Fabella. I was so fascinated by the way this very spontaneous community of women formed in this ward. They were fleeting relationships but they were also intense. They shared this cramped space with one another and their newborns, all of them experiencing such a vulnerable time. But then that would end and they all knew that they would all go on with their lives and probably never meet again. But during that time, they all were so open and helpful and really shared everything with the other women there. There was kinship. I thought of my own childbirth experience where I gave birth in total isolation basically in a US hospital. There was something about giving birth with other women. I also don't want to over-romanticize this either because it was incredibly uncomfortable and hot. There was no air conditioning. And at the heart of the story, it was still about that bill and all the consequences of not passing it.

PC: You worked with director of photography Nadia Hallgren in a very particular way. Can you talk about the discussions you had together during shooting?

RD: I knew I'd be able to make it purely observational because of the content. I was just going to film in the hospital. I wasn't going to follow anyone home. That was very clear even from the beginning. I wanted to be there when they give birth. I wanted to be there when they figure out how to navigate through that, the friendships they make there, the husbands or partners they wait for—and the ones that never come—and other support systems that are there in that ward. I've always wanted to make a film like that but it never presented itself, this ability for me to be that ghost-like figure that could observe. Working with the right cinematographer was key. Nadia Hallgren is amazing; her observational skills are wonderful and she just doesn't leave a footprint. You can't leave big footprints in a place like that while

you're filming. We would engage with them but only when we put the camera and sound equipment down. I was the one doing sound since they only gave us permission for two people to be in there at any given time.

Of course they were as curious about us as we were about them. I told them what we were doing but I don't think they fully understood and then after a while, they did get it because we answered all their questions and I shared things from my own life. But this only happened about halfway through production. Nadia didn't understand the language but my main instruction to her was that I wanted her to hold shots for a long time. I wanted whoever was the emotional center of a scene to be the total focus. I didn't really care about the doctors and what they were saying; I cared about the reactions of the mothers. Nadia stood there and filmed until I told her to stop. Eventually, she got the cadence of the language and because she's so observant, she could read faces. We were in that ward for weeks on end, just the two of us.

PC: So our conversation has been all about the women in your life but I'd love to talk a bit about this film on Arnel Pineda, this young Filipino man plucked out of obscurity to become the new lead singer for the mega-band Journey. Even amidst this macho world, you still spend significant time with Cherry, Arnel's partner and wife. Most directors would not have even thought to include Cherry's voice in this film at all. The film showcases a really beautiful balancing act of telling this larger story alongside the very strange story of Arnel whose story is very dark, in fact. There must have been many struggles.

RD: There were *so* many struggles. We filmed so many concerts with them that summer in '08 and every time the concert began, the music worked. It never got old—it was amazing. I can't call myself a big Journey fan. I like their music very much. But I wouldn't have done that film if it hadn't been for Arnel. He was the story for me. He wasn't even famous in the Philippines and really not even any kind of YouTube sensation. He was just found by Neal Schon, like the proverbial needle in a haystack. I can say that there were many opposing interests obviously with all the executive producers, as well as with the members of the band. It had to be a certain kind of film and I understood that going in because that's what I signed up for. But I was also hoping to inject Arnel's Filipino experience in there.

One of my favorite scenes in the film that I fought to keep in was when he's in the van with the bass player Ross Valory, Ross's wife, and their friends. Arnel starts riffing on his life and the things he had to do when he was a teenager on the streets of Manila and about the man who fell in love with him and on and on and things

start to get uncomfortable in the van until Ross says, "What about those 49ers!" They don't know what to do with this story because he's telling them an uncomfortable tale that they don't really want to know about. They want to keep the Cinderella story going, not the actual things this guy had to do to survive. In one cut, the scene played for a long time and we found even the test audience got very uncomfortable. As it exists now, it's a pretty diluted version. But it's still one of my favorite scenes because Arnel is like: Do you *really* want to know my story? Well this is it. It's too dark for a film like this.

PC: Because of the rapport with Arnel and your common culture and language, there must have been a lot between you that could remain unspoken. But nonetheless some of it does come through, this darker part of his story you're talking about. Otherwise the film is the stuff of homage to a rock band that we could see on MTV Classic.

RD: Unfortunately, you're one of the few who read that because it *was* read as just a total fan film. I screened this in the US and audiences here see it as a total Cinderella story. But when I screened it in Europe there was a totally different reaction where audience members felt for Arnel and the ways in which he had been trapped throughout his life, and continued to be, even though he became a rich rock star. He becomes trapped by his own fame. He can't sing his own songs. And yet that's all he's ever wanted.

PC: I told Khavn de la Cruz this when I spoke to him back in 2010, that the only way I've gotten to know the Philippines at all is through the films I've seen about it. I rarely see international news items either in the US or Europe about the Philippines unless something happening there has an impact internationally.

RD: With this current film I'm facing similar challenges. I always go the rougher route because I choose to film people in power and it's really tough to get a commitment from people like that. The commitment is never solid—it's there one day, gone the next. Maybe I like the hunt. Journey was a hunt, for sure. I got permission and then had it taken away over and over again, especially when they understood that the film I wanted to make was about Arnel. The thing with this current film though is that I'm essentially going after "breaking" news right now and I don't like breaking news because it hasn't been processed or filtered in any way. I wouldn't have wanted to do a profile on Mrs. Marcos right after the revolution. By the time I went back so many years later, the mainstream press had left. Now, however, with this story, the mainstream press is very much on the ground in the Philippines. Oddly,

I was there for a month filming and everywhere I went I bumped into Mrs. Marcos' daughter Imee who is running for a Senate seat. The Marcoses refuse to leave my films. I mean everywhere I went she stepped right into my frame!

In fact, a lot of what's happening in the Philippines is a reaction to those promises made during the Marcos era. There's real nostalgia for the Marcos dictatorship, believe it or not. After *Imelda* premiered at Sundance, this Jewish woman came up to me and said: "Oh my god, Imelda? She reminds me of my mother." [*Laughs.*] Yes, thank you so much. That was the point. There's a white filmmaker now making a documentary on Imelda Marcos. It will be interesting to see what kind of portrayal that will be.

PC: The risk is that a portrait of Imelda now might be conveyed mostly as a metaphor for this fascistic moment the world seems to be undergoing.

RD: I'm more interested in exploring the roots of fascism. Why do people believe in this man, [Rodrigo] Duterte? Why are they giving up power and their own human rights in order to feel free and secure? What irony. They must really feel desperate. To investigate and ponder the fascinations of all this is what we get to do in this line of work. The hope is that we'll make something that stands the test of time.

KARIM AÏNOUZ

I first met Karim Aïnouz in 2010, the year I moved to Berlin. The Brazilian-born writer–director has also made his home there although he's constantly traveling the world to make his films. I was familiar with Karim's name since he's directed over twenty films in a career spanning almost thirty years and I'd been deeply impressed with his first feature drama *Madame Satã* (2002), but seeing *I Travel Because I Have To, I Come Back Because I Love You* made me a die-hard fan. It encompassed everything everyone around me kept going on and on about: breaking free of the bounds of genre and form in order to create distinct and transcendent cinematic work.

As a film director Karim Aïnouz remains hard to define. He rejects the notion of having created a body of work. Even though he's been directing big productions for decades, on 16 mm and 35 mm film, in 2018 he made his first feature documentary on HD video, *Zentralflughafen THF (Central Airport THF)*. The story takes place mostly within the confines of the hangars at the Berlin Tempelhof Airport. Unlike most urban airports built many kilometers from the city center, the Tempelhof grounds sit in the midst of a residential neighborhood.

Tempelhof was one of the first airports in Berlin, designated as such by the Ministry of Transport in 1923. In the mid-1930s, the Nazi government began reconstruction of the main terminal, one of the largest structures in the world at the time. Upon its permanent closure in 2008, the citizenry of Berlin petitioned to have it reopened as a public-access leisure space, known as Tempelhofer Field, a huge expanse of grass and concrete for picnicking, bike riding, kite flying, and barbequing. Karim had begun filming a project at Tempelhof based around this transformation when part of the property became a refugee center for the tens of thousands of people pouring into Germany. These displaced persons were coming from

Syria, Ukraine, the Central African Republic, South Sudan, Yemen, and several other places on the planet. Climate change, genocide, war, and other catastrophic events and human rights abuses have caused traumatized populations to flee, attempting to find refuge in an increasingly inhospitable Europe. Germany is one of the few countries to accept such a robust number of asylum seekers, and it's changing the fabric of German society very quickly.

With the massive refugee crisis swelling to epic proportions in 2015, the airport's hangars—used for concerts, fashion shows, and other events—were retrofitted as an emergency shelter that provided temporary housing, food, medical care, psychological counseling, immersion language courses in German, and a place to wait while an overburdened foreign office grants permission for individuals and families to stay. Asylum seekers are given resources for what they need to run the gauntlet of getting papers, but it can be random in terms of how long that takes—anywhere from several months to several years.

With a haunting score by Benedikt Schiefer, superb cinematography by Juan Sarmiento, and flawless editing by Felix von Boehm, Karim and a very small crew managed to capture a slice of life portrait amidst an exceedingly fraught year in the life of an asylum seeker.

PC: You're somewhat of a shape-shifter in terms of your cinematic work. What are some of the creative impulses that let you know what form things should take?

KA: I think it's a few things. It is sometimes what the story dictates as to how it should be told or there is something I want to say and I figure out the best way to say it. I wasn't trained as a filmmaker. I have a background in a wide array of disciplines, as well as a history of living in many different cultures. So I feel quite free. My relationship with storytelling is a complicated one and it can be quite organic. But organic isn't quite the right word either. It's a learning process.

My first film, *Madame Satã*, was based on a real person, so my first question was should I make a fictional story about him or should I make a documentary? Since he was dead, a documentary would likely have consisted of mostly archive. But the more essential question was how to make a documentary on a character that was constantly reinventing his identity? That really was what led me to think of his story in fictional terms.

PC: My favorite film of yours is *I Travel Because I Have To, I Come Back Because I Love You*, an indefinable work. It's something that I rewatched right before I

rewatched *Central Airport* and so arbitrarily or not, I was already making associations between the two films. In *I Travel*, your protagonist talks about strategies for survival. This idea comes up in most of your film work. There's often this sense of mapping or surveying something that is incredibly fragile, on the point of disappearing.

With *Central Airport*, you use a more formalist structure, portraying a "life of careful measurement" and "the solace of marked days" which is how your character describes himself in *Viajo*. We can also describe Ibrahim's story that way. However, here you're asking a real-life person going through a real-life scenario to help structure the film using a diary and narration that marks time month by month.

KA: This was the first time I worked with a complete non-actor. But there was something I needed to find and something I needed to follow instead of instigating a performance from someone. In the beginning of shooting there, once the hangars became a refugee center, there was huge resistance on the part of people staying there, as well as the people working there, to be part of a film. There had already been much exploitation when it opened. There had been a significant amount of media presence in that space.

I had a very open approach to the possibilities of characters and there wasn't an explicit understanding with Ibrahim that he would be the main character or that the film would be guided by his voice. That came after we had developed a relationship, when it was clear to me that he *wanted* to tell his story. He's full of mysteries and I think that's the best quality for any actor to have. You can talk about charisma or whatever you want to call it but mystery has to do with ellipses and silences, the things you might project onto someone because there's an open space for you to do that.

So his willingness to take part in this adventure was there even though he didn't really know what that meant. He had no idea what this film would be. I didn't really either, not in a definitive way. It was intuition on my part and trust on his but there was definitely an exchange. I mean he could have left the next day—we didn't know he would be there an entire year. And he does end up leaving before I had set the film to end. It was an ongoing process of making choices together. It was the same with Qutaiba, the Iraqi man we also followed. But with Ibrahim, it was distinctly about making a portrait of a young Arabic man and how we could make choices to enable spectators to empathize with him. There is so much silence, all the things he does not say, and that was what held my fascination.

When we talk about elliptical storytelling, I will say that I feel that we're in a time of a more active viewer than ever before in the history of audio-visual practice. I think it's very important that we open up space in the overall structure of our stories. There are cracks in the story that you can actually move into and construct on your own. Ibrahim really allows that to happen. There's a lot for you to imagine what might be going on in his mind and in his heart. I mean it's very similar to casting. The difference is that in fiction you need someone who can repeat over and over again the same expression, the same feeling, or the same movements. I never asked Ibrahim to do something twice.

PC: When we talk about your relationship with Ibrahim and Qutaiba and the others, it's also an opportunity for them to be seen.

KA: It's a complicated situation because on the one hand there was a desire to tell Ibrahim's story, but also to tell those of the others that appear in the film. And you're right, those that did appear before the camera did have a wish to be seen and be visible in a world where they are more times than not invisible or dehumanized in some way. In this hegemonic European media, young Arabic men are constantly being vilified. I wanted to affirm their presence in the world. There wasn't an explicit decision in this project of doing something together and this is what it's going to be. Rather, the construction was in the exercise of having some of these people write diaries and it was meant to be a construction, this diary of their lives within that context and within that space. I mean I did hold many interviews with many people there but it was a way of starting a conversation, not necessarily of whether or not they would appear in the film. After that was done, it became much more about how to do an observational documentary, something I'd never done before.

PC: Would you talk a bit about this juxtaposition of filming the interior space of the center and the surrounds of Tempelhof in different seasons and from different perspectives? The Tempelhof grounds are also a hard-won space of recreation for the inhabitants of Berlin and its visitors and this creates a fascinating contrast. Again, the links here are something you leave up to the spectator but they're quite potent.

KA: I think there's something very singular about this shelter. There's a very close friction between being inside that fence and being outside it. I have deep admiration that this was a space that was fought for and conquered—but it is a space of privilege. After the refugees came, the hangars became a space to house people who

were basically dealing with life and death on a constant basis. That divide is *the* definition of late neoliberal culture and the state we're all in.

I think for those living in the West, the perception might be that the refugee crisis is something that's far away. But it's not. This was why I was so interested in Tempelhof as well. It was a total accident that a refugee shelter came to be on the grounds of Tempelhof. The newcomers are always put in the periphery. But here this is happening right in the midst of the capital of the richest country in Europe. I thought this should be documented, this non-relationship taking place, the shelter and the park side by side.

PC: The expansive space of the park in such close proximity to the interiority of Ibrahim is illustrated in the simple way he starts to speak in German all the time, even to fellow Syrians, because that's the language he hears when he goes outside. His trying on of his new language was so moving since he's so eloquent in Arabic. It's really beautiful to see something so subtle portrayed as part of his daily existence. In the narration, we hear him speaking Arabic and the diaristic aspects of what's on his mind become more personal and private. Did you play with space and time and text in the same way you did in *Viajo*?

KA: Absolutely. The moment you decide not to work within the parameters of Aristotelian storytelling based on causality and conflict and surprise, and move into a more essayistic way of working with your characters' stories, there's still a lot of construction that comes into play but it's a different kind of construction.

With Ibrahim, we had only one recording session. We had him read only what he had written and then we edited with that. We recorded him in a studio so we would have clear sound. It was like embroidering the text to the image and the image back to the text because they needed to be constantly moving against one another until they meshed. We didn't overthink too much but when it felt right we just didn't touch it anymore. So those decisions happened in the edit, paying attention to the rhythm of the syllables against the rhythm of the images.

There's also friction between the history of the space—this airport and its specific architecture—and its use in the film. The space was never meant to have people living in it. Illustrating those details and making sure they made their way into the film was essential.

PC: In the penultimate scene of the film, we encounter another newly arrived refugee. This time he's from Ukraine, not the Middle East. Ibrahim has gotten his permission papers to stay in Berlin and goes out into the world even though his

voice remains as our narrator. It's a really interesting choice to show this man from a completely different part of the world, but one very close to Germany. He's experiencing such intense PTSD from the war he can barely communicate at all. He cannot make himself understood because he's so traumatized. He can barely speak in his own language let alone English or German. This flood of refugees is not abating; they will keep coming.

KA: There was actually quite a debate around this scene when we were nearly done and started showing it to friends and colleagues. Someone whose opinion means a lot to me told me he didn't really understand why that scene was there, that it looked as if it belonged to another movie. For him, the story had ended when Ibrahim left. And that comment actually made it very clear to me that that scene needed to be there. Yes, it's a film centered on two characters but it's not just a movie about them. It's also a portrait of a space, a place, a time, and a planet. It wasn't an easily made decision to keep it, but I just knew we really needed it there. Ibrahim might have left. But this is not over, you know?

If there's something that's so beautiful about documentary, it's that it's a framing of a certain period of time and a certain place or places. Life goes on. That scene is there precisely because people are coming every single day and they're not just coming from the Middle East. Don't think that asylum seekers are only coming from faraway places. There's a war at your doorstep.

The situation does not end with the film. One needs to always be aware of that. There are different mechanisms and different devices but these do not represent the ultimate goal of storytelling. The ultimate goal, particularly in a film like this, is to capture a state of things crying out to be portrayed.

TRAVIS WILKERSON

In an expanding contemporary American canon of distinctive stories told in first-person, Travis Wilkerson's voice is the instrument that unleashes cutting-edge visions of little-known socio-historical-political incidents and flays them wide open. These days Travis is a dedicated family man, the lion's share of his time spent raising his children, a not-necessarily-by-choice stay-at-home dad. Still, Travis manages to also use this time to start making and hand-processing 16 mm films again and preparing his next feature project. When we spoke in early autumn 2018 the family had just moved from Los Angeles to Ann Arbor, Michigan, back to the house where Travis' father had lived for many years before passing away from cancer in 2017.

Travis Wilkerson's films are deeply researched, and his work quakes with sturdy amounts of agitation and urgency. Despite this, he endeavors to tell his tales with vocal restraint. We discuss the training of that essential voice; refining it has been a career-long process. Travis says that he's worked hard to use a more phlegmatic register to deliver one sonic boom after another as he describes in detail the unendingly violent history of America.

PC: In *An Injury to One*'s chronicle of Frank Little and his time in Butte, Montana, you talk about the "savage capacities of humankind," referencing not just what's happened in Butte, but extrapolating Little's story into a universal view of the state of the world. Part of your historical treatment and a device you use throughout your work in a very liberal way is text, the graphic qualities of text, but also text as an instrument of editorial rhythm, a formally structured device. I wanted to start our discussion with the power of language because you use it as a dramatic device as well as for creative expression.

TW: It probably won't come as a surprise that my original aspiration was to be a writer. It's a very powerful thing for me, language. I dropped out of high school in Butte, a lost person with no vision for the future and no notion of what I would do. I wanted to be an athlete for a long time, a professional bike racer. When that collapsed as a dream, I just had no ability to move forward. Then I discovered books. I was late to it, seventeen or eighteen at the time. Books lifted me out of that place emotionally, physically, and spiritually and enabled me to dream of a different kind of life, a different kind of world. So words were really powerful in terms of beginning my process of transforming my life. That led me to want to go to a good college and that's where I encountered things I never would have otherwise; I was able to embark on my journey in a more concrete way.

What's interesting about *An Injury to One* in particular is that I did the original research for that film in high school, before I dropped out. Somehow, I was already interested in those questions. I don't know entirely why I had that fascination. Fifteen years later when I finally made the film it turned out to be remarkably similar to what was playing in my head then. What was playing in my head had a lot to do with words and images and the one image that seemed powerfully emblematic was the portrait of Frank Little. It's iconic and weird and looks like a portrait of a significant figure, but was not inscribed in history as such. It was an anonymous picture, more or less. The speeches, the songs, the documents, the newspapers—I saw all those words in headlines but it all became much more powerful than just a headline. Words illustrated a point of view, a point of agitation, an incitement to violence, and also an instruction to halt the violence. Those were all the ways in which words ended up having so much power for me.

As a teacher, I'm often told I don't teach enough. I introduce ideas only to encourage an egalitarian approach to them. In my films, I think I operate in a similar way. I see an image and a text and a song and a word, a landscape, an inter-title—I see them all as the same, different aspects of that larger fabric that builds the story. When I was in Cuba learning from Santiago Álvarez and saw all those inter-titles, I wondered why everyone wasn't thinking about inter-titles as strongly as they think about images. Why is it that people add text at the end, or the music at the end? Why do they not see it as something more profoundly organic and interconnected? I didn't want to work that hierarchically. When I started making work, I was in search of this non-hierarchical way in which I could simultaneously express a really clear point of view and then underline that clear point of view in different ways, criticize it

using all these elements as part of that larger fabric. Histories are just different forms of storytelling—this is the argument I'm making in *An Injury to One*. That's why we understand certain pieces of history and don't understand others.

I'm very aware that I'm participating in that discourse when I'm making work. My eldest daughter is sixteen now but when she was thirteen or fourteen she was living in Butte. I made her watch a couple of my movies because she never watches them. She watched *An Injury to One* and when I asked her what she thought, she told me, "Well, it's just all a cliché." She thought it was just the story that everybody tells—the mining disaster, Frank Little comes to town, his lynching. It was such an interesting moment because I thought, holy shit, she is living in Butte now and in the high school the version of that history that they're telling basically comes from the version I told in that film. That version was definitely not being told at all when I was in high school.

PC: In much of your work, there is a manifestation of a traveler headed down a road, usually in a car. You use it as both a physical conduit to get from one place to another, but of course there's the metaphor of the road as psychic passage. But this long abiding road it seems to me is something that can only exist in art for many people. For me, it was and still is, a very authentic element. I'm obsessed with traveling through landscape because I grew up with very young parents too, and they had no money but gas was cheap and so we piled into the car and would just drive for days and days, particularly around the western part of the US. That has always provided a very private place, the conveyance an enclosed and safe capsule in which to dream and make movies in my head.

TW: What you're touching upon is a way I see all the work interconnecting. I had a very similar situation to the one you're describing with this kind of driving experience from my childhood. We traveled a lot when I was a kid and it was always by car. We would drive all the way to the South. Or we'd drive from Colorado to Chicago where my dad was from. Those journeys always had this other significance, this other charge, this other task, and this was primarily my mom's influence. Oftentimes, we were going to investigate something. For example, when I was a kid, my mom became obsessed with nuclear war. In Montana where we lived, we were surrounded by nuclear missile-silos. There were two hundred minutemen missiles there. We would do family trips where we would go to Great Falls and then have a picnic at a nuclear missile silo and talk about the consequences of nuclear war. This was an actual family activity when I was a child. [*Laughs.*]

Throughout my childhood in Colorado my parents were going through medical school on the National Public Health service. My father had just returned from Vietnam. They worked in migrant farm clinics mostly in southeastern Colorado while they were training. We would go out there all the time. These were mostly migrant workers from Latin America. But there were also still indigenous communities here and there.

When you drive through southeastern Colorado, there's virtually no relationship to what we think of as Colorado and the Rocky Mountain region. There is this spectacular endless plain and tiny little rolling hills and grasslands. It's a very stark atmosphere. There was this visceral sensation that something terrible had happened there, something had been erased. Something had existed but didn't really exist anymore. Part of the reason we could live the way we did was because of that erasure. I mean, it wasn't like we talked about this and I can't explain where this certainty came from. But it was something I was really aware of. When we moved up to Montana, I still would drive to Colorado all the time. I got my driving license at a very young age because in the '80s in Montana you could get your license before the age of sixteen.

I would drive the hundreds of miles between Butte and Denver on a regular basis. I would always stop in Sheridan, Wyoming. It was my halfway point and there was a motel that cost fourteen dollars a night where I would always stay and there was a restaurant across the street that I liked so that was my plan. One time I stopped at a McDonald's and there was a mother and her daughter from one of the local indigenous tribes standing in front of me trying to figure out what to order. They were speaking their own language, not English, and at that moment I thought, oh my god, I've grown up my entire life in the West and this is the first time I've ever heard people speaking an indigenous language—in line at McDonald's in Sheridan, Wyoming. It was an illuminating moment where I thought: That's genocide. I remember vividly thinking, that's what genocide is, where language is erased, culture is erased, an entire people's presence is erased. And yet there are still little fragments of it. When I think about this kind of process in the films I make, I'm convinced it's connected to those kinds of moments. I always have a basic question I'm asking and then I start driving. When I made *Machine Gun*, I didn't drive. I rode the train, the Gold Line in Los Angeles. Otherwise I'm always driving around in a cheap car and then I figure out a way to approximate my vision of it somehow. Then I look for these fragments and pieces in the world. They're so powerful when you find these tiny little things.

When I was making *An Injury to One*, I didn't have audio gear or anything like that. I was shooting non-sync 16 mm. I was shooting a landscape and this guy came up to me. He had been one of the last generations to work in the underground mine. He was up there to lay a wreath as a marker for the speculators' disaster. I've never been able to find this guy again but we had this long conversation where he gave me a vision of the life he had lived through in the '40s and into the early '50s when they opened the mine. He was obviously in failing health. The only way you can have those weird moments of illumination is by getting into the car and going to these insignificant places with no permission or permit to be there and you just get out of the car and start talking to people.

PC: This is particularly fascinating for me because you talk about these stories being defined by borders but you're playing with borderless borders—or invisible ones. You map the coordinates of your stories particularly in relation to how you're constantly dealing with America's persistent cycle of violence.

Did You Wonder Who Fired the Gun? could be read as the culmination of this. You decided to tell part of your own family story, the murder committed by your great-grandfather in Alabama, a white man murdering a black man for no other reason than he could and get away with it. But there is a stark discipline in how you manage your rage and this goes back to the voice of the storyteller and the storyteller in this instance is really you, Travis Wilkerson, not some construct of a destabilized narrator as in *Machine Gun or Typewriter?* How do you rehearse so you can hone this aspect of an enraged voice while keeping it contained enough so that the storyteller remains trustworthy?

TW: That's been a very haphazard process for me. I was really into theater when I was in college. I loved the immediacy and vibrancy of theater as well as the social and collective nature of it. I was thinking about those things already when I started to make films. But then I came to this place where I began to try to make my own statements and felt strongly that it all needed to be stated in my own voice for a variety of existential reasons. It would have a kind of sincerity and resonance, genuineness and truthfulness if I used my own voice. A huge part of my filmmaking was about being the author, making the images, recording the sounds, writing it, speaking it. When I did the first voiceover for *An Injury to One* I was overwhelmed because I was a novice and didn't know quite how to do it. I had someone helping me then in a recording facility related to the grad school at CalArts, but it's become a very solitary process since then. Initially it felt rushed and would often be too shrill

or angry. I was convinced that the words were strong enough and that I didn't need to raise the pitch of my voice. In fact, I needed to resist that. The words would not be heard if I were engaging a stronger emotive voice.

When I watch it now, I can actually hear myself getting better at this as the film goes on because I recorded it in order. What I learned is that I didn't like the recording space where I was paying someone to do the recording. I was constantly aware of the cost and that altered my performance. I wanted to find a way to deliver it in an entirely different way. Then something significant happened which was that when I finished *Who Killed Cock Robin?* I did a performance piece for two years called *Proving Ground*. It was about the history of US bombing. It was a crazy piece. I was recently divorced, full of angst, and I took it out in that piece. I performed with my brother's band, a quasi-punk rock old-timey band, very heavy guitars and drums but then there'd be a banjo. [*Laughs.*] They'd play live and I would perform it over the music and it would get bigger and bigger and louder and louder. What I began to realize is that that was completely counterproductive. For me, it was a great purge and catharsis, but it was abusive for the audience. They hated it. They felt silenced; they felt bullied, yelled at. They couldn't hear anything I was saying. A woman came up to me after one of the performances and told me it had been one of the most powerful experiences she'd ever had and she hoped never to have it again. That was an incredibly useful thing for me. It allowed me to explore the outermost limits of this other kind of discourse, the angry, shrill, bitter, vicious, screaming kind of discourse.

It's funny to think about that now in this current political moment we're in. That's the only way people are engaging in discourse. Even if you have a short-term victory, you'll have a long-term defeat. You cannot communicate with people that way. You will never actually change anything. You can win an election, maybe, or get someone shoved through a Supreme Court nomination process but you can't actually change anything in a profound way because you're using a discourse that automatically prevents that from happening.

So I wanted to move in the total opposite direction and challenged myself to take it even further. The next significant voice-over I did was for *Los Angeles Red Squad: The Communist Situation in California*. It's a film that doesn't play very much. It's told not with a narrative tone but more of a factual one. I can still hear the bark in my voice and it bothers me. So that was a failure because I didn't manage to remove that. I feel like I prevented that film from reaching its community based on the discourse it was presenting. The next time it was *Machine Gun*. Here's a narrative that

is voice-over driven so that was an obsession. When I wrote it, I was speaking it out loud the whole time, practicing aloud, writing down a line only after I'd figured out the line in my head. I practiced in the shower, on the train, while taking care of my little kid. I was constantly developing the language for it. I knew this film would completely fall apart if the tone was wrong. I set up a physical space in my house and recorded after one o'clock in the morning after everybody was asleep. Except for a couple of times where I redid a line or two, I did it in one take and never went back to it again.

For *Did You Wonder*, the rehearsal process was really long. I did a performance first, which premiered at the Sundance Film Festival. Performance is always such a powerful teacher. You can tell right away if it's working or not by the reactions of the audience. You can tell if you've irritated someone so much they stand up and walk out in protest. That went on for about six months before I set it down. When I finally recorded it, I took it down another notch. It just really needed to be in a place where it was sincere, direct, and honest.

PC: In this film, you also ended up finding another voice, that of Ed Vaughn, a man who talks about his own militancy and his own protest tactics as a young Black man in Alabama in the segregated South, a very long segment in the film that you give over to his voice. Can you talk a bit about your relationship with him? He's one of very few people willing to even talk to you in Dothan, the town where the 1946 murder of Bill Spann by your great-grandfather took place.

TW: My first encounter with Ed Vaughn was watching him on the local news broadcast in Dothan. He was talking about the African-American museum he had built in his mom's old house. It was in the process of being shut down so they were honoring it. I felt like I'd like to have a conversation with him to see if he knew anything about Bill Spann's murder. We met several times, first at the library and then at the food court in the mall. I was incredibly enchanted by him. Part of what defines discourse in the South is that no one is really saying what he or she thinks. Everybody has a coded way of expressing himself. For some, it's because they're being oppressed and they fear the consequences of saying what they think. For some, they are the oppressors and they wish to conceal the fact that they continue to oppress people, right? This is around race but also around gender, a lot of stuff. You really feel it.

It really felt like Ed didn't have any of that. He said what he thought. He would make me laugh but he also would say things that made me feel uncomfortable. I

mean he took it really far when he wasn't on camera. He was very open about the town and its racist history, about fighting back.

Once we sat down and actually started filming I recognized a very powerful and useful digression from the myopic narcissism of the film. It's an equally powerful narrative and shows the limitations of the myopic narrative and also gives an incredibly important voice to an intellectual, a politically active Black man that was from that time. There was probably another quarter of an hour with him that I thought about using in the final cut. You could have a whole film just about Ed Vaughn. He's also an example of a person who'd been tremendously successful in resistance and activism and is a prosperous and well-regarded person in the community.

One of the things I'm constantly wrestling with is how these films can be adequately critical of this continuity of violence we've talked about that exists in US history. How can they be adequately critical and at the same time not be incredibly pessimistic? I think my films are often too pessimistic, I really do. Ed's presence to me is this really concrete alternate essence of something quite optimistic. He's a really funny guy and whenever I did the live performance, people were laughing all the way through that part of it. That was really beautiful. I think about this continuity question and I think it's a significant issue in my work and in our society. For example, we're dealing with this [Brett] Kavanaugh nightmare right now. People are expressing this rage about his behavior, the kinds of things he's been engaged in that he should not be able to get away with. I think on the one hand, of course we must condemn that. But on the other hand, there's a long relationship of these things that have to do with broader social issues in a profound way that I feel people are fully identifying with.

How is it that our country has such violence inscribed in its very founding acts? That's the landscape I've continued to investigate and ask questions about. That's inscribed into the history of settlement, slavery, and the whole economic system of the US. That historical level of sexual violence up until today is a constant feature of the system and always has been. The US is the most war-like country in the world. There's something like a bit more or less than a decade of time that the US has *not* been engaged in war since the country's founding, two hundred-plus years of war. What does that tell you?

This is part of the narrative about the American South from slavery to the rise of the Klan. There is an obvious connection in the ways in which power is projected that comes up over and over and over again. How to depict this is another question.

How explicit should things be? How implicit should things be? I wrestle with this constantly in my work. I'm convinced when you're too explicit with imagery and so forth, the consequence tends to be the thing that shuts people down, as an overly aggressive voice does. It tends to create more victimization.

PC: Does your process of working through these things in your art relieve you in any way?

TW: Not really. It's a bit like a feedback loop for me. The bizarre thing is that when you look closely into any aspect of American society, or any culture for that matter, you're going to find these same things. If you look closely, if you look clearly, you are going to find them. That's the ultimate gesture I'm trying to engage in, to produce some kind of an attempt to move away from them. Within my own family the defining thing is not even the racist stuff, although it's a big aspect of our family's history.

It's about a racist war, the Vietnam War. That war was present in the life of my family in a way I cannot begin to describe. My father recently died from cancer-related Agent Orange exposure, going all the way through that cycle. It is a constant thing to be aware of, this war, and yet we *still* have no capacity to engage with it critically at all. The most critical perspective is that it was a "tragedy on all sides." No, not really. It was a neocolonial war in which millions of poor people were murdered to prevent them from gaining full independence. We cannot reckon with that. My dad was a decorated pilot in that war. So what does that mean for me? My dad was a bad person? That's not it at all. It means that it was impossible to do the right thing in a war that was fundamentally wrong. My dad and I had many long conversations about this. In terms of future work, can I step out of this loop? Probably not. I'm already working on a project that deals with Agent Orange and the Vietnam War. It's definitely going to have autobiographical elements and it's probably going to make people even more uncomfortable than the last one to be honest with you.

PC: I totally agree with your idea that by moving in ever closer to our own family histories and investigating the people whose blood we share might help to reconcile that conflict that resides in all of us. I feel that's a very fine artistic mission and an important one. It's the hardest road an artist could possibly take.

TW: However, I feel like I never grapple with it adequately. It's something that drives me crazy. At different periods, I've been more or less politically active—organizing, participating, agitating, nothing too extraordinary. Right now, I'm not. My wife Erin makes fun of me. She was raised Mormon and she tells me that the protest

is my church. You go to the meetings and events and then you're a good person again. I don't really experience it that way but I think there's an element of truth to that. I'm not going to church right now. I mean, I don't think I've ever really accomplished anything as a political activist, let's put it that way. I also think that when I'm being politically active as opposed to just making cultural work, I somehow feel more optimistic about the possibility of social change. You come home from the demo where you've demanded full rights and amnesty for immigrants and yet we don't have full rights and amnesty for immigrants. Nonetheless being part of those demonstrations makes me feel optimistic about the capacity of people to work and band together and form alliances.

We should have better aim if our films are to be a form of weaponry to wage a social struggle. How can we aim better? I do not know the answer to that. But I can guarantee that I will still be wrestling with it in the very last movie I ever make. These themes of roads, journeys, abstraction, of the personal, of the broader view, of how much violence should be depicted, of how much is alluded to—they all have been and will continue to be part of the questions asked in every single project I embark upon. Part of the challenge of the conventions of powerful storytelling, the kind that instructs—particularly in the context of festivals, pitch sessions, the culture of nonfiction and documentary—is that what's often championed are pieces that use conventions that actually *prevent* powerful storytelling. All this is organized in such a way as to discourage the sense of grappling, the sense of unfinishedness, the sense of incompleteness and imperfection. To me those are all markers of struggling for something bigger.

PART FIVE

MEMORY & MAGIC:
INTER-DIMENSIONALITY

As disparate as the filmmakers in this section are in their methodologies and approaches, each endeavors to access his or her interior pathways in order to over-write entrenched histories of "the way things have always been." Terence Nance, Sky Hopinka, Ja'Tovia Gary, and Mila Turajlić untether traditional conflations of history and memory, repudiating established narratives through oral storytelling, family legacy, ancestral connections, the inter-dimensionality of personal relationships, and archival material—with no small amount of cinema magic thrown into the mix. The work is granular and deep, shining light on hidden areas of knowledge, understanding, and wisdom passed down from preceding generations to make better sense of the past in order to move into more illuminated futures.

TERENCE NANCE

I encounter Terence Nance, creator of the startlingly fresh and emotionally stunning film *An Oversimplification of Her Beauty*, in Los Angeles, virtually, via Skype. It is mid-morning there to my Berlin evening. The window on my computer screen displays a just-awakened Nance enjoying a breakfast of large, cold strawberries which he will devour as we talk. His massive head of hair is in glorious bed-headed disarray and swirls like a halo around his young handsome face, which is more often than not displaying a gentle gap-toothed grin.

His début feature is about a young man's love for a young woman, a woman who also happens to be his very close friend. It could be described as a vérité documentary-narrative-animation-film-within-a-film feature. Nance takes great risks, both creative and personal, and the result is a work of cinema that is hauntingly evocative of how human beings experience emotions when they're spinning out of control. Nance's voice is a real discovery, straightforward and artful, exuberant, at times disorienting, intelligent and also very, very funny.

PC: Your film resonates with me on such a deep personal level since you express so much of how I feel, particularly about romantic love. The shock of recognizing things I have also thought and done was surprising, wonderful, and unexpected. In cinema, especially, these feelings are extremely hard to articulate with images. As part of this articulation, you reference one of my favorite books ever, one to which you pay homage in the way you've structured the film, Louise Erdrich's *The Bingo Palace*. The way Erdrich threads these different voices and experiences all radiating from one protagonist's experience is very similar to what you do in your film. In the book, her main character speaks quite eloquently about how love and our quest for

love and the way we suffer for love is the main motivation for absolutely everything we do. Can you talk a bit about this notion of longing for something you never had in the first place? How did you figure out how to cinematically show this?

TN: I'm not going to call what I attempted an experiment exactly, but I did very much set out to develop this way of conveying experience that didn't filter anything through the use of metaphor or the language of symbols. That was the guiding principle for making the movie. I consider it a children's book way of making a movie, minimalist in its execution. I was trying to articulate this experience of being lost, confused, trying to make sense of all the available information. Very purposely, the voice-over is for the most part emotionless, stating the facts, impartially relaying what happened from some kind of third-party point of view. I think this is especially how men might talk to each other about these things. It's another way of attempting to explain something without metaphor. It's saying: This is what it is; this is what happened. Most creative decisions that exist in the movie are trying to obey that rule and I think that's how it retains some kind of authenticity. So watching the film feels authentic to the experience of what I was going through—how beautiful, complicated, and annoying it was, how long it lasted.

PC: The way you make these statements and how you set out to define the narrative of the story ends up showing immense fragility and vulnerability. Did you experience a lot of self-doubt while attempting to create this?

TN: Surprisingly, there weren't really that many moments of self-doubt in how to do it. But subconsciously at least I did have to tell myself that what I'm putting up on the screen is, in fact, not really me. More of what I think I did, actually, was to think of that person as me at a very specific moment in time, and that I'm just not that person anymore. There's a theory that puts forth the idea that several times in your life you are molecularly brand new. All of the cells in your entire body die off and your body is a totally new thing, reborn. Supposedly this happens about eight times in a person's lifetime. I guess in that kind of existential or even scientific way, in terms of what I'm made up of now I am indeed not the same person. This idea allows me to treat myself as a subject that way, a whole other entity than the "me" I am now.

PC: How collaboratively did you and Namik Minter work together in creating or reenacting these scenes together, the ways in which you relate to one another as you perform aspects of, or moments in, your relationship in front of the camera? There's this triangle where you are the director, you are the protagonist and she is the other protagonist for most of the film. Then in the finale there is this very

intimate interview where the two of you engage in a discussion, both of you naked in front of the camera. We understand there is no one else in the room except the two of you and it feels like some sort of confessional. The way you position yourselves, it's as if you're one being with two heads talking about this creation. And Namik's own film is embedded in the middle of it all. I found it delightful that the name of her film is *Subtext*.

TN: I'm glad all this was apparent to you because much of the subtext or commentary in this discussion she and I have at the end was edited out. This is something I explore in other work I do, the same ideas and elements I explore in this film. It's this idea of having a doppelgänger. But I mean this in the sense of having a male and female housed in one being and the solipsism inherent in that idea. Namik's and my representation is always as kind of a matched pair. We don't really look alike but we are reminiscent of one another. Even in the environments in which we were raised, we are connected. How we look, how we wear our hair, the color of our skin—we're almost the same in a weird way. We're both really laidback, not very aggressive, so you have two nonaggressive people trying to have some kind of engagement with one another.

So subtextually there are all of these aspects of twin-ness that are very present. In working with her and being with her, being around her, being friends with her, this is a huge thing that draws us together and continues to draw us together, this twin-ness. It made the making of not only this film possible but everything we invent together. Our relationship is mapped by the artwork and the projects we work on together and this is also in the subtext of the film.

But the movie was not collaborative in the traditional sense where we were consulting with one another on creative decisions. I very much directed her in this piece; I created the storyboards. In a strange way, I think I probably was the only person taking it at all seriously in a certain way, especially at the beginning when we started to film. But at the same time, there was always the understanding between me and Namik that we were making some kind of representation of ourselves as the same person, this representation of this energy that's between us, not us as individuals. It's what the connection between us looks and feels like and that connection kind of looks like both of us. The movie is also encapsulated in a period of time. Maybe the year after we shot that, we really weren't so much alike anymore. Now we're once again a little more alike. It's very metaphysical in a way, something that

illustrates dealing with aspects of our existence or the existence that's there when we're together.

PC: One of the film's distinct accomplishments is that even though you're engaging and thinking about all of these philosophical and transitory ideas, you were still able to convey all of this heady stuff in a pretty straightforward manner. It's a very full palette but simple, primary, easily digestible.

TN: There's this conversation oftentimes about form, or genre, or "breaking form," or what have you. This is a way of encountering this movie in the context of cinephilia. In other words, understanding it in relation to cinematic influences. But I definitely made this outside of that context. So, for me, the conversation about breaking form doesn't make sense because that's not what I set out to do. I did have several versions of it since there are myriad ways of telling the story, but at the heart of it there was always the attempt to create dramatic minimalism, to really stay away from concepts and ideas and such, and just have straightforward narration, to strip away every creative decision, or any rationale other than directly articulating the experience. That's what gave rise to the film's form and that was developed in a very strict, predetermined way.

PC: Interestingly it's the animation sequences where you allow yourself to go for big drama—the scenes you drew and the performances given by the animated characters. Whereas you directed your live actors to be reserved, polite, restrained, acting within the confines of social conventions where we don't really show how we're truly feeling.

TN: Yes exactly, and the voiceover is that way, as well. The hardest thing to do was to get it to a place of as much desaturation as possible, my own voice as well as that of the actor Reg E. Cathey's in the short film *How Would You Feel?* that is embedded in this one. I wanted all the color taken out of our voices. I'm trying to be faithful to these emotions in that they're all based around this idea of restraint, of not feeling able or ready to say something. There's a lot of negation of what's going on inside. And then, in the animation, what's going on inside your mind gets played out in the most melodramatic way possible to such an extent that it's hilarious, bordering on absurd. There's a sequence where I'm literally pulling my heart from my chest, handing it over to the object of my love, or writhing in agony on the floor, crucified.

PC: So molecularly speaking, who are you now compared to the man you were when you started making this film? It was several quite formative years of your life.

TN: The movie took so long to make. I *was* a different person after making and exhibiting *How Would You Feel?* even before I started making the feature. The making of the feature created a transition for me that didn't so much have to do with relationships or love or anything like that. It had more to do with artistic expression and making something. I mean the experiences articulated in the movie are old. They were very relevant when I was making the short film. That's not to say they're not relevant now, but then they were very present. When Namik and I are sitting together and I'm interviewing her about her thoughts and reactions, I display a forwardness there because my feelings at the time enabled me to boldly ask her, "I'm in love with you. How do you feel about that?" This is how I feel. So what's good with that? I became filter-less in a very specific way.

PC: She takes it well but you are essentially bullying her even though you speak in a gentle voice.

TN: I also need to state that that section is heavily edited. She also interviews me. I was more aggressive, I guess, because I was trying to make sense of this whole thing. It goes back to trying to tell this story efficiently.

PC: As you state at one point in the film, the healthy emotional environment in which you were raised seems to have made it difficult for you to relate on any kind of aggressive level. I think a lot of men act more aggressively than they really feel to protect themselves from the vulnerability of being in love.

TN: On some level, this film loosely maps all of those moments in my life from very early memories onward. When I was a kid, I don't even remember people raising their voices in front of me. I remember the first time I got into a fight in a relationship when I was nineteen or twenty. The woman I was with started yelling and I remember I had no precedent for how to deal with that. I felt like I was on TV or something. [*Laughs.*] It just made no sense. It took me a long time to realize that all of this formed my personality; the way in which I navigated emotionally was not something that everyone shared. It was a huge awakening for me. In the film, I'm trying to map all of these transitional moments.

This idea of layers of the animated me, the live action me, the interviewing me, I can say that in that regard, the film is very linear. The animated representation of me is not dead now, but by expressing myself that way it gave me the capability, in a weird way, to respond or act the way I do in the interview sequence. There's a linear cause and effect-ness to it. I still feel or can express myself in those ways occasionally now, of course; they're still part of who I am. But creating and expressing those

things in the animated sequences allowed me to be the way I was with her in the interview. Then I was ready to hear what she had to say in response to the way I was telling her how I felt about her. It was a direct result of what I'd gone through with her before and learning something from that. That interview is a fully realized transition that I wanted to capture.

The transition that happened off-screen manifested itself in constantly continuing to see her, which I talk about in the movie a bit when I talk about emotional memory. Images of her and engaging with my emotions towards her tell me that it's really not necessarily a bad thing to not let things go, but that you can come to a place of maintenance. I think that's the most important thing. It's a very Western idea to discard "useless" things or emotions that don't serve us anymore, or to not continue to see someone because your feelings have changed. That's just not how I operate. I don't have these defined portions of love to give like pieces of sweet potato pie, where this part is for Namik and this portion is for someone else. It's not like that.

PC: So what other walls of emotional mystery are you interested in breaking through in your work?

TN: There's a lot of stuff I'm exploring, but the next project I hope to do is a sort of portrait of a fantasy I have. It's a reaction to this sadness I feel about the nature of social change and political change in my environment, and probably anyone's environment that doesn't have a lot of money. It's called *The Lobbyists*. I imagine it in the genre of political thriller, perhaps, to talk about lobbying. It's very distinct to American culture and it runs everyone's life in a specific way. I'm going down that road because right now I constantly have the feeling of "there's nothing I can do." And that feeling of hopelessness becomes epic. It's a general malaise that people of my political persuasion and economic circumstance feel. We're at a place where we're under a certain thumb; the system has adapted so well to our discontent so that the viable ways of changing anything efficiently are shuttered. So it's about that, and a fantasy story about reacting to all of that in an extreme way and the consequences of that act. Right now, it's a two-character film where I play a con man and there's a woman who plays an ex-CIA agent. And we become lobbyists!

SKY HOPINKA

After finishing school, Sky Hopinka had an astonishingly productive artistic period, the work centered around a deep and abiding exploration of the Native American experience—or more precisely, its erasure. Like Travis Wilkerson, Sky gets in the car and drives, the act of conveying himself from one point to another the catalyst for dreaming, remembering, and listening to stories and songs told and sung by family members as the scenery rolls by.

Sky first started making video work around language learning, specifically Chinuk Wawa, the indigenous language of the Lower Columbia River Basin. His first video called *wawa* (2014) centers around the relationship of Wilson Bobb, a ninety-two-year-old Native American, and Henry Zenk, a white man who is thirty-eight at the time. The elder and his student dialogue about a language that "wasn't a cold lexicon without heart or figurative meaning. Rather, [it was] a communal space that revealed how the language was used amongst friends." Bobb says to Zenk: "You should say anything you want to say even if it's completely wrong—say it. That's the way you'll learn it." Thirty years later, Henry Zenk at the age of sixty-eight is the twenty-nine-year-old Sky Hopinka's teacher. Sky, in turn, teaches it to his contemporaries, some of whom also appear in his 2015 film, *Venite et Loquamur—Come All and Let Us Speak*, one of my favorite films of his that beautifully illustrates states of inclusion and exclusion. Shot in black and white, it expresses the longing and ambivalence of the observer.

Sky's conjuring of personal memory alongside the history that's been written and rewritten, remembered, misremembered, and then forgotten holds much of its power in the way he juxtaposes and layers his audiovisual works into intoxicating blends that defy categorization. Languages (both English and Indigenous), music,

animation, and mediated video image collide to create personal manifestoes on Native American history accompanied by stories from the ancestors, particularly from his beloved grandmother Sylvia, a primary influence on Sky's life and work. As he's continued to create, his filmic language has become increasingly sophisticated. It's an artistic vision that has been honed organically. He masters the technical elements that will help him express what he wants to say; he plays with light, sound, presences, and absences until intuition and interior rhythms take hold.

Similar to Michael Robinson's many lists of random inspirations, Sky also keeps a cabinet of collected curiosities made up of passages he's read, music he's listened to, images he's seen, items and objects to spark his imagination when he's making a piece that asks for something very specific to set it aloft. As a kid, Sky traveled across the US on the powwow circuit, accompanying his father whose voice was a repository of Native songs. His *Jáaji Approx.* (2015) is dedicated to those memories of traveling with Mike Hopinka and echoes of other distinctive voices that gave much solace to a perpetually dislocated boy. His rediscovery of that voice and what it means to him today as a grown man makes *Jáaji Approx.* a deeply melancholic, tenderly vibrant collage that describes a very complex relationship.

While living in Milwaukee, Sky—a Ho-Chunk Nation tribal member and descendent of the Pechanga Band of Luiseño Indians—penned a memoir of sorts about his growing-up years and how certain life experiences have intersected with and influenced his work. Published by the Green Gallery Press, *Around the Edge of Encircling Lake* is a collection of autobiographical sketches, essays on his own art making, and calligrams. Calligrams, pieces of text in which the design and layout of the letters create a visual image related to the meaning of the words themselves, are in the shape of effigy mounds, the Ho-Chunk tribe's way of describing the boundaries of the earth and clans. Sky and I talk a lot about language, how one learns to acquire fluency, how one can teach a language to others and thereby create community.

An erudite and expansive thinker, Sky speaks in a soft, low register. He is respectful and holds much in reserve but what he does share is straightforward and thoughtfully articulated. When I spoke with him in November 2018, he was in residence in Boston as a 2018–2019 Radcliffe-Harvard Film Study Center Fellow working on the completion and post-production of his first feature, *małni – towards the ocean, towards the shore,* which follows Sweetwater Sahme and Jordan Mercier's wanderings through each of their worlds. Spoken mostly in Chinuk Wawa, their

stories are departures from the Chinookan origin of death myth with its distant beginning and circular shape.

PC: *Around the Edge of Encircling Lake* is an elegantly layered book, evocative of your moving image work in its structure. It doesn't really de-mystify your work so much as clarify your creative process, how you want to approach these examinations of memory, language, landscape, and the various translations they evoke. In a footnote in the section on *Jáaji Approximately*, you write about your family and specifically the women who raised you: "The strength of Indian women who survived so much is a lot to live up to, but a needed call. The privileges I'm afforded are because of them." Can you describe further what their presence in your life meant to you?

SH: My mom and dad divorced when I was about two years old. She and I lived with my grandparents. Then at age four or five, my grandfather left so the household consisted of my mom, my grandmother, and my brother Nosuun and me. There came a point where we couldn't stay in the house where we were living and we moved in with my Aunty TeeTee (Stephanie). Her daughter is about the same age as I am, six or seven months younger. It was an important part of the family structure growing up. My mom had a job at the casino working the graveyard shift. I have so many memories about my aunty and who she was as a person; she was really sick most of my life but she was such a force and had so much determination. She didn't give a shit about anything. She only cared about and loved her family, and she had a huge impact on me. It was the same with my grandmother Sylvia. She'd been through a lot but she was always there. We'd sit up at night watching old movies together and she would tell me stories about her life in Alaska. These women were the stabilizing forces in my life.

PC: Did your fascination and determination to master various lexicons, including the one indigenous to your tribe, begin with their influence as well? Your book, which is entirely in English, nevertheless has varied ways of writing—autobiography, memoir, your texts about your video pieces, and the extensive footnotes on the influence of familial and cultural objects and experiences. Sometimes the tone of your writing shifts from one sentence to another in a fashion similar to the way various sources and visual and aural elements enmesh in your moving image work.

SH: My maternal great-grandmother was the last person on that side of the family to speak the Indigenous language and my grandmother went to boarding school

in California so it wasn't an active part of my life growing up. But it was always somehow present. My tribe isn't from Washington but that's where I grew up. My grandmother's tribe is from Southern California so I was partially displaced in that way as an outsider, while still being part of a Native community. I was always into reading. I had this relationship to stories, words and language. But at the same time, in grammar class in elementary school, I was always kind of stressed because I had no idea what a noun was or what an adjective was. I really enjoyed reading and I read a lot and understood a lot of what I read but I struggled with the functions and mechanics of language. I always thought that was strange.

My grandmother was into science fiction novels and she shared those with me so there was a mix of science fiction, fantasy, and traditional stories—a commingling of different ways of storytelling. I really wanted to be a writer for a long time but I think I liked the idea of it more than anything because I never really had the discipline to be a writer. I couldn't imagine sitting for hours and hours writing something. But being immersed in these different worlds through story did lead me to a point where I could start to become critical of what I was reading, paying attention to word choice and structure.

I can't say I really remember specifically what made me want to learn an indigenous language. In my college career—which spanned about ten years—I took Spanish, American Sign Language, German, one semester of French. I was in and out of various community colleges. Language just seemed so strange and I couldn't imagine being fluent in anything. There did come a point though where I needed to get my foreign language requirement to graduate and I realized I didn't want to do it in Spanish or some other language, but in my Native one, Hoocąk.

Oh, I'm remembering something else. I totally forgot about this: I remember being twelve and my grandma started ordering these tapes in our tribal language and I listened to those. It was really challenging to learn on my own with the tapes but it gave me a fuzzy idea of this language I'd never really thought about before. Then a decade later, I found myself wanting to fulfill this language requirement with it.

PC: It's so much more difficult to learn a language when you're older.

SH: Totally. I was living in Portland, Oregon at the time. I was twenty-five but I needed to learn it so how was I going to do this? Then I met Evan Gardner and he had developed this system to teach language called Where Are Your Keys around Chinuk Wawa and he told me I should learn it. He told me it would make learning my own Native language much easier because your second fluent language is always

the hardest to learn. He also said that I'd be helping the Portland community where I was living so I was totally on board with that. I managed to learn Chinuk Wawa and it made me realize that this is what the labor of a passion looks like, hours and hours of learning something and all the tedium and boredom that goes with it. But it builds into something that you can feel becoming part of yourself.

PC: In your 2014 piece *Kunīkaga Remembers Red Banks, Kunīkaga Remembers the Welcome Song* there's a line where your paternal grandmother says, "We hold our language sacred because it's dying." It doesn't take that many generations before something just isn't spoken at all anymore. Should we be responsible for having fluency in a language our ancestors spoke? What does it mean when a language dies out and no one speaks it anymore? What does that mean for the culture that spoke it?

SH: It's a scary thought in many ways. When I was learning Chinuk and was working towards fluency, Evan told me that I had given the language thirty or forty more years. That felt good because that's what this is doing. It's managing a sense of urgency and managing a fear of loss with hope. That's part of language revitalization alongside helping this community you're creating emerge. You're fostering something by being part of a small group that sustains the language, holding it and taking care of it. It's also something that no one can do without community.

PC: I really love your piece called *Venite et Loquamur, Come All and Let Us Speak* for precisely this reason. It's an apt illustration of what you're talking about: the sense of community around a common language, one spoken by nobody, at least not in the colloquial way you show in this film, an everyday language for making meals and socializing and gathering. It's a very joyful piece. I started to wonder whether this group would be that free and playful if they were speaking English instead of Latin—or would they be more reserved? Is Evan, who appears in this film, a professional linguist?

SH: No, he's not a linguist but as the inventor of this method for learning language, he's a teacher. There's a bit of a conflict, I guess you could call it, in the Indigenous language revitalization community where the people doing the really good work are, in fact, linguists. They've developed a curriculum. There was a time where it was challenging to make that kind of language curriculum useful, for the exact reason that it's being written by linguists. Can you imagine learning grammar—nouns, adjectives, or verbs—in preschool? It's an approach based on a certain vernacular. In the last ten or fifteen years the curriculum has become more inclusive

in terms of finding more natural ways of teaching language. The other woman you see in this film and who's also in *wawa* is a Latin teacher. I think there's this sort of outsider approach to the Where Are Your Keys method because traditional language classes never really worked for me and I don't want to learn that way anymore anyway. So when I met Evan and his left-field approach to learning and teaching language that was entirely immersive based upon using sign languages as a bridge, it totally made sense to me. I was really happy to be a part of that.

PC: You put a lot of thought and artistry into these stories you've been told since you were little, reinterpreting them and then allowing the space for a spectator to reinterpret them again. Cleo Keahna expresses this thought in *Dislocation Blues*. Cleo says that the story of Standing Rock is a story that has to be told by everyone, communally. It's a communal story and a communal memory. But that event also took place within a landscape that's contested in confusing ways, even within the Native community. How does this manifest itself in your own modes of storytelling?

SH: The landscapes I'm referencing are never the whole thing—it's not the entirety of what I'm up to, how to portray landscapes or how to portray different geographies. For me, landscapes can't really be parsed separately from everything else going on in a video. I try not to think too much about how these works are being met or interpreted because it would drive me crazy. I would eventually feel a desire to make things more accessible, for better or worse. With each video, I feel like it has its own logic and its own structure.

It needs to feel like it makes sense to me and that I'm not trying to be too clever or mysterious. How can I teach you to watch something in the first two minutes? There are ways I'm inviting an audience in and whether or not everything I'm up to is accessible, there's *not* a certain way that I want things to be interpreted. I know what things mean for me that often can't be described through words or through any explication. The understanding is in the edit or in the image or the construction of a piece. And if people are trying to meet that using the words they know or the way their community has learned to describe it, then that just makes it more open for me in how I might want to interpret it.

PC: In your book, you question and investigate your own work using different syntactical approaches, some of which are really funny and sly, including the ways in which you question what you're doing holding a camera and recording events. The spectator-outsider stance is one you grapple with in *Dislocation Blues* quite openly, more subtly in other pieces.

SH: Here again, I try not to focus too much on how the work is being interpreted because it would drive me insane. But I also think about the work a lot and that also drives me insane. [*Laughs.*] I think about all these different choices I'm making but it depends what the different questions are. Am I part of this system of oppression or am I not? I'm in a position of privilege to be able to do what I do. I've felt that from the very beginning when I first picked up a camera or when I was able to go in and out of college.

How can I respect that privilege or honor the opportunity I have to do this because of the sacrifices my family made and my ancestors made in order for me to do this? That sense of responsibility or that weight comes up in all these different areas where I have to be critical of everything I do. Because if I'm not, who will be? If I don't respect what I'm doing, why would anyone else? If I'm not a person who feels worthy of love, then no one else will think so either. It's a similar cycle with the videos too: When I finish something, I think it's the best thing I've ever done. Two months later, it's the worst thing I've ever done. And then a month later, I find I need to just start making something new.

PC: You grew up partly in the powwow culture, traveling with your dad on the circuit. I don't know if you know the full answer to this, but you linger on a sign in *Jáaji Approx.* at the entrance to a reservation. It says the land is under the jurisdiction of Federal, Tribal, State and County law. Are these various jurisdictions cohesive or is it much more complicated than that? Your camera dwells on the sign long enough to read what's on it so I wondered what kind of significance it might have for you.

SH: That's at the edge of my mom's reservation in Southern California, right on the border of the Pala Reservation, which is a separate tribe. That's the boundary line. *Jáaji,* in part, isn't just about landscapes traversed but this idea of these roads and their infrastructure within that landscape. I don't overtly question them but that's part of it. And that sign has a lot to say about questioning where the boundaries of these reservations are. How do the roads connect these different communities and how are the roads themselves disconnecting the community in terms of traveling from powwow to powwow, or across the United States, or the relationship between different tribes that are right next to each other? It's really complicated because it's about how tribal land is managed and who owns it. Federal land, State land, Trust land, land that's owned by the tribe, land that's not owned by the tribe, land that's in trust to the Federal government.

Essentially, it's about land. A lot of the reservation system works with this idea of what it means to be enrolled in a tribe and who can own your land after you die. Who does it go back to? Is it the federal government or does it get passed to your descendants? Are there other incentives for your descendants to sell the land? Because it will probably get divided and divided and divided and the next thing you know four or five generations later someone owns a piece of land that's the size of a coffee table or something. Very reductively, the government is trying to get as much of the reservation land as possible. It's also different for every single tribe, each system having their own ways of dealing with this issue.

PC: I'd like to go back to *Dislocation Blues* again because this piece you made about Standing Rock actively grapples with this reticence to define—the attempt to decipher what that sign is really saying being just one example—and I have to think that casting Cleo as your main protagonist here was no accident. Cleo is such a moving voice precisely because of the experiences he had there. You juxtapose his reminiscences with Terry Running Wild's voice. Terry is even more reticent to talk to you about certain things even though you're Native—but one with a camera in his hand. Add to that your own palpable reticence in shooting what's going on there. This is a piece that really illustrates the conflicts of the person holding the recording device.

SH: That reticence is something that's always been there. This question of who has control of the voice and what does it mean for me to be the one pointing the camera? How do I direct attention away from those feigned subjectivities and how they manifest through these narratives? It's something I've been thinking a lot about for a long time, questioning representation, as well as the act of editing itself, through the choices I make.

JA'TOVIA GARY

In 2016, Ja'Tovia Gary attended the Terra Summer Residency program in Giverny, France. While there, she made a short film called *Giverny I (Negresse Imperiale)* in which she situates herself right inside Claude Monet's glorious gardens. In some scenes Ja'Tovia wears a brightly colored dress, blending into the electric and flamboyant colors of the surrounding flowers and trees. In some instances, her face is completely obscured by a brown box she drew and animated over the video. In an effect similar to the moth wings in Stan Brakhage's *Mothlight* (1963), the boxes are made of petals and leaves from the garden that Ja'Tovia then affixed to celluloid. In the short film, the materials are abstracted into patterns and colors when light passes through. In other scenes she is naked, a reclining nude in repose, distinctly not blending in, an image to be consumed by the spectator—out of place, out of time. Juxtaposed against the filmmaker's presence in the bucolic setting of the gardens are selections from video phone footage recorded by Diamond Reynolds in July 2016 in Minnesota—posted as a live feed on Facebook—as Reynolds' boyfriend Philando Castile lay bleeding out in the front seat of his car. Castile had been shot at point-blank range *seven times* by a police officer after being stopped for a random check.

Ja'Tovia works with a purposive oppositional gaze, a bid to reframe and retell modern historical incidents from a Black perspective. When I spoke to her in February 2019, she had just returned home to Brooklyn from Paris after launching her first solo exhibition, *Tactile Cosmologies*, at galerie frank elbaz.

In early 2019, Ja'Tovia was a featured artist in critic and writer Hilton Als's latest show at David Zwirner Gallery in New York, a wide-ranging and hugely imaginative exhibit taking on the myth of American writer and intellectual James Baldwin. Ja'Tovia's film *An Ecstatic Experience* (2015) was part of the section of the show that

Als called a "universe of pure metaphor." Made with archival footage, *An Ecstatic Experience* is Ja'Tovia's first experimental work, and the foundation for the style and substance she'll use, in part, for her début feature film, *The Evidence of Things Not Seen,* currently in production, its title echoing Baldwin's 1985 nonfiction book about the Wayne Williams Atlanta child murders that took place in the late '70s and early '80s. The evidence of things not seen also references the definition of faith from the New Testament's Epistle to the Hebrews 11:1: "Now faith is the substance of things hoped for, the evidence of things not seen." Conceived as documentary memoir about her kin in Dallas, Texas—those still alive and those that have passed on—Ja'Tovia's creative mission is to explore the resonances and vibrations of the ancestral legacies that have been passed on to her and her generation.

PC: As a maker that works consistently with archival footage, what is it about using that material that captivates you, that helps you form a way into personal content?

JG: Even my earliest works as an undergrad have archival footage in them. It's a weird kind of impulse that has always been there. Largely it began with my love for the way the material looks. It's textured, soft, otherworldly. There's a ghostly quality to the imagery. You're looking at footage of people who might have long since passed, places that have changed or no longer exist. As someone who's really interested in the metaphysical, the immaterial, the numinous, I find archival footage and objects from the past incredibly evocative. The material is loaded, super charged with time, a kind of residue. Using the footage allows me to layer contexts and experiences, make connections across time.

With the feature, I'm really blessed because I have this footage of my family that dates back to the early 1960s. My great-aunt Mae had a bit of money and purchased a Super 8 camera. In many ways she's one of the family's earliest documentarians, and more generally she fits within a tradition of Black women documenting Black communities right alongside folks like Zora Neale Hurston. Sure, these are home videos, but what happens to the camera when it's held by Black women gazing at their communities? They become the timekeepers.

I see my maternal grandfather and grandmother, both of whom passed away when my mother was a teenager. I see my great-grandmother. I knew her but she's long since passed away. I see aunts and uncles when they were young people. Viewing this footage, having access to it felt very affirming. It was powerful to see this visual representation of family and community, this evidence of people who

are now ancestors that I had never met before but of whom I'd heard stories and feel deeply connected. I also see folks I grew up knowing as elders or grown folks and now I'm looking at this footage seeing them as babies. It was a really moving experience.

Working within the archive allows me to merge these images of the past with contemporary imagery so that we can begin to reestablish this connection across time and space with those who have come before us, with events that have occurred in the past but influence our present-day realities. A lot of what I'm exploring is very relevant today because these are age-old concerns, whether it's about family, love and redemption, state violence, the abuse of power. It's important for me to insert myself into this conversation and insert people like me and people in my family line into this conversation. The archive is not objective nor is it a neutral space. It is filled with gaps, deliberate erasures and ruptures. I want to make sure that I'm able to have a presence there and bring my own subjective experience to the materials.

PC: You speak a lot about the spectator, the audience members you want to engage with. In your film *Women's Work* profiling Brooklyn-based artist Simone Leigh, she says that the viewer or spectator of her artwork is what activates the artwork. With the freshness of this newly discovered family archive, can you talk about your relationship to the audience for your own work?

JG: What I'm about to tell you is something I also just spoke about in this talk I gave at Radcliffe the other day and I've said it before that. I knew it was going to get an interesting response, particularly from the audience at Harvard. I'm talking very specifically to Black people. Oftentimes, I'm speaking specifically to Black women, Black queer folks, Black young people, Black men, or those who have passed on. Sometimes I'm speaking to a future me, someone not yet born. The works I'm creating are interior conversations I'm having with Black folks. That doesn't mean that white or Asian or Indigenous people can't access the work or learn something from it or have it resonate on an intellectual or emotional level. But this specific audience is important to keep in mind because that shapes the conversation. It shapes what kind of imagery I'm going to put into the work and how I'm going to structure that imagery. It also lets me know what to leave out. I don't have to worry about speaking, as Toni Morrison said, to the invisible white person over your shoulder. I can speak directly to you. Whether or not white people are transformed by my work is not my concern.

I'm often urged to be "universal" because all storytellers are supposed to be universal. But we only get to the universal by being extremely specific. If I tried to speak to everyone or water down what I want to say then no one would want to watch it. It wouldn't be worth it. You wouldn't care. An audience of Black women is not a small range of people. It's a huge population that's incredibly diverse, millions of human beings from different countries and generations and ethnic groups. It lets me know what kind of story I need to be telling and how to tell it. Keeping the audience member in mind is important. I've had to suspend belief and put myself in the shoes of random white male directors my entire life in terms of making anything for a little Black girl from Texas, you know? I'm sure they're happy that I'm watching and I so love good films. I like the work of Martin Scorsese and Paul Thomas Anderson. I like the work these folks are doing. But they're not really concerned about whether or not their work floats my boat or whether or not I'm being transformed by their work.

In my short experimental film called *Giverny I (Négresse Impériale)* where the footage of myself and that of Diamond Reynold's video is juxtaposed I don't show Castile's body and that was very important. I don't show dead Black bodies in my work. It's not necessary in order to get the work across. It's not necessary to show a dead Black body in order for the work to resonate with people emotionally. It's, in fact, re-traumatizing and it's a violent act that's been in practice in America for decades going all the way back to photographic postcards of gruesome lynchings that were then circulated and sold as souvenirs. So I withhold this. This is a deliberate act of refusal. How do I know to withhold this? Because I'm talking to Black people. My audience doesn't need to see Philando Castile bleeding out in his car after being shot by the police. We already know what this scene looks like even if we're not looking at it. Why? Because we've seen it so many times before in so many different iterations and time periods. Now folks have to sit with the sound only, the audience has to do a bit of work now to fill in that blank, which means they have to contend with their own personal relationship to state violence. I don't need to re-traumatize Black folks in order to make some sort of statement. So, thinking of my audience and being specific about who those spectators are keeps me grounded, focused and on task.

I decided to use archival in an early graduate school assignment, even though the point was to do a very basic exercise for grasping the techniques they taught us for interviewing, lighting, and cutting. So, yeah, I got that part but I'm also going to throw in some ethnographic material from the past because I wanted to make a

statement in the film about Leigh's work. That what's happened in the past is still very much at play in the present, this conversation between Black women's labor practices now and Black women's modes of labor from the mid-twentieth century. For them that was a bit much because here was someone who wasn't that interested in following directions. That issue could take precedence over whether or not the work was going to be supported, you feel me?

But also fortunately for me, I had professor Michel Negroponte. He attended MIT and he studied under a lot of the forerunners of American cinema vérité. He was supportive of my engagement with the various modes and techniques of documentary filmmaking, but he's also really interested in experimental forms. He saw my interest and he gave me this long list of works to watch and books to read. So then I wasn't just being exposed to the curriculum that espoused this focus on cinema vérité and observational filmmaking. I was also learning about Trinh T. Minh-ha and Nina Davenport and doing my own research on William Greaves, St. Clair Bourne, and Marian Anderson. We were not exploring any Black folks' work either in that curriculum, by the way. So I had to go and expand my education while I was in grad school, to go outside that space and take various workshops and base my research around folks who were working in nonfiction—but not necessarily observational filmmaking.

It's important for me to interrogate notions around objectivity because of how it hides or mystifies imbalances of power in crafting the narrative while positing a certain fundamental truth. As a filmmaker, I'm the one holding the camera. I've chosen the subject and collaborators. And I'm making all these decisions and not a single one of them is neutral. The moment you decide who you're going to shoot, that's a decision. The moment you decide where to place the camera, that's also a decision. Standing in front of someone with a camera and walking away with the material and cutting it how I see fit includes a great deal of power and responsibility. I'm creating the terms in which the observation occurs and also deciding what parts of that observation are going to be seen by others. I reject that observational filmmaking is the truth being presented.

I'm really influenced and inspired by Black feminist thinkers like bell hooks. She wrote a seminal essay called "The oppositional gaze" and it's a strong grounding principle for a lot of my work. She talks about Black female spectatorship going back to the very beginning of television. There weren't a lot of Black people on TV in the beginning and those that were there were these over-the-top caricatures. When

everyday Black people saw this on television, we were engaging with a very critical gaze, with skepticism, parsing what we saw and not being accepting of everything that was being presented to us as truth and as fact. We saw these images as distortions that came from the white imagination. When I'm thinking about watching work and making work I'm making it from an oppositional gaze, specifically from a Black feminist oppositional gaze. This is a powerful space from which to create and a powerful space from which to gaze at the world. I have a *very* clear point of view. I'm not attempting to mask my position. In fact, my position is the point of departure.

PC: You made a very powerful piece in 2015 titled *An Ecstatic Experience,* a multi-layered video where you hand-draw animations over the images of the actress Ruby Dee's face. What was your point of departure in making this piece?

JG: What Ruby Dee is reciting is a slave narrative from Fannie Moore. In the 1930s, the Federal Writers' Project interviewed formerly enslaved people as an oral history project, taking down memories and experiences of enslavement. Here, Ruby Dee is doing a dramatization of one of these stories of Fannie Moore's where she talks about her mother's experiences on the plantation.

PC: As an actress Ruby Dee imbues those words and that story with her own reading or interpretation as your drawings are placed on top of Dee's image expressing your own nonverbal commentary. As the director, animator and editor you're, in turn, imposing something on this story. It's a beguilingly layered work.

JG: Layering is definitely the active word. While thinking about making the film I watched this footage repeatedly. It's about a thirty-minute long reel and I pulled out the Ruby Dee portion. I watched it over and over and also recorded it on my phone so I would always have a digital reference at hand. I wanted to become really familiar with what was being said and what was being emoted or transmitted before I began. There's the actual narrative and then there's the recording of the narrative and then there's Dee's interpretation of the narrative as performance. On top of that is my response. These etchings or mark makings are evidence of my emotional response to what I'm seeing and hearing inside the frame.

In the narrative, she talks about captivity, fugitivity, escape, and transcendence. She talks about moving beyond beyond the body. You see a halo around her head because I wanted to venerate her as an ancestor. I believe deeply in venerating these folks who have come before us, giving them their due. How often are you seeing Black people with halos around their heads? There are moments where she's behind

prison bars because she's talking about being a bonded woman. Engaging with the archive is my way of having a conversation across time.

PC: Your next project is a feature that needs to sustain a longer narrative arc, a project with larger breadth and scope. In other words, this longer piece will have its own language. Is it daunting to think about sustaining that over the course of a feature-length film?

JG: It's a daunting prospect, definitely. I will need to carve out this language as I go. Each project is quite singular, meaning the form is determined by the materials, subject matter, collaborators, et cetera. There is no formula and no two projects are the same, even if they're related or somehow connected. With this project I want to invoke something that has not been in a lot of the films that I've made up until now. There's a silence or stillness, a quietude that will be in this piece because that happens when I'm sitting across from my grandmother or my 85-year-old grandfather. There is a self-reflexive imperative with this work.

How long do we sit with things? How do we modulate and mediate the material? That's what I'm exploring every time I turn on the hard drive. It's a hugely daunting task because this is my first feature and I am trying to go against the grain in terms of how story is laid out.

PC: You'll have multiple storytellers within the film. When you look at this array of voices, do you have a sense of personal narrative that can include all those voices and your own specific ways of responding to them within the film?

JG: I have some idea of narrative, but it will be more impressionistic. The series of moments should act like memory or the telling of fables or tales. It's not an Aristotelian three-act story structure per se; it's more circular or cyclical and I'm always looking towards Black music, the Black jazz aesthetic, blues, and gospel. These musical expressions that are historical and deeply connected to Blackness and spirit are core formal models. It's helpful to consider that and to consider how memory works in how I want to structure the film. I'm interested in capturing what I felt at a specific moment or what my mother says she felt in a certain time period and then communicating that to the audience. In what ways are our memories inconsistent? How does memory shape the stories around us, the people we love, our sense of time, our connection to history?

PC: As you're going through this archive and figuring out what to add, what stories are bubbling to the surface that took you by surprise or that perhaps convinced

you that you needed to change course? Are your family members, both here and gone, speaking back to you in ways you didn't expect?

JG: I am *constantly* surprised by my family, both the living and the dead. [*Laughs.*] They're always kind of dropping these bombs on me. [*Laughs.*] You think you have an idea of who these folks are and then they tell a story that completely rearranges your reality. Sometimes I'm completely terrified, other times I'm delighted and gratified. I'm trying to remain open, courageous, curious.

PC: You grew up in a certain place and then left. In some ways you're extremely far from those origins. When you look at your own story, do you think of someone in the future being as surprised by you as you are by your ancestors? I find the most beautiful aspect of these family stories is the way the maker is somehow taken captive by the other stories that surround his or her own.

JG: I would hope that future folks that are a part of my line are surprised and inspired by the type of life I lived, the things I've left for them. I mean that's the whole point, right? For someone to see this work and be moved, to feel reflected, affirmed, emboldened. That's my hope. That's how I felt when I saw that first Super 8 home movie that my mother gave me.

It's strange because I don't necessarily see my family as subjects. I do see them as collaborators. I mean there's definitely still the power differential that I spoke about before. I'm collecting these stories, conversations and confessionals. I'm editing the film. I'm not discounting that. But in many ways it is really up to them. Are they willing to meet me in this place? What are they willing to share? What are they willing to give and receive? I feel I'm at their behest somehow, that I'm in service to them.

I can say, as we're making this, that one of the things we're really grappling with is the notion of trauma, the kind of trauma that can be passed down or imprinted on genetic material. I am looking for repeated behaviors and patterns. How did my behavior in the relationship with my first serious boyfriend that I was in love with mirror that of my mother and father's very tumultuous marriage? How does my grandmother's trauma affect me in my life? Does anyone else in my family struggle with mental illness in the same ways I do? Who else is touched by fire and is sometimes manic? Who is anxious or completely depressed? How many deal with alcoholism and addiction and how does it affect their children? How does my father's relationship with his father impact my relationship with him?

Some would call it epigenetics. My mom calls it a generational curse. How do we get to the root of these patterns that seem to repeat? Are we stuck or doomed to be in a never-ending loop or can we free ourselves? If there's generational trauma, is there also generational wisdom that I can access by uncovering these stories? Can I excavate the actual source of these wounds and also discover the antidote? These are all narrative concerns as well. It's not just about getting in these people's business. It's not about getting my mom to tell me all of the dirt about my dad and having my dad tell me all of the dirt on my mom. Who am I in relation to these people and can I free us up a bit to breathe and not be bound and constricted so much by our past and the violence of that past? And yes, it is also for the folks yet to be born. It is concerned very much with the future, as it's very much concerned with the past.

PC: There has been a constant socio-political loop in my lifetime that dismays and alarms me. This personal way of investigating the families and societies we're born into and the things we're given can also be somewhat of a minefield. Clues can easily be misread and messages misunderstood, particularly by those we trust to tell us the truth about the world and our place in it.

JG: The film is certainly about the larger world and as I mentioned before, because it's so specific, it *is* about everybody else, you feel me? When people from the organizations that have supported the work ask me if this is going to be universal, I say to them: You know, everybody has a mama. And if they don't, they feel some type of way about that. Everybody has a first love. I don't have to go out of my way to make this universal. This is a story of a woman self-actualizing. This is a story of an American family.

While we're looking at this one family, we're also looking at the arc of history. I'm talking to my grandfather, a man who grew up under some of the most egregious forms of white supremacy in Texas. When he was a boy, he was taken to the hospital to get his appendix removed. And they decided to stash his body in the basement until he died. He survived because his mother worked for a white woman. She petitioned that white woman to intervene on his behalf. Stories like this emerge. We're also talking about the history of the United States. We're talking about the human condition. To be alive means to suffer. To be alive means to struggle. To be alive means to be in love. To be in love means to be hurt or to be ruined by that love at some point. It is about the intimate, the hidden interior. That's the only way we can get at something larger.

MILA TURAJLIĆ

No one's thinking of the future. All we do is fight each other to rewrite the past.
— Srbijanka Turajlić

Imagine part of your country's history playing out right in front of the windows of your family's apartment. Imagine that within the walls of this family apartment, the events that helped to form your country from its very inception took place around the same table you've had breakfast every morning of your life. Imagine that during your mother's childhood, total strangers came into your apartment and sectioned off a portion of it where three other families would live from then on. Imagine that during your own childhood your mother became a powerful voice of revolution in your country.

Serbian filmmaker Mila Turajlić grew up in such a household, a member of a family that somehow destined her to making transcendent documentary cinema from Serbia's national film archives. The trajectory that led her to become a documentary filmmaker is one that could have moved her in many different directions, a political leader like her mother being just one option. The potential mantle her mother Srbijanka lays down before her daughter is a fraught one. In her luminous multiple award-winning second feature *The Other Side of Everything*, Mila intrepidly mines the lively Socratic dialogues that occur between her and her mother regarding what Srbijanka's generation tried and failed to do and what exactly this revolutionary legacy should mean to Mila's generation—if anything.

Her first feature film, *Cinema Komunisto,* tells the story of the defunct socialist state of Yugoslavia's life and death through the very specific lens of its old communist movie studios. Mila was able to mine the archive at the old Avala Film Studios, the MGM or Columbia Pictures of its place and time, a studio built in the 1950s by

the decree of Yugoslav president Josip Broz Tito. Marshal Tito also happened to be a hardcore cinephile and had mobile projectors follow him and his wife from their various residential homes, as well as on board his train and his ship. The leader hired Leka Konstantinovic as his personal projectionist and it is partially through Konstantinovic's memories of Tito that Mila recreates a profile of a country that no longer exists. However, in *The Other Side*, she uses archive material quite sparingly, rare and carefully chosen selections that are specifically meant to echo her mother's own memories as she shares them with her daughter.

Before departing from her home in Paris on a whirlwind speaking tour in November 2018, Mila and I spoke about the magic of waking up history to offset and enhance the setting for a mother-daughter tête-à-tête as they both step through the portals of the archive and personal memory—and eventually, move through the door that leads to the other side.

PC: It occurred to me while re-watching *The Other Side of Everything* that your love of working in the archives might come from your mother. She herself is an archivist, who has built a personal record of the family's history in Belgrade since the 1900s. The flat is a living, breathing archive of so much more than just the family's history. Can you describe your initial conception of the film in trying to hitch together all these treasures that you're finding in the archive in Belgrade and your curatorial process of that material? How did this conceit evolve of using the apartment as the sole space from which to tell the larger story of the history of your country?

MT: There were some things I knew when I started out and there were other things that were only discovered once we started to edit. What I knew in advance was that I wanted to try to make a film to create a space where there was a locked door and use that locked door to symbolize a country and its past using this idea of how politics shapes the personal, as well as this idea of a political frontline running through a private home. That was all part of the original concept. I knew in order for that to work, the film should never leave the apartment. I go into the hallways and upstairs to the neighbors', but only in that way do I slightly break the conceit. Once I had this concept of an enclosed space, the windows become really important not just as a storytelling device because they help you understand what's going on in the streets and what's happening in Belgrade today, but it's also this idea of inside–outside and how when you look at the outside world directly around you, it can inform what's happening inside the home. Obviously, Victor Kossavkovsky's

Tishe! was an influence and even though he was doing something else in that film because he's shooting out the window looking out onto the street, there is the idea of how much one can learn about the character of your country only from what you might be able to see from your front door.

Our apartment is quite strategically located in Belgrade. The building sits across the street from the British Embassy and the Italian Embassy but also on the opposite corner of the street is the Ministry of Defense building that was bombed by NATO. On the other corner sits the Supreme Court of Serbia. It's the political nerve center of the city. This is part of what I was trying to metaphorically suggest, that politically you're at the heart of what's going on but you're in a house, watching it all from a very personal, intimate perspective. Formally what I was seeking was something along the lines of Thomas Mann's novel *Buddenbrooks*. In the background is history being played out, but what's foregrounded is this chronicle of generations of a family. What's at the forefront thematically are questions of heritage, those achievements and disappointments and failures, this kind of transmission of the quality of a lived life. Even though German history shapes and influences the characters' trajectories, it's very much in the background. What I thought I might be able to do is some kind of balance of investigating several different historical periods in Serbia. However I ended up with a heavy accent on the decade of the '90s so a lot is skipped over, particularly the time of Communism. I worried that it would just end up being too reductive if I tried to cram it all in. It was also clear that in the space of one film I just could not address an entire century's worth of history. So I concentrated on the decade that encapsulates the main questions the film is raising—engagement, responsibility, the breakdown of the country and what you do as an individual about that. It's also the decade in which my mother found her voice and the decade in which I grew up.

What I didn't realize until we hit the editing room was that it wasn't just to be my mother talking us through this history. My editor Sylvie Gadmer and I were struck by the fact that we had to set a context for why this woman is revisiting the past. What she's saying are answers to my questions to her and those questions are very insistent. So the axis of the film shifted less towards being about her memories and more about me needing to understand something about how she formed her worldview and how that worldview influenced her decision to engage. If you listen carefully, it's actually obvious, this shift. I never put a microphone on myself because I never thought you would hear my questions. It just goes to show you how little I

realized it would be a dialogue, in fact. The film took on a whole new sense. It's not her journey or point of view through which you enter the story, it's mine, and it's a much more confused point of view than hers. It's a voice that can't find its place or figure out its stance. I think that helps the viewer come into the film in a more intimate way rather than through the point of view of a woman, my mother, who had very few doubts about what she needed to do and how to do it.

PC: "Moral courage!" is Srbijanka's cri de coeur. Several times, we hear her talk about this specific responsibility of her generation to the one that follows—meaning yours. Your family was an essential participant in Yugoslavia's formation. Do you feel the weight of that legacy? Or are you describing a more free-floating generational angst?

MT: Speaking on behalf of a whole generation happens specifically when she talks about being of the generation of '68 and how she resented her professors for not standing with the students as they protested. I kept that in the film because I wanted to situate her as a protagonist of a generation that was so much about how one individual's engagement can change things. It was the definitive credo of that generation, that if they invest in trying to create a better world, it's a worthwhile exercise. At one point near the end of the film, she fixes her stare on me and says, "I'm old now. It's your turn." And I respond that I can't and so then she responds that *someone* of my generation will. And we see that interestingly, it's not my mom who's pessimistic. It's me. Usually it's the youth that brings the energy and the optimism. She still believes that there's a fight worth fighting.

My generation saw that generation fail and maybe that's what's led to this state of being switched off for the most part. So I am trying to speak to something that is of catastrophic implications for us all—meaning that if you switch off and don't pay attention and think the news doesn't concern you, as my mother says, you wake up one morning and there's a war on and you have no idea how it happened. She does warn us about where we're headed precisely because we're not engaged.

When you ask me about what might have been personally weighing on me, I wouldn't call it legacy as much as I would call it roots. My mother is a storyteller and we grew up on these stories. There's a feeling in my house that it's full of ghosts. My great-grandparents were people I never met but it sometimes felt that they were sitting at our dinner table with us because my mom is so good at evoking their personalities and their stories. She kept them alive for us. It was the evening entertainment throughout my childhood. As you talked about this archive in the beginning, the

space is also filled to the brim with all of these objects that belonged to these people that I've never met but they're my ancestors. I grew up with a very strong feeling of where I came from and of being *rooted*.

Since the age of eleven, I followed my mom around and went to all of her public speeches and demonstrations. She would run all of her speeches past my father and so we were all a part of what she was doing. As a result, I never thought that what she was doing was very strange or very extraordinary. I found it quite natural.

I started making this film when I was thirty-three and I was thirty-eight by the time I finished it. Something happened in those five years that made me stop watching my mother as my mom and see her instead from the point of view of an adult. And then, all of a sudden what she was doing didn't seem natural or normal at all. When she was only slightly older than I am now, she made a conscious decision to speak out. I think that moment can only arrive when you reach the age where you face the question: Are you going to be one of those people that spoke up or are you going to be one of those people that checked out? Every one of us faces this. Everyone of my generation has to find our own answer to that question. So right in front of me I have someone who answered that challenge in a very unique way and in a very brave way. That is the question that weighs heavier on me than anything, perhaps, and that is where I do feel the weight of that legacy.

PC: She asks the question: What happens on Day Zero when the revolution has been "won" the day before? What happens next? She has a very dour view of revolution in fact, since she's seen it fail time and time again. The revolutionaries become the new regime. She and her cohort did change things—but only for a very short while so that it felt like a kind of dream. And then everything snaps right back in her face. But we do feel that she might be bereft at the thought that there might not be anyone to pass this legacy on to. Can you describe the evolution of how you became a documentary filmmaker from growing up in this politicized household?

MT: I remember the first time I cut school was to join a demonstration and I ran straight into my mom because she was leading it. [*Laughs.*] I got into a shitload of trouble but she let me stay with them. This led to a decade of intense political involvement. I joined the newly created debating club in Belgrade and ended up creating an NGO for parliamentary debate as soon as I finished high school. We created an NGO because at the time the government had passed a law that no one could criticize the government within the confines of the university. At least six or seven years of my time as a university student was as a debater and training and

coaching others in parliamentary debate in Serbia. I deeply believed in this space of public political dialogue and the potential it held. It was just a matter of teaching a new generation how to use that space to express themselves but more importantly the beautiful thing about debate is the search to find all the common ground you can with the other side. At least that's always been my strategy when engaged in debate.

When we had the revolution in 2000, I was twenty-one years old. I was very involved in the protest movement and the student protests. One year after the revolution, there was a one-year anniversary congress of the protest movement. At that congress, the movement broke into two with one side expressing frustration that as a movement we had stayed outside the political process and that the movement needed to move itself into forming a formal political party. The other side thought that if we were really going to stay true to the purity of the resistance movement, it could not coalesce into a party or any kind of platform that serves anyone's political ambitions—a kind of hippy stance, I guess. All of a sudden, I found myself in a no man's land because I didn't agree fully with either side. I began to see the very clear limits of political engagement.

There's a wonderful moment at the beginning of Yanis Varoufakis' book *Adults in the Room*. He's having a drink at a Washington bar with an important US political figure who says to him that there are only two options if you're going to go into politics. One is that you're going to remain an independent outside voice with autonomy to criticize anything and anyone. But you will never have access to the process or a seat at the table. Or, you can decide you want to be part of what is happening in the decision-making process that changes things, but then you have to become as dirty and compromised as everyone else at that table. You won't have the autonomy of an independent voice nor the freedom to criticize. I can't think of a better way to explain the moment I lost my political faith. I was studying political science and film production, the film production being just out of curiosity because I didn't know anything about cinema. My parents were both engineers. There was very little art in our household. Anyway, that was the time I just lost my compass completely.

Around that time there was a festival of women's cinema in Belgrade and in the space of one day I saw Agnès Varda's early film *Du côté de la côte* and her latest film at the time, *The Gleaners and I*. The first had been a commission from the Riviera Tourism Board but she ended up making an incredibly subversive film. That piece seen back to back with *Gleaners* was amazing. *Gleaners* is often interpreted in a variety of ways, but to me it's really a film about what it is to be a documentary

filmmaker—which is to be a gleaner. I came out of the cinema and thought to myself: *that's* a cinematic language I want to learn and be able to speak. I received a scholarship from the French government to do a summer documentary course in Paris and had another realization, which was that if I wanted to make documentaries that interested me, I would have to be in France, and so I started learning French. I was doing a master's degree at the time at the London School of Economics in Media and Communications. In the UK there's a very strong tradition of factual television. My first internship was with Paul Mitchell who was one of the directors of the BBC series *The Death of Yugoslavia,* the landmark political documentary series of my childhood. The quality of how they managed to get into the heart of what was going on in the war in the Balkans was extraordinary. So the UK felt like the place to be if I wanted to marry my interest in politics and work in this kind of high quality documentary television.

But after working on two or three series for Paul as a researcher, I began to realize that my creative heart was elsewhere. I wanted to make auteur-driven documentaries. When he offered to help me extend my visa to stay and work there, I told him that I was going to head back to Belgrade and make my first documentary, having no idea about anything. That's why from that statement to the finishing of my first film, *Cinema Komunisto,* five years went by. I mean the first thing I shot for that film, it never occurred to me to make any cutaway shots. I didn't really know what I was doing, but I had found my language. When I came home and said to my parents that I wasn't going to pursue political movements and that I was going to become a filmmaker, they were kind of shocked and a bit scared. They both come from very binary worlds as mathematicians and engineers and filmmaking, of course, is unquantifiable in any way. It was a world in which they couldn't give me any kind of advice or guidance. They didn't know how to help me navigate.

PC: This gathering of like-minded souls leads me to talk about the other people who entered the apartment while you were filming, your mother's cronies and lifelong friends. The lively scenes around the dinner table with arguments and debates and rehashing memories are so invigorating, wonderful observational scenes. The piece of archive you chose in relation to these scenes provides searing and profound echoes. We see people sharing a meal and arguing around a dinner table and then we see a mob of people on one side of an avenue, a mob of people on the other, just coming at each other like animals with sticks and truncheons. It's sickeningly violent and scary.

MT: You really touched upon something here. If we break down the structure of the film into building blocks, then the core of it are the dialogues between myself and my mother and then those window scenes which served as a leitmotif and literal breath of fresh air now and then. Then there are those group scenes. The third block is the archival pieces.

In terms of the group scenes, I really wanted to construct that space as the political salon it was when I was growing up. My earliest childhood memories are going to sleep and hearing the voices of the adults down the hallway arguing late into the night, high-spirited and intense political discussions. I wanted to use this idea of the political salon as a way to give voice to all the different points of view in Serbia, but not just so you could receive some kind of primer on the political currents in the country but much more to show that there is a place in which it is possible for people to be on different sides of a very deep political divide—to say someone's pro-war and someone's anti-war means these are two people inhabiting two completely different worlds. And yes, seventy years on, these childhood friends are still able to meet up once a week around the dinner table.

I really wanted to say something about the nature of the world we're living in today with this. Two opposing sides no longer have a space in which they can talk in this moment. I see this in Europe and I see it really strikingly in the US. There is simply *no more* public dialogue. One side treats the other as stupid; the second treats the first as arrogant. There is absolutely no space between two people who disagree where they can engage in a discussion. But I grew up with that and it *can* exist and it does exist. I grew up in a home where that is possible even though I grew up in a country where it's not.

There's obviously a lot at stake when you decide you're going to film people who've known you since you were in diapers. They've been invited by your mom for dinner and don't necessarily know that they're entering a film set. And I can say I *totally* abused the fact that they've known me all my life because there's so much trust there. I never really asked their permission. They would show up and the camera would be there and they'd ask why and my mom would say, oh you know she's filming one of her things. [*Laughs.*] I'd hang around and I found that what tended to break the ice was for me to interject something now and then so they would know I was listening. They don't have a problem looking at the camera to speak to me. I know what most people might aim to do is become invisible but I just really wanted to blend in as just another person participating in the conversation. It works really

well for the form of the film since I also talk to my mother off camera most of the time. I will say it took a long time moving around with the camera and tripod to no longer upset the flow of things. But after three years of that, not a single person around that table, myself included, actually believed that one day there would be a film. It became a bit of a running joke that my poor family would have to sit through hours and hours of my footage like someone's endless vacation photos. It didn't necessarily bother me because it lessened the threat of a camera in the room.

PC: In the midst of this cozy domestic atmosphere, you pull in quite devastating pieces of old footage, very particular things that concretely echo what's said in the room before we see them. Were those moments scripted?

MT: Yes, it was part of the scriptwriting process. I look for my archive before I shoot my scenes because it informs how certain scenes play out. I tend to do three or four rounds of archive research because in some cases, what I shot informs a new search for things I want to find. The episode with [Vinko] Hafner's finger is a good example of that. I only looked for that after I filmed that scene where the conversation they were having evoked Hafner's pointing his finger at [Slobodan] Milosevic.

I don't have many rigid ethical dos and don'ts in documentary filmmaking, but I have a very strong point of view on the ethical use of archive footage. There are many documentaries from the Balkans that I have real issues with because of the way they use archive. There is a kind of pornographic value of what's in the archive as far as war footage goes and it's often used indiscriminately and irresponsibly. If I'm in the logic of making a film that never really leaves the confines of my family home and has this idea of what one Serbian family could have observed from the windows of that home in this particular period of time then *obviously* I'm not going to be showing you the field of war in Bosnia or Sarajevo because we didn't see that. This film is not going to tell you the story of the war in the '90s. And most importantly this film is not going to abuse the evocative power of images from the '90s to try and take you on some kind of manipulative emotional journey.

The archive of this film had to be used as sparingly as possible. I wanted to reduce it to between four and six key political moments where personal experience and the larger political one collide. The archive in that Hafner scene is from a television broadcast in 1987, an image that belongs in the sphere of state-produced, public record. I wanted to appropriate those images for private use. It appears pretty early on in the film and the first moment we invoke archive is the first time my mom tells you how she remembers that moment. And then you see it. I had a note from a

colleague about how that wasn't a very good idea: you're told about something and then you see it. It was felt that that was merely duplicating information. I felt that comment completely missed the point. What it's achieving is that it establishes my mother's voice as the chronicler of the past because what she tells you is what you then see happen in the archive. From that point on, you trust her as the storyteller.

Just as important is how it's edited because it asks: What is a public record? You see the image travel the distance from public history to private memory. The archival image travels that distance and now lodges within one woman's personal recollection of a moment that was emotionally stirring for her. It kind of explodes my mind because that's exactly where I think the power of working with archive lies. We can wake up those images and reappropriate them and re-question them and have them tell us about other versions of the lived past. There's something incredibly important for me. When the war began, my mom says she woke up to the fact that all these childhood stories she'd been told of women singing their sons off to war could not have possibly been true. And then we see the archive of those women in the Parliament begging the government to return their sons from the army. I wanted to illustrate that we're not working with history now. We're working with memory.

What I want to emphasize though is that I really wanted minimal archive in this film. In something like this, you really need a key to the logic of it, the key that will unlock the reasons as to why those scenes are being shown and not others. Once I found that key it really helped me move forward with the use of the archive in the film. There is a voice of reason that speaks out that doesn't get heard because of the climate and the media hysteria of propaganda. It became easy after that to locate all those other moments in the film where I wanted to use archive because I'm going to show you those moments when someone spoke up against the madness going on and went completely unheard.

PC: I want to circle back to this other element that stays pretty much in the background until the final scene—the reality and the metaphor of the locked door and the quandary of whether to open it or not after your neighbor Nada dies. That neighboring flat—which was abruptly cordoned off from your own family's flat—is now empty after so many decades. Towards the end, your mother really opens up to you about this strange relationship with the "protected" tenant. In the film, Srbijanka discusses the reverberations of that moment when the government just barged in and truncated the family's living quarters and strangers moved into the space on the other side of the wall. Where does that end scene place itself in the trajectory of

your mother's narrative? It's a fairly anti-climactic ending, as it needs to be since it's been the elephant in the room all your lives.

MT: When I started shooting the film, the idea that that door would open one day did not exist, not even as a remote possibility. None of us ever imagined that we would live to see the day when that door could be opened. Nada had no successors, no children. If she had, we probably would never have gotten the other side back. Also, a law on the restitution of property was passed around the same time that she passed away that allowed us to do this. It was an incredibly unexpected thing. It was also something I had never considered as being part of the dramaturgy of the film. It was a very difficult moment for us because there was absolutely nothing triumphant about it mainly because the protagonists whose lives had been most affected by this were dead. In some sense everyone in that story is a victim of a larger history. My mother was very ambivalent about submitting the claim for the restitution of the property and that's the scene you see in the film when I argue with her. I heard her say over and over in real life and also on TV that you don't right the wrongs of the past by passing laws and introducing new wrongs. And then I watch her filling in the claim forms and so I accuse her of being a hypocrite. And she says, "Okay, no problem. Let's all renounce this heritage." And my sister and I object very quickly. [*Laughs.*] It's one of those moments when principle meets reality.

After Nada died, a year went by before we decided to open the door. Funnily enough, it was on a weekend and the date was the 9th of November 2014, exactly twenty-five years *to the day* that the Berlin Wall had come down. I realized that in hindsight but it's kind of unbelievable. And you're right; it was anti-climactic. We fade to black before it happens, but as my mom's walking away from the camera and says, "Okay, it's over," her next line is: "Let's close the door and go out to lunch because I need to wash this off." She doesn't even want to be in the space. And so we closed it again and it stayed that way for a long, long time. A year and a half ago we opened it up because it was decided that I would be the one to clear out Nada's apartment. It was very strange but I was the one that ended up organizing her funeral because there was no one else to do it. I didn't want her to have a municipal burial. When I went to the hospital for her records they asked who I was to her and when I told them she was our protected tenant, one of the nurses said, "That still exists?"

I filmed the scene but I wasn't really sure I wanted it to be in the film because my whole feeling was that if you do see what's on the other side of the door, the door's no longer a metaphor. It's just a door. It only works dramatically if it's evocative and

cinematic. Hitchcock's *Rebecca* was an inspiration for this film as well as for *Cinema Komunisto,* the idea that the power of something's presence is in its absence. So I did originally conceive the film where you wouldn't see the apartment. And you wouldn't see Nada either. This was a very, very long conversation with my producer Carine Chichkowsky but I realized that the stakes of the film weren't there—we weren't making something along the lines of Polanski's *The Tenant.*

Why is the film called *The Other Side of Everything*? I'm trying to say that the only way we're ever going to progress as a society and heal is if we can start a conversation in which there is enough space for our very different and very opposite experiences of the past. If that's what I'm truly trying to do with this film then Nada belongs in the space of this film. She is the other side of our story, just as our family's story is the other side of the official story. Her life was shaped by political circumstances and ideology just as ours were. I thought I might make a short companion film about her, which would be called *On the Other Side* and that would be her story.

But they're not supposed to be separated into two films. She has to be in the space of this one. And the scene in which it was ideal to discover her was the census scene. My mother is answering questions about identity and then Nada answers questions about identity to the census taker. Here is the moment when one can really realize all of the damage that is produced socially and politically by the reductive nature of categorizing identities. All of these people inhabit this very volatile space and none of their identities can be so simplified or so neatly resumed. When we start reducing our identities to these easily divisible categories, that's when the door opens for manipulation and nationalism. We're all so much more complex than that. It is only in accepting that complexity that we find the possibility for dialogue.

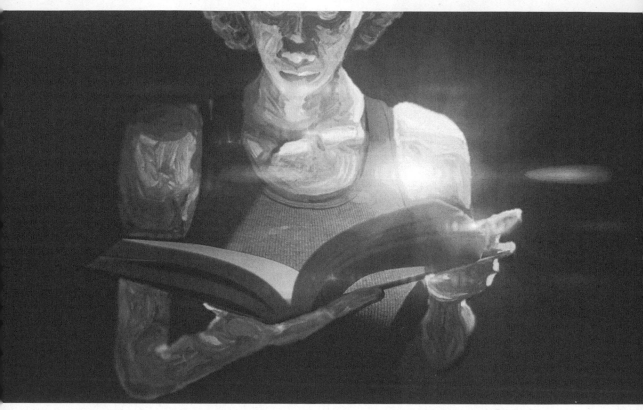

Still from *An Oversimplification of Her Beauty,* © 2012 Terence Nance.

Still from *An Ecstatic Experience*, © 2015 Ja'Tovia Gary.

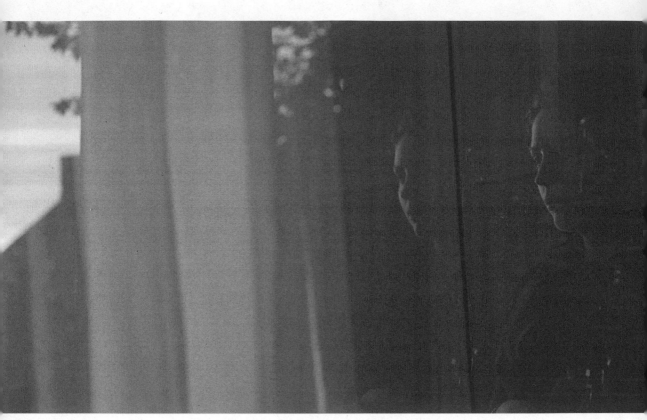

Still from *The Other Side of Everything*, © 2017 Mila Turajlić.

Still from *Man*, © 2016 Maja Borg Filmproduktion.

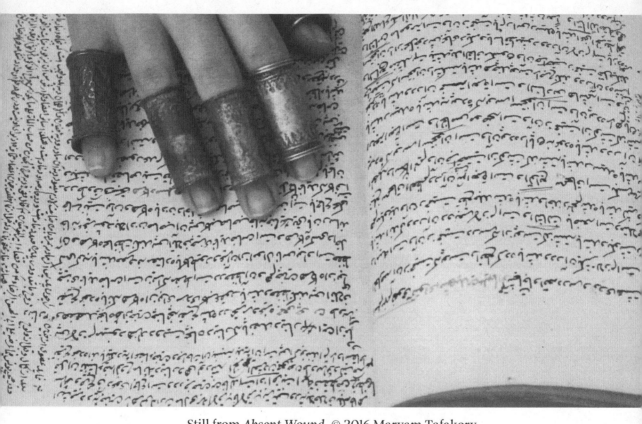

Still from *Absent Wound*, © 2016 Maryam Tafakory.

Still from *Collisions*, © 2016 Lynette Wallworth. Photo credit: Piers Mussared.

PART SIX

NOTES FROM THE INTERIOR

The four artists in this section—Ognjen Glavonić, Maja Borg, Maryam Tafakory, and Samira Elagoz—use personal interior journeys to craft first-person accounts, told specifically from a female sensibility and point-of-view. Women, being the looked-at or gazed-upon objects since time immemorial—or else rendered completely invisible—have had to learn to objectify, then re-subjectify, and finally write ourselves into existence on our own terms.

OGNJEN GLAVONIĆ

In his brief filmmaking career, Ognjen Glavonić has made not one, but two works of nonfiction that defy facile labeling. This is an artist who never planned on making documentaries at all. In fact, his latest nonfiction work stems from his research for a fiction script he's written titled *The Load* about a truck driver who becomes an unwitting participant in the cover-up of a mass murder. But during his research, Glavonić was flooded with articles, documents, and tribunal transcripts from The Hague and Belgrade Special Court that recounted the discovery of mass graves in Serbia and was compelled to dig much deeper into how that discovery came about, in the process creating a profoundly moving ode to the silenced victims.

These mass-grave sites located in Batajnica, a suburb of Belgrade, were found in 2001. They contained more than 700 human bodies, first exhumed from the ground in Kosovo amid the chaos of the NATO bombing of Serbia in 1999 and then transferred by freezer truck to secret locations in Serbia where the bodies were then reburied. At the beginning of *Depth Two* we see a rapidly flowing river set against vertical walls of rock as a man's voice intones, "The police officer on duty informed me that in the Danube River, near Tekija village, a fisherman noticed an object floating on the water, something that looked like a truck's trailer box." So begins a heart-breaking postmortem about a deeply buried secret, one only revealed by the inevitable geological movements of nature and time. We discover that in matters like these, the evidence never quite disintegrates enough, that whatever remains through disappearance, fire, burial, and the ravages of time persists, eventually revealing itself to the generation directly following the one that perpetrated such crimes in the disorienting midst of wartime.

PC: You're still making the fiction film that preceded the conception of *Depth Two*. Quite often a fictional account is made from a documentary film or story, but rarely the other way around.

OG: I started working on the script for *The Load* seven years ago after I discovered two articles about this case by accident. One was about a driver who had not known at the time what he was transporting. The other was about all the objects and clothes found in the mass graves. I started the script based on those two texts, along with my own childhood memories of that period. I knew that I wanted a minimalist structure for the fiction film too, one character involved in a mystery. But it's not just about this character or particular crime; it's about *everything* that happened, about what one does with the truth when one finds it. Since *The Load* is a period piece and a road movie, raising enough money to make it has been a hard and long process. But as time passed, I found out more and more information, and the stories, ideas, and testimonies I had put aside started to grow and gain a voice of their own. That was the beginning of *Depth Two*.

PC: It's quite a baroque story, but there's a clear minimalism in the narrative structure. What was your research process like in terms of figuring out how you wanted to reveal the details? While much of it presents as a procedural, in the second part you take a detour into very singular terrain, that of one survivor's first-person testimony.

OG: I wanted a particular articulation of images of desolate places juxtaposed with aural testimonies of the eyewitnesses. I didn't want to reconstruct the event itself, but to structure the narrative as a sort of thriller by providing traces of the larger story. This gives the audience a chance to connect it all together, enabling the film to speak directly to their senses, imaginations, and emotions. In making *Depth Two*, I knew I needed to be really precise and correct, because I was so fed up with the stories we are surrounded by here in the Balkans, not just in Serbia but also in the entire ex-Yugoslavian region. There's a persistent sense of competition to win the championship of who is the bigger victim. Being the victim gives you an excuse not to deal with your own crimes. So even though I'm using a story that happened in Kosovo, the responsibility for it came directly from the regime and from people still walking around the town in which I live. I wanted to approach it without trying to find some alibi or any kind of neat correlation. It's really important that my colleagues, the filmmakers from all Yugoslav countries, turn their cameras toward themselves so as to dissect and question what really constitutes our recent history. I don't believe in

collective guilt; however, I do believe in the responsibility of the collective. This film is about dealing with the responsibility of a previous generation, the generation of our parents, and it's a reflection on what that does and means to our generation today.

PC: The journey through the film becomes one of constant discovery for the viewer, moment by moment, as bits and pieces of the story coalesce. Is this mode of discovery similar to yours as you collected more and more information?

OG: Yes, in a way. Initially, I only had access to this material through transcripts, and I read a ton of them. And even though I never planned to make this documentary, I started to dream some of these stories I was reading. They started gaining presence in my imagination. I started seeing the river and the mountain landscapes where the truck bed was found floating on the Danube. For this film, we shot for only ten days, but the edit took eleven months. Eventually, we ended up with around 350 hours of testimonies. One of the producers of the film, the Humanitarian Law Center, has the entire archive of the Hague tribunal. We received around 400 DVDs of video material related to the case. There were testimonies from three separate trials between 2002 and 2011 and the technology changed a lot during that period, so the sound quality improves over time.

I first envisioned this film in black and white and with much longer shots. But I kept uncovering material and couldn't see making something too experimental in this case. I counted on finding the people who would be willing to speak out and then based the film around their stories. But the only person who would speak to us was Marko Minić, a man present at the exhumation sites near Belgrade. When I realized no one else would speak to us, I decided to go to all the places connected to the crime and see them for myself. One reason for this was very practical and that was to scout locations for the fiction film. The cinematographer Tatjana Krstevski and producer Dragana Jovovic are working on *The Load*, as well. So we went on this shoot without really knowing what kind of film we were going to make. But what really set things in motion was getting permission finally from the Defense Ministry in Serbia. They gave us access to the special units police base where the mass graves were located. They gave us a specific date and time to come and that was all we were allowed. This forced our hand before I even had the film figured out. We shot there the same day we interviewed Marko.

PC: In terms of audio, you very carefully curated the voices. Would you elaborate on this middle section, the testimony of Shyhrete Berisha? Her testimony is particularly bone chilling because it's so specific, even though we understand her

story is representative of many similar stories. She tells us the people involved in her persecution and that of her family were people she grew up with, people she knew, neighbors and acquaintances.

OG: Upon reading her transcript, we realized Shyhrete Berisha's testimony would be the heart of this film. All the other stories would have to surround hers. I'm interested not only in the narrative of what happened, when, and how, but also in the particular voice, the small details, background sounds. The places where these crimes happened look similar to one another, as they are similar to that place of connection between them all, the mass graves. Every location leads there. Every story ends there. In many of these places, even today, there are no signs, no monuments, as you said, no indication of what happened, even at the spot where the mass graves were found. The way the story is told is as important as the story itself, so when I discovered these voices I then figured out how I was going to make the film. The viewer is asked to be my co-conspirator. The film is a seed. You are the soil and if it grows it becomes a part of your imagination. Then you must decide what to do with it.

PC: The evocative way you end the film speaks to that idea quite literally. It's also a distinct stylistic shift as all the voices drop away and we enter a more experimental realm, perhaps closer to the way you originally conceived the film.

OG: Yes, yes, exactly. I needed something concrete and graphic as an anchor to the more abstract elements. That's why we used real objects and clothes dug out of the pits, showing them only after you'd had time to imagine them going through water, fire, and burial, what the passing of time has done to those objects and to imagine the people to whom all those objects and pieces of clothing belonged. This is the story of a regime trying to bury the truth, to bury the fact that these people were ever alive, that they existed. The civilian victims today are forgotten, completely ignored. The way in which I shot the end is meant to speak about them in a different way and that is to distinctly *not* use them as they are used in daily, para-political quarrels as victims are often used here whenever some politician feels like competing with another. The point is to give them a voice while not denying or stripping them of their truth. In Kosovo, this is also important because not many people know about this story. When we showed this for the first time in Prishtina, Kosovo, Shyhrete Berisha was there. The only thing she said in response to the film after watching it was: "Now I know that I am not forgotten."

I owe an incredible amount to my editor, Jelena Maksimović. One of the early versions of this film was five hours, full of archive material, with a lot of politicians speaking. But we made a list of rules that we decided to obey. One was to only use the voices of the people who saw these things with their own eyes, touched them with their own hands, the ones without any reason to lie.

PC: Let's circle back to this notion of collective responsibility. Even though you had read through the testimonies and knew the case well by then, here you and Jelena were, two Serbs, sitting with all this material, day in, day out, for close to a year. For you, what precisely is this legacy you referred to before, this burden that's been left to your generation to deal with?

OG: This film goes against the already institutionalized way of seeing things and the institutionalized logic behind all the things that happened in the '90s. All the countries created from this war were created based on similar crimes. When you speak about something that not a lot of people want to hear or that the country did its best to hide, even when you speak about empathy in these circumstances, it is considered a rebellious act. I could even say it's a blasphemous one. This film is a fight for a new kind of logic and a kind of communication that is not common or very visible here, not just in daily politics and public life, but also in art and education. Yes, being an ethnic Serb and making this film is a political statement, but it's precisely a statement about ethnic divisionism, nationalism, nationalism's myths, and the resultant destruction and hatred that's been installed and perpetuated in my lifetime.

PC: What remains then from this uncovering is the truth that cannot be denied. While you set the challenge to the viewer to participate, you do present an airtight narrative.

OG: The unearthing of these truths is now more relevant and important than ever because these events happen when fascism is allowed to blossom. It always leads to the pits, to the unmarked graves. It's important to say what that does to humanity. It is possible to shake up, if not defeat, accepted logic with facts, with the truth. The *only* way to fight back is through the patient and persistent explanation of truth.

MAJA BORG

Growing up in 1980s Norrköping, a small formerly industrial city in the east of Sweden, Maja Borg honed an artistic voice early. Maja collaborated with other directors as a cinematographer, producer, and co-director on short documentary projects throughout the 2000s. In 2005, at the age of twenty-three, Maja made *To She in Me*, an experimental six-minute film they wrote, directed, shot, sound designed, and edited, establishing their distinctive playfulness with a dead serious edge.

A prodigious writer, the texts used in Maja's film and video work are evocative of a condensed novelistic approach. They use language to access, investigate and then describe a life as it's being lived, posing self-directed questions about their emotional state moment by moment.

In the mid-2000s, Maja started writing what was to become their first feature film *Future My Love* (2012). The film would be the realization of a panoply of ideas about how to represent fresh depictions of non-heteronormative sexuality. An experimental documentary, *Future My Love* is a complex and challenging manifesto in which form and content mix to expose theses on the power plays in intimate relationships while exploring larger universal concerns. In *Future My Love*, Maja specifically focuses on the crisis of capitalism, its effects on the environment and the world economy, and how this free-floating global anxiety has leached into a personal crisis of toxic and potentially violent interpersonal relationships. During research for *Future My Love*, Maja stumbled upon the writings of 90-year-old futurist Jacque Fresco and decided to seek him out with camera in tow. He and his life partner, Roxanne Meadows, co-founded The Venus Project in Florida in 1995, a non-profit organization that proposed "an alternative vision of what the future can be if we apply what we already know in order to achieve a sustainable new world

civilization." Fresco's project called for a total redesign of modern Western culture in order to negate war, poverty, hunger, and debt. The film is made with a mélange of varying textures consisting of archival footage, black and white Super 8, and digital color formats, in part to show the long passage of time it took to finance and finish the film.

The year after graduating from Edinburgh College of Art in 2006, Maja made a 13-minute film called *Ottica Zero* through the Scottish Documentary Institute's Bridging the Gap filmmaking initiative. The short piece was a precursor to *Future My Love* featuring Nadya Cazan—who goes by the moniker N.E.M.—the love object in *Future My Love,* a woman who does not touch money and has taken a vow to never engage in any commercial transaction. Naturally Nadya resonates deeply with Jacque's utopian vision.

After making *Future,* Maja wrote and directed two short works around their desire to have a baby. *We the Others* (2014) is an 8-minute piece that describes the overwhelming choices Maja faced in choosing a sperm donor and their troubled feelings about the power they possessed to choose what kind of child they would have. *Man* (2016) is a 12-minute piece that documents Maja's pregnancy and the metamorphosis of their sexual identity as their body changes.

Maja's second feature, *Passion,* currently in post-production, creates a portrait of desire through two entities—the church and the BDSM community—that can only function successfully if a code of strict rules is in place and is adhered to. While also adhering to the rules of the game, Maja bids for a shift in perspective, presenting thoughtful and challenging notions that can't help but allow a spectator to more deeply inquire into his or her own personal strictures and limitations on embedded systems of identity.

PC: I'd never seen *Ottica Zero* and was surprised to see that it was the precursor to *Future My Love.* Can you speak to that sense of time in making one piece of work that is itself, in essence, time-based? Did that expanse of time ultimately help you dramaturgically find the way?

MB: Yes, yes, absolutely it did. Time is very much something that's needed, this slow kind of time you need for personal work. It's kind of a double-axis thing when you make films about your own process. This complete lack of distance to yourself is both positive and negative because, on the one hand, you have direct access to the experience; but as long as you are inside that experience, you don't have the

perspective to analyze it and by stepping away to get that perspective you lose the access to the experience. It's always necessary to find that balance, to leave enough space between the living and the writing.

PC: The self-trust you need to have on a consistent basis must be profound. I love the way you reveal your own trepidation about whatever journey you're embarking on or in the approach you've chosen. You leave the questions embedded in the work. Do you start with text, image, something from your past that's re-emerging in your life to get you going?

MB: I wish it were just one of those things. It's very important for me to write spontaneously during the process. And most of that time, I have no idea if what I'm writing has anything to do with the film. But I'm constantly writing. It's very much the kind of writing that comes from the edge of consciousness. I'm in the middle of something that has to do with living, not filmmaking, and then these lines come to me and I write them down. I then go back to these when I'm making a film and pick out some of these lines and then write something new that emerges from this combination. It's a *very* slow process.

For this new film, it's very similar to the process I went through for *Future My Love*. I had six notebooks of writing, as well as collecting things that have some relevance to the film. That adds a lot more. I wrote about one hundred pages and for *Passion*, I have almost one hundred fifty pages at this point. Then it's very much a dialogue with what's already happening in the images and the overall narrative and how that all chimes together. It's a personal process that goes on for a long time, even beyond the making of a film. As well, my brain is divided into the subjects of the things I think and dream about in English and the subjects I think and dream about in Swedish.

PC: Does fluency in more than one language influence the work?

MB: Definitely. I'm so interested in language and it's one of the things I return to over and over again in all of my films on one level or another. Our ability to think in one way is restricted to language but our experience can keep moving beyond language. It's a constant give and take or a constant movement between conscious thought and experience. Then there is the experience or gut feeling that demands language to expand. It's very liberating to learn a new language. When I started to learn English in a less restricted way by living in Scotland for a couple of years, I found it very liberating to describe myself and the world in yet another language. Some words could be more in-line with a certain experience.

PC: When you first encountered the writings of Jacque Fresco, how did you think about using his ideas as a hinge to talk about your angst about a specific relationship? It's a captivating way to approach this sort of micro–macro view on humanity, and also, I would imagine, quite tricky. Maybe unwittingly, Fresco helped to move your personal story forward in unexpected ways, even though it often seems the two of you are at odds with one another in how you see the world.

MB: That meeting and relationship with Jacque was also something that took a lot of time. Once we met, we spent a lot of time together. During the first trips to visit him in Florida, I just listened and listened and listened. It was important for Jacque that I received certain information and understood certain things before he could start to talk in a different way to me. He was not interested in debating about things he had spent a lot of time learning and I respected that. He had a lot of knowledge that I didn't have. I had to really do my homework and then we could talk. So in the beginning it was very much a student-teacher relationship before it evolved into a loving friendship. He was this incredible person and was so certain in his own beliefs that it wasn't in any way threatening to him that I saw the world very differently. [Fresco passed away in May 2017 at the age of 101.]

I was quite scared of showing him the final version of the film because it's very far from the semantic frameworks with which he was working. He had a very matter-of-fact attitude about things. A more poetic stance was confusing for him because it can be perceived as dangerous or be incorrectly interpreted. The most beautiful form of communication for Jacque was a blueprint because a blueprint will not be misunderstood anywhere in the world. I was a bit scared that my approach would in some way make him feel unseen. But he was very positive and was very happy that I was able to speak about all this in a very, very different way than he would ever speak about it. It was a huge relief. I respected him so much to be open to that.

In *Future My Love*, my story talks more about the feeling self and the thinking self is expressed more through Jacque. I appreciate that you picked up on the fact that they're not juxtaposed; it's more like they're bouncing off each other, often because they are paradoxical and that's very good, I think, when you find these paradoxes because that's a point of resistance where language can be expanded. This is something I'm working through in this new project, *Passion*, which is all about power relations in a very literal way. There's this kind of cognitive dissonance where your experience of the world no longer fits into your idea of the world. I suppose there are these dissonant points in *Future My Love*. You either need to change your

mind or you need to re-understand your emotions. There's a bit of a battle going on with these sides of oneself.

PC: *We the Others* is such an interesting point on the trajectory to making *Man,* as well as the current feature. From the very first frame you start to place these labels on yourself so you can work towards tearing them down. It's like the work that's come before has enabled you to move more efficiently to that place where you can start to deconstruct.

MB: *We the Others* came from being asked to make a short piece for *Dazed & Confused*, which was a magazine and art platform [now *Dazed*]. It was at a time when one of my best friends, Janet Booker, to whom the film is dedicated, was a key activist fighting for the rights of people with disabilities. She passed away last year. During my time at art school I was working with her as her personal assistant. A lot of my work was assisting her in political situations. So I've lived close to the politics of disability rights and my sister also has a school here in Sweden for differently-abled students. The school participated in that film because my sister is also active in these political questions and finds them important so it's been a part of my life.

This was also the time when I wanted to become pregnant and I was shocked at how many specific genetic choices I was asked to make when choosing a sperm donor. That situation was a bit of a wake-up call. I realized that we have so much power through technology, but I didn't really feel like I had been part of the enormous philosophical humanitarian questions that I felt like I should have been in order to make these decisions presented to me. It's probably the film of mine that has been exhibited the least. People are a bit scared of it. Tate Britain exhibited it with a live reading but I heard that there had been a huge debate about whether they were going to show it or not because of being unsure where the film stood politically. They were scared of possibly offending various communities working on behalf of people with disabilities. It's an uncomfortable film.

PC: It's too bad the work was received that way. It's ironic as well since you seem to be addressing exactly that kind of limited thinking when you're representing genetically "flawed" individuals. The language you use in the film, however, is quite explicit that this is a *personal* struggle facing so many choices of what kind of human being you want to reproduce. You say, "A lack of language is not my impairment—but one of your own."

In *Man,* however, language takes a backseat to explicit imagery where you are showing yourself manifesting as male in one set of scenes and then repeating those

scenes in the same manifestation except you're hugely pregnant. Was that film met with the same reservations as a film that featured protagonists with Down syndrome, or other disabilities and if not, why not?

MB: No, it wasn't. In *Man*, I use my own body and am exploring my own identity. That always makes it safer for someone to show something. My positioning in *We the Others* was as someone who would become a parent faced with these choices of basically who's allowed to live in our humanity. And I'm obviously talking about myself in *We the Others* where I'm talking about a future possibility where one could choose not to have trans children or homosexual children. I suppose it's not as clear in that film that I'm representing myself.

PC: What is so vital for you in making work where the first person singular is the vernacular of the narrative?

MB: When I started making films I had a very activist approach. At some point I realized that it wasn't working because it was just too contrived. It's not like I ever made a choice that I would only make personal films. I have tried to resist that a lot, but other people have always provoked me to involve my perspective in my films and in the beginning that annoyed me. I, too, wanted to speak with the universal voice of the most privileged. I'm not a cis man so therefore my perspective is important in terms of the subject matter. But that's kind of changed. I also had this fear of appearing too self-involved and egocentric and all of that in the beginning. But at this point I feel like my films are definitely not activist in that way but perhaps on a philosophical level, I'm making them in order to have conversations that I think we need to be having.

I don't think we are all that separated. The things that are deeply important to me are not just deeply important to me. I can make films about myself because I am very similar to a lot of other people because we live in the same world. It's a way in and it's a way to understand where I'm coming from. It's more important to be able to honestly describe *why* I think something than what it is I'm thinking about in terms of what type of communication and dialogue it will lead to. At the same time, I do think that self-representation is important politically. It's important to have different perspectives and that the person from that particular perspective must be the one to tell it.

We don't live in a world of equality, so some of us will have to actively give space to other voices and some filmmakers do that beautifully. This notion of wanting to support filmmakers that are not white, male, heterosexual and so on has come quite

far on paper. But in terms of what stories you're allowed to tell, that's still a challenge. The funding entities are still so self-censoring. If you don't want to tell one of these stories that we all already know, you need more time to explain it and the funders won't have the security of knowing exactly what it is you're going to make so they might not want to take the risk. You might want to say something that they don't agree with if they're from a different background. I sometimes feel like there's a space to be a non-cis man or not straight filmmaker and that will tick some boxes. But when you actually want to talk about the films that are from those specific perspectives, it's a different kind of challenge. I mean I honestly don't know how this current project will be received. A public gallery here was interested in including parts of it. Every four years they do an exhibition of new Scandinavian work and they select as broad a range as possible.

They were looking at my work and another queer artist's work and they really found it problematic that the images were sexual in nature. They specifically looked at both our work because we were queer artists and it's like, well, at this point what we want to talk about is not a coming-out story. We want to talk about these other things and we're being grouped together because of our sexuality. But we're not allowed to talk about sex! Ahhh. Yeah. But regardless, you shall see this new film in a year.

MARYAM TAFAKORY

In 2008, after studying mathematics and physics in Tehran, Iran, Maryam Tafakory moved to London. Barely out of her teens, she told her parents that she wanted to go abroad to study computer science, which she did for one year in Southampton and then promptly switched her studies to animation. To voice her dream of becoming an artist to very traditional parents was not possible at the time so she just quietly became one, self-taught, working solo in her studio, crafting personal stories about growing up as a young girl in the city of Babolsar in the north of Iran. It was an era of great upheaval in her country; she grew up in a time when Iran was in the throes of violent revolution and at war with Iraq. The people of Iran lived under brutally repressive doctrines and had to conduct their lives carefully in a pervasive atmosphere of strict religious fundamentalism, particularly targeted at girls and women.

I was five when I became a woman (2013), Maryam's first film, presents a metaphorical portrait of a young girl who shares her understanding of female genital mutilation and the rituals that surround it. That year she also made the ten-minute *Taklif*, funded by the British Film Institute and aired on *BBC Fresh*. *Taklif* consists of an inner monologue describing the life of an observant Muslim girl. Her most recent films, *Absent Wound* (2017) and *I have sinned a rapturous sin* (2018) have exhibited at many international arts and film festivals, *Absent Wound* winning First Prize for Best Short Film at DocumentaMadrid 2018.

When we talked in December 2018 during the nether days between Christmas Eve and New Year's, she and I took mutual comfort in a very rich conversation between two women who, left to own devices, are prone to go into hiding from the world to refresh ourselves with solitary pursuits of reading and writing.

PC: Your work thus far deals with a young Iranian woman's attempts at emancipation, ways to find and express her voice within the confines of the culture. Can you talk a bit about the atmosphere you grew up in and your growing understanding, once you came to the UK, that you would devote an artistic practice to tapping into those personal experiences?

MT: The country of Iran is very divided in so many different ways. It's manifested differently in each city. I am originally from Shiraz but we moved to the north of Iran when I was still little and that's really where I grew up. Shiraz, near the Persian Gulf, was a lot more of an open society than Babolsar, which is a small religious city. Everybody knew each other so it was easy to interfere in each other's lives. Parents needed to control their children so as to make sure the neighbors weren't gossiping. My family barely had anything. My father worked in a sugar factory and we were given a house inside this factory and it became my playground. So I was brought up with all this industrial equipment. I became obsessed with big metal machinery and still am to this day. Then, when I was about thirteen we moved to Tehran and I lived there until I left to come to England.

Living in the north formed my most vivid memories of how the Iranian system works, how those in power exert their ideology not by force but by this ingrained mindset of how parents conduct themselves and how they raise their children. It's justified in the name of protection. All of that is very much embedded in my work. It's impossible to ignore because as much as I think that my identity or my Islamic education or my religious upbringing are things I can now separate from myself and claim that I'm not religious or this and that, the truth is that it's impossible to separate myself from that part of me that has dictated years of my being. The more I try to separate myself from all of it, the more I associate myself with it. In my earlier work, I can say there were more unconscious decisions since I was almost blind to this fact. I always worked with my presence in my films but I was only partly present. I was self-censoring in a way. But it was only later I realized this. My Islamic education is part of my identity. It's under my skin. I can't just say I'm not a Muslim. I *am* a Muslim. That identity has been with me for over thirty years and it's impossible to undo. It doesn't matter how much Simone de Beauvoir I read, you know? [*Laughs.*]

PC: Various elements converge to describe disparate sensations that speak of absence or only a partial presence. Using material objects from your culture is part of the way you communicate ideas that are so difficult to articulate. We assume

these objects have meaning but it's a meaning that's deeply embedded in your memory. Part of the appeal of your works is their elusiveness.

MT: In terms of these absences or partial presences of me—in this aspect in which I exist but am never really whole—one thing to keep in mind is this background I was brought up in because I never experienced a time that was pre-Revolution. I was born in the middle of the Iran-Iraq War. This was the period where women completely disappeared, particularly from the cinema or any public forum. I was brought up with a cinema from which women were almost entirely absent. This was the case for advertising or anything in the media. I've written quite a lot about this because it speaks to my interest in cryptic forms of language. The material language you're talking about is where that comes from because as girls we could only speak through things; we couldn't say anything, just show things. We could touch things. I also like exploring the performative language of the absences and presences and devotional objects as well as the normal artifacts that have an agency that is charged with, perhaps, things from my childhood, or an idea, or a religious thought. I simply like juxtaposing these things.

There is no deep meaning to be gleaned from the objects used because when I was a child this was also a mysterious realm for me, this religious side of my schooling since the age of seven where we recited daily prayers and once a week we had Maddahi, Muloody, or other mourning ceremonies. We got used to these things from an early age and rarely questioned them. I was always puzzled by the details and the materiality of some of these events like Moharram, the objects that were used, the stones, the chains, rose water, blood stained headbands, the chants and the tears, the self-flagellation for the death of Husayn ibn Ali [grandson of the Islamic prophet Muhammad]. But as kids we actually often enjoyed some of these ritualistic ceremonies precisely because we had no clue what was going on except we were told to do these mysterious enactments, making playful but strange discoveries. Some of these rituals are used or performed in all my films. Because these are fragments of my past, sometimes I might start with an idea that I've had for a while, not necessarily an idea for a film but a thought that's been in me for some time.

PC: And what about the influences of what you saw and heard around you while growing up? Your most recent works beautifully reveal epiphanies about things that may have confused you when you were young.

MT: Yes, my most recent film, *I have sinned a rapturous sin,* came out of a childhood confusion so it was baking in my head for years. In Iran I used to watch a lot

of TV. We didn't have a computer or Internet until I was fifteen or sixteen. I used to watch channel four and it was famous as the channel that no one watched because it was all these religious figures advising everyone how to live their lives properly. I was brought up with these men telling me what to do and what not to do. I was so baffled by the ways women were portrayed because on the one hand many of these clergymen suggested that women are asexual beings, uninterested in sex and that all we want is affection, love, and marriage. Men are the sexual beings; they desire variety, and this is how they could justify polygamy. In Iran you can have four wives and as many "official-temporary" wives as you wish. Obviously, this can be seen as legalized prostitution but rebranding it allows them to carry on saying that we don't have such things. These "marriages" can be as short as five minutes or as long as one hundred years.

But then there were other religious figures suggesting that women are insatiable sexual beings that need to be controlled. One of the ways to control them is to have them eat lettuce or "apply vinegar to their underbelly equipment." [*Laughs.*] This same channel also advised men what they should eat to boost their libido—dates, figs, cinnamon, a whole list. There was a lot of emphasis on food! This contradictory stance on women puzzled me but I was used to it. I wondered though why these men couldn't make up their minds—are women asexual or promiscuous? That's an example that's a part of me that I've been thinking about for a long time. I'm very interested in how the personal can become a collective experience and therefore inevitably political. As much as my works are culturally specific, I try to reveal their universality. *Absent Wound* is very much about a girl's rite of passage into womanhood. Yes, the images are culturally charged but that bizarre experience is something anyone can recognize, this mark of menarche, the onset of menstrual bleeding. But the Iranian language is my only means of speaking about it.

PC: When men do appear in your films they are fragmented as well. You portray a young woman grappling with her place in society, but she also realizes the expectations placed on men, how trapped they are as well by the demands of a repressive society.

MT: A large element of juxtaposing these various images is that I'm trying to bring together a collage of materials that don't really function well together. I feel it can represent how we are all brought up, all the various projections of what's expected of us all. Of course, this becomes heavier in totalitarian regimes but I can see this in places like England as well. I don't think these things are specific to Iran

and other religious fundamentalist countries. And it's not just the women that have these false images and expectations of the roles we should perform in society. It's also men and they are boxed in, too, just as limited as women in a way. It's just that they're not aware of it because of the privileges that they're given and they become blind to their own limitations.

But there is an expectation of masculinity and what that really means in a society. I wouldn't confine that to Islamic society because I see it here as well. Even our drinks are gendered here. Many consider vanilla or caramel latte, whipped cream or wine spritzers girly and *threats* to masculinity whereas a double espresso can affirm your manhood. [*Laughs.*] There, however, it's a lot heavier with a history that is still functioning. Here, it's re-formed and changed, meaning however that only the surface has changed; the core is the same. I would say that here in Europe, it's a lot worse actually because you don't see the core; you just see the surface. It seems as if things have moved on, but basically they haven't.

PC: One of the images in *I have sinned a rapturous sin* captivates me but I don't know what it means or what it signifies specifically. There are shots of a man threshing bleached cotton by hand in bright sunlight.

MT: That man is a cotton carder and we used to take our pillows and mattresses to someone like him and he removes the fibers and beats them as you see it in the film. It's an attempt to rejuvenate the fibers. Essentially he's making a bed. The material part of everything I choose in my films is like this, representative. I didn't want a bed but a material part of a bed. A bed also has a contradictory aspect—on the one hand, it's a site where a kind of holy event functions, that is reproduction. On the other hand, it's a site where all these sins occur. The line between the two obviously is very fine in an Islamic or fundamentalist system. The cotton carder, for me, through his preparation and making of the bed, is manifesting this contradiction. But it's also about the fiber itself as metaphor for these kinds of systems and how they function. It's very subtle. It looks nice and it's peaceful and orderly, but it's also violent. I enjoy playing with that as some way to reveal things when I psychoanalyze myself, trying to go into the past and see why I like certain things. Why do I enjoy these things that I now recognize as violent?

I like controlling my compositions, which you can see very clearly, but at the same time it's kind of impossible because of the situations I'm in sometimes. So the editing is the last thing that happens and it's based on what I'm left with after I film. It's unpredictable. I did have the cotton carder scene in mind when I was writing the

text. I knew I wanted to film him very simply so that was straightforward. But most things I'm filming I can't control. I do enjoy that fact, even though it can be painful and difficult and I have gotten into trouble. When filming *Absent Wound*, they threatened to take my camera away and call the police.

PC: How did you get in there in the first place?

MT: Each Zurkhaneh or House of Strength has its own rules. In certain places they told me that there was no way I could go in and some told me I could come in but stay for ten minutes, stand at the back, and no filming. It was irritating because I found a couple of places where I really wanted to film because the set-up was perfect for the images I wanted. I would have full hijab and chador and my camera would be hidden under the chador so no one would see it. I stage everything very carefully and make them feel as if I'm one of them. That works to a degree so that they did let me in in this particular case. Some of the guys that were performing wanted me to take their photo. I didn't tell them I was filming so I had to have the camera at strange angles. That's why you see the images you do, just parts of bodies.

The security guards came and realized I had a camera so that's when they threatened me about calling the police. But the men who had made friends with me helped me out of the situation. I am familiar with that system so I always feel I can manage even if I get in trouble. Sharia law says the space there prohibits women. Literally, they say that a woman's breath is not allowed. After I finished filming, I was talking to some of the men, asking them why this was so. And they didn't know. They just said it's a tradition of the Prophet. It's not the Prophet's tradition. They don't know the reason. I'm used to that. I'm used to being told to do things and not given any explanation for it. My whole childhood was like that.

But that's not to say that sometimes things don't get scary. When I shot in the public bath, the guard let me in but he told me he'd have to lock the door behind me. The last night I was shooting, he locked the door and left. It was ten at night. It was in a part of the city that's in the south of Tehran and even during the day you don't see any women. It's known as a dangerous part of the city particularly at night, even for men. This guy fell asleep! I called him when I was finished and ready to leave. I had a flight the next morning back to London. He wouldn't answer. I didn't know he had fallen asleep so I panicked and thought he'd bring back some of the men and they would rape me. I was terrified. My feeling of control comes from knowing how the system works but at the same time, I know how violent the system is and that it would take a second for the whole scenario to flip and everything would just go

crazy. It is something I fear and I'm also used to that fear. My whole childhood had this kind of chaos all the time. When I came to the UK, I couldn't believe that life was possible without this fear. That was how my culture shock manifested for my first two years in the UK. A life without fear—is that even possible?

PC: This fear manifests in your refusal to concede to a lack of control. But we do understand through some of your body language that you're frustrated or even enraged. However, you never go wild. I think you now know that in Western culture, the way we deal with this embedded fear is the same but it's manifested quite differently because the violence is overt, not hidden at all, in fact. The violence you're speaking of is something boiling underneath the surface and is controlled by a regime that is in place to make sure it doesn't boil over. The kind of fear that exists there completely speaks to the female experience. We must hide to protect ourselves; if we don't we're vulnerable to attack.

MT: This thing that you say about me not going wild is really interesting. I always feel like there should be self-criticism in place and I do think I should go wild sometimes. It's important to go wild and it's important to get angry. For most of my upbringing, I was taught how to be sure *not* to go wild. I was taught to hide, how to stop, how to not say, how to never get angry because anger is a masculine trait. It is something I try to resist but I don't think I do it successfully. I can see in my work that I have a very conservative approach in a way. I'm very careful about what I say and how I say it. Basically, I'm scared.

The main reasons for this have to do with the fact that I would still like to be able to go back to Iran. If I do get into trouble and am on my way back to here from there, how do I justify that my films are not political? I have friends who've been arrested for almost nothing in the last couple of years. It's not just going to places I'm not allowed to go. It's also about the time when I'm getting ready to leave. Recently they've been having an issue with dual nationals, especially with Iranian-British and Iranian-Americans. So every time I'm returning I have fear. It's funny how you can leave a regime and its totalitarian system, but yet you're still controlled by it even miles away. I fear for my family. It's easy to underestimate the regime's control.

I completely agree with what you say about the West. Islamic totalitarian systems aside, more and more I'm becoming aware that similar things happen here. Women are raped and still blamed because they were wearing certain clothes or they were drunk or they were smoking or they were wearing headphones. In the UK recently the police warned women not to wear headphones or look down at their

phones while walking alone at night. You hear something like that and suddenly realize that this is no bloody different! The Western system can have a lovely pat on the back when everyone describes how shit it is for women in these "third-world" places. We treat you so well—don't complain.

That's a real form of violence also—to silence women by showing them how barbarically women are being treated in some other part of the world and then telling them they're in a safe place. Yes, it's safe if you don't go out alone and don't wear this or that. There are all these suggestions about "how not to get raped" but nothing about "how not to rape." It's much worse here. In places like Iran, it's all right in your face. You put scarves on women's heads and it's there. You can see it. Here, the violence is a lot more embedded under the skin so it's much more difficult to see and that means it's a lot more powerful and a lot more brutal.

PC: Has learning how to emancipate your voice in real life given you more confidence in your artwork?

MT: In general, I have to say no. I'm not getting more confident in my work. I'm actually losing confidence. I don't really consider myself an artist. I don't even know what it means to be one. I don't feel that I have the authority, let's say, to speak about the Iranian psyche or the Iranian experience or even the experience I'm having here in the UK. As I live in this kind of perpetual middle ground, I'm not Iranian nor am I British. I don't live there. I don't really live here. I'm not accepted there and I'm not accepted here either. It's not a complaint. It's just that I'm gradually more and more coming to terms with the fact that for the rest of my life I will be in this liminal space. Language is probably the most important thing that gives one confidence. I feel like I'm losing my Farsi and that I'll never acquire English the way I used to speak my mother tongue. I am losing confidence in my own routine in a sense.

What am I doing? What is happening in the world? And why am I making work? What's the use of my films apart from them giving me a voice in the only medium I have of speaking? Shouldn't I be more useful and do something better, help others? I start to see my own vulnerability in a lot of my work. It bothers me. I watch my films and am reading myself, reading how my thoughts got processed.

I told you I went ahead and re-edited *Taklif* recently and now it's an almost completely different film. I don't like the way I used to think so I'm changing a whole film just because of that. At the moment, I'm questioning just everything about my *being*. How do I step outside my own body, my own work? It's impossible. I'm writing about ethnographic research and documentary research right now, and there are

claims of representation, reality, proofs, the science behind it, et cetera—how easily all of this is taken for granted. How easily we forget our bodies, forget the body of the researcher, and how impossible it is to step outside one's insecurities and vulnerabilities and family issues. Then the research is presented as some kind of independent scientific output as if it's something separate from all those personal issues.

PC: Can you talk a bit about this new project please? I'm curious.

MT: I'm working on a very rough text for a film I recently shot in Kurdistan in Iran, a few kilometers from the Iraq border. I filmed a Sufi ceremony, one again where women are not allowed. The thought of performing in a site where my body is forbidden obviously isn't new in my work but this time I was much more prepared so the thought of "failing" never occurred to me. I managed to film some of the ceremony but far too many things happened unexpectedly. On one of their nightly rituals, I was caught and told that I had to leave. I was literally begging the men to let me stay but there was no way they were going to let me in.

I was in tears feeling as if I'd lost a child and was not allowed to attend its funeral. I was guided out and sent into the women's room in the basement. I sat on the floor, hiding my camera in my bag. A woman placed a cup of tea in front of me. Seeing my watery eyes, she asked if it was a family member that I had lost. I was silent and was ashamed of my tears all because of a research failure, especially when I found out that these women had gathered to grieve the loss of their father.

Little did I know that I was about to witness a female Sufi ritual, something I had no idea even existed. It happens every year behind closed doors and no one attends or even knows about it. Whilst performing this ceremony, the women's bodies must not be seen by the men so they are fully covered. It's only their hair that is unveiled because similar to male Sufis, hair plays a significant role in their rituals. I was the only witness. There was no one else there. Many come to watch the Darwish men performing, but not the Darwish women. So it turned out to be a productive failure and I was delighted that this was granted to me. Once again, a project became a very different creature in the process of making it. The filming is finished and I'm re-writing the text. It's a project I feel very close to. It's inside me. It's the only film of mine where I have no physical presence, but it feels the closest to me and has made me vulnerable and insecure about its completion. I'm trying to gain the confidence to finish it. Hopefully that will happen soon. Let's see.

SAMIRA ELAGOZ

I spoke with Samira Elagoz in late 2018 when she was home in Amsterdam on a short layover. She'd been traveling tirelessly for over two years with her hour-long performance piece called *Cock, Cock... Who's There?*, a one-woman tour de force that's taken large swaths of Europe and the UK by storm. Thus far, it's played in over thirty countries. The 30-year-old choreographer, performer and filmmaker had also just received a two-year artist grant from Koneen Säätiö (Kone Foundation) from her native Finland. The Helsinki-based foundation is an independent nonprofit with a mission to "make the world a better place by advancing bold initiatives in research and the arts." One could certainly call Samira's work "bold," but more than that, her film, theater, and installation work are artfully cunning, meticulously crafted constructions of one young woman's mission to free herself from the depressingly persistent constraints and stereotypes still caging the female of our species.

Samira's creative testimonies from the landscape of young modern womanhood are refreshing, unexpected, humorous, and deeply moving. The basis for both the performance and a documentary feature film, *Craigslist Allstars,* is her experience of attack and rape. In this instance, it was from someone she knew. Samira reported it a week after it happened but no investigation followed due to insufficient evidence.

Samira, who is half-Finnish, half-Egyptian, began deep research into the male versus female gaze as it's been manifested in cinema, the visual arts, advertising and fashion. And since she's of the social media age, she started her experiments by posting sexy photos of herself for virtual encounters on various dating apps so that she could "experience men experiencing me." She then asked certain men of her choosing to make videos for her just based on the profiles she had posted. The responses ranged from one astonishingly limber guy managing to get his mouth

around his own member in an act of autofellatio while staring straight into the phone he was holding at arm's length, to faux-romantic proposals consisting of all the things they would like to do to Samira given the chance to meet her in person. As she moved into development for the film, which would be her 2016 graduation project at Amsterdam University of the Arts, she used Craigslist to post ads to find men who would be willing to invite Samira into their homes so she could film their encounters: "Hey, I'm a 24-year-old girl making a short documentary film, and I am looking for strangers. The concept is—I meet you in your home and film how we get to know each other. There are no specific directions for you. We shake hands, the camera is on the table for you to use, or me. It is quite open, and will be a different experience with each of you. I hope for many contacts. Msg and I'll give you more details. xo" After recording a series of encounters in Amsterdam, Samira continued her field work in Berlin and then Tokyo. She says that, "Almost all of them wanted to present me with a skill."

Not surprisingly, the work Samira has done and the way she's presented it has not always been warmly received, either by men or by women. Because as we discuss, there are certain rules or ways a woman should act after being attacked or raped, which include the task of comforting and reassuring the people around her who are traumatized by her trauma. This is to be done while also maintaining attitudes of intense fear and intimidation. As well, one should put the fact of one's very existence on ice. For isn't being a living, breathing sexual being—a girl who just wants to have fun—how this trouble got started in the first place?

PC: Let's start with one of the statements you make in your intro to the show: "There are certain rules or ways you should act after being raped" to console, comfort, and reassure the people you told about it, specifically friends and family. What's at the heart of that statement is something we know well, that the responsibility of a sexual attack on a woman generally lies squarely with her and not the perpetrator.

SE: What I've learned from audiences who have seen the show is that, yes, this is a very recognizable thing, the way friends and family might receive it. Some people also say that they feel I'm not supported enough. However, these segments with family and friends were shot a full year after the attack. *Of course* my family and close friends were there to support me after it happened. What I'm asking from them one year later is for a very honest reaction about how they first experienced the news—how was it for them? For me, their honesty is a sign of friendship. I'm

not a person that needs to be petted and consoled. I appreciate honesty more than anything. The work emerged just on the cusp of the #MeToo movement. That movement changed things. There are some aspects of the performance that seem really obvious now, but a couple of years ago, they didn't. I began working on this in 2014 and there wasn't #MeToo yet. There also was not a touring live performance about rape that I was aware of.

PC: The #MeToo movement, such as it is, is a bit of a letdown in my opinion. Like most social media movements, it lost steam very quickly. You take your story and investigate all the complexities imaginable. There is nuance in the writing as well as in the performance to which nothing I've seen come out of that movement comes close. I think #MeToo ultimately failed the people it was meant to help. It was asking women to publicly confess, to share their pain so that we could all heal together—a universal purge.

SE: I agree. For me what's missing are all the contradictions. Most of these rape stories were about this certain type of victimhood, how women are completely destroyed. Making this certainly was not about me wanting to relive the event so much as expose all the actions one might take after rape. I felt like I'd never really seen that happen, where the victim had any sort of real agency. Because there was nothing I could identify with, I wanted to share my own story. I find it odd that people have expressed that what I'm doing is an unconventional way to deal with trauma. I mean, what would be a conventional way to deal with trauma? In terms of my family and friends, the project was conceived originally to just deal with them and their reactions with this idea of celebrating an anniversary because a year had passed since it had happened. I jokingly said to a friend that we should celebrate this day so I asked some of my friends to send me a video greeting like you do for any other kind of anniversary. Humor was at the core of this from the very beginning because it was another way for me to deal with it.

PC: You take this all the way back to when you were fourteen or fifteen. You're part of a generation that grew up online. You were able to present yourself the way you wanted and were able to ostensibly possess ultimate power in how your persona was created—however close or far it might be to the person you are. We see the young teenaged Sam, a girl who, as you say, is "looking like she can take it hard since 2005." This is the age when you realize very clearly that you have this strange power over men. But then you go on to say that there's no greater threat to women than men, a contradiction any woman is fully aware of. We're encouraged

to sexualize ourselves from childhood. Society, including family and friends, helps us along. Without knowing about this rape, when I first saw *Craigslist Allstars* I really felt at times that you were putting yourself in peril, even when you explain that someone knew where you were at all times. At any moment, you could have been physically overpowered by any of these men. Even in the midst of a fantasy of representation and role-playing, things can tip over quite quickly.

SE: The safety regulation was very important. Danger was something I was never interested in when I decided to visit these men in their homes. Every woman is aware that when we're alone with a man, there is potential risk. Once I removed some element of that danger, I didn't need to censor myself in the film and that was very important. I talk about the film and the performance differently when I talk about them separately. But when you do look at them together some things emerge. For instance, the way my grandmother compares her experience of her attack and mine, a scene I use in the theater piece. She says that her experience had made her afraid of what is outside, or the unknown. My experience had made me afraid of what's close since my rape came from someone I knew.

For me, that whole idea of the stranger became less scary and with the camera, it became a way to create a laboratory for myself where I could still expose myself and be safe. I did not want to lock myself in my house and decide to be afraid. I recognized the risk I was taking but I built myself a space where I could play with that. It's continually frustrating to live in a world where I'm not permitted any fun, that it's somehow *my* responsibility to protect myself from men. That gives all the power to the predators and I've decided not to live like this. Rape culture is exactly about creating that fear in us, so that we as women will be afraid to take part in public life. This is not about "protecting" women. It's about controlling them.

PC: You must have had to decide quickly how you wanted to frame and what you wanted to show of these men in any given situation. There is a distinct narrative that builds from those first episodes in Amsterdam to those in Berlin and then in Tokyo. As you move from city to city, we can see you gaining your confidence back because the episodes become more and more playful, some of them delightfully funny. In the film, however, not all is revealed about what happened to you in Japan.

SE: Those scenes do accelerate and by the time I am in Japan the pace is even faster. There are multiple things happening at the same time. There is the issue of me becoming more and more curious about what it is about my femininity that provokes men. I find the meetings between cisgender men and women kind of pathetic

in their lack of communication. I've never had similar issues with other women or any other gender nonconforming people. But with men it can become very bizarre.

PC: The most touching aspects of these episodes is that in most of them, you end up dancing together and when people dance, their guard is down.

SE: I'm a trained dancer and so have had several years of training in body consciousness and movement and I worked with others who were also trained in that way. But I really wanted to escape that. I didn't want to work in studios anymore, nor did I want to collaborate with professionals. When I was listening to my teachers talk about what they'd done throughout their lives and compared that to moviemakers, I saw that people who make films move into the outside world and find their stories there, whereas, as a dancer, you're inside a studio all the time and you're constantly turning your gaze inward. The notion of choosing performers in order to train them as I wanted them to be felt bizarre to me. I wanted to let the men be as they are. It was just so fascinating to work without a script. There was nothing I knew beforehand so I was really collaborating with people I'd never met before, nor did I know the space I'd be in. I didn't know what the chemistry would be. The potentials of that felt endlessly fascinating. That was how I wanted to work and how I wanted to make my material, which was created in this process. I was curious about how people would perform as themselves in front of a camera and how the camera influenced their behavior. The most intriguing question was what would happen if the filmmaker is also inside of the film because that effects how the plots play out.

This relates to my background in working with my body because a main strategy I would always use is this performative empathy, meaning I would try to become a bit like them. It's hard to explain because it happens very instinctually and because it's not something I planned to do. But it was a way for me to understand them more, to step into their frame and be there with them. I didn't only want to stay behind the camera. I felt that that would disrupt any hierarchy that might take place if we were both on the same level, so I could try to understand them from the perspective of their world. I'm not neutral in these episodes but I also don't display shock at what they're doing or saying. I think it gave them a feeling that they can be as they are.

PC: There are endless portrayals in pop culture about the damaged, avenging female or the raped woman who seeks revenge. It's actually quite a masculine treatment of the topic. The woman has to become a warrior out for blood, whether she's defending herself or another woman that has been violated. Given this legacy and

expectation, for the performance of *Cock, Cock* how did you figure out how you wanted to present yourself as a "wronged" woman? You could have moved in many directions, but you insistently do not take a vengeful stance. Instead, you delve quite deeply into the psychology of what it's like to move through these various iterations of shock, anger, and healing. The climactic scene shows highly-sexualized video portraits of you with cum spilling out of your mouth, to my mind an incredibly emancipated statement given what's come before.

SE: It's also the part that many women—and also men—have trouble with. But for me, it felt like an obvious scene. I say very clearly at the end *I've gotten it all out.* It wasn't meant to be a provocation at all but a statement of liberation. But people have told me that they see the cycle of the performance as starting and ending in the same place. A Belgian woman, a #MeToo activist, was highly critical of this work. She felt that this was not at all how a work on rape should be made. She claimed there was no growth because she saw it as me just going back to the sexual image. But that was important because I didn't feel I needed to repeat the same feminist statement everyone's used to, that you shouldn't show yourself as a sexual being. It's not the accepted portrait of a rape victim. It's important not to have to justify that I can portray myself as a sexual being. Female sexuality is shown as something that's self-destructive almost everywhere we look. Another part of her critique was that I'm not as critical towards men as I should be and again, it was so important that I make a work about rape that wouldn't attack men. When you announce that you are going to be talking about rape, you feel the audience step back. My job is to lure them in so that they come back to me and then I can punch again. I worked extremely hard on the dramaturgical line of the show, the order in which I tell certain things. That took a lot of time because it had to be subtle.

PC: Another element that you flip on its head is the portrayal of certain men featured in your film work that you claim have this kind of sexual intelligence. These are men who identify as dominators, some even calling themselves sadists. They seem to be the only ones with the sensitivity to see the sadness and pain in your eyes even though you never mention the genesis of why you were doing this project when you met them. In their sexual life, they take on the role of the aggressor but they don't present nearly as aggressively as the other men who dominate you in more traditional ways.

SE: The majority of people misunderstand S&M or BDSM practices, perceiving them as just another aspect of male violence. I really loved those opportunities to

stretch this conversation and talk to men who do use violence and power in their sex lives. It's a setup that's completely agreed upon, kind of the polar opposite of rape in which there is no consent given at all. There is no other form of sexual expression in our society where you have to discuss this exchange beforehand. In "normal" sex, you fall into bed where there has been no discussion of rules and you're encouraged to go with the passion. I really respect this world of BDSM because it's all based on rules, discussion, dialogue, mutual decision, and safe words. That should be the way any sexual encounter works, really. It prioritizes consent and communication and listening. You have to connect first. In this performance there's so much information coming so fast, maybe those things move by too quickly for some people to fully grasp. If people do get up and leave, it's usually during these scenes. I just saw a film at IDFA called *Touch Me Not* by Adina Pintilie that dealt very nicely with this idea of consent.

I really do want to continue working in this way where I'm in the film as a character using people I've never met before as my collaborators but exploring other subject matter. It won't be me going to people's houses as I did in *Craigslist*. As fascinating as those first meetings were, it wasn't so strange anymore after a while. That's why I did this installation project about meeting strangers in public and kissing [*The Young and the Willing*] because this idea of meeting a stranger in his house became very familiar. I also noticed that I started looking for things that weren't necessarily there and it didn't feel authentic for me anymore.

PC: The only live actors you have on stage with you during the performance are two Japanese people speaking only in Japanese as they help you reenact your experience at the police station to report the second assault. Once again, as you say in the show, it was someone you knew, someone you considered a friend. However, this time you decided to report it immediately after it happened. This provides another surprising turn in the story because while you do the right thing and go to the authorities right away, you show us that the humiliations encountered in the retelling of what happened to you to total strangers is yet another layer of victimization, part of the reason many women decide not to report an assault or rape.

SE: It became essential for me to have those performers with me on stage. That could have been another video clip. In fact, someone suggested I make some super cinematic movie about this police station episode. But it's a vital disruption in the show because I've set this pattern of me talking and then showing a video clip. The beauty of theater is the unexpected because it's happening in front of you and you

have to face it. On a darkened stage, you have to use your imagination. Using this theatrical element very much fit here. There are two documentaries running at the same time in the show, the one on film, where my past self might be emotive or confused, and the one on stage where my present self is gifted with hindsight and informed by contemplation.

As well, making a performance about rape, I felt that in order for people to listen to me I had to make sure that they weren't worried about me. I speak in a very neutral way when I address the audience. You see me in many different emotional states throughout the film. But then you come back to me here in the present as the narrator again. That was the way to keep people with me. Another colleague suggested that people would want and need to see me crying. For this particular work it would be mental to reenact it with me crying every time I perform it.

PC: I was hugely relieved that you don't weep on stage. [*Laughs.*]

SE: The point is to show that it's not touching me anymore. A work such as this can only be made when you have that distance. To be able to properly analyze yourself, that works like any other kind of personal history. That distance is needed to see what actually was going on. It wasn't like I planned to make these works five years ago when I was raped. Three years ago, I looked back and saw what I had been going through so then I knew I could make a work about it. It wasn't like I was consciously building up to this. But that neutrality is the very thing that bothers some people because they feel like they can't believe me. I was reading a text about how to talk about trauma on stage and it talked about this distant tone, about how to tell an unreasonable story in a very tidy and reasonable voice, which I found very fitting. It also offered possibilities for humor.

Objectively, you can look at this detached tone and think about how we always push women to deal with a rape, this alienation that is being forced on you. At a performance of the show in Israel, a sex crime lawyer had come to listen to my talk afterwards. A man was asking me how I could be so detached. Why didn't I feel anything about my story? She came up to me after to tell me that from her experience detachment is a very important part of telling the story. By the time a case gets to court, there is a certain detachment or maybe the victims don't feel much of anything anymore. But then the judge wonders how he can take a woman seriously because she doesn't seem to be showing any emotion. As a rape victim, you are the evidence basically. Your body is the crime scene. This lawyer told me that it is a very healthy thing to be able to detach yourself. For me, it was the distance of time, time

has passed and now I'm here to tell you how it was. I think this gives the audience some stability.

PC: I'm not a theater critic but I was aware of what careful costume choices you made knowing that very sexualized images of you would be up on a big screen behind you. And you naturally carry yourself as a body-conscious dancer with a lot of grace when you walk across the stage or sit in a chair. Your spine is erect and you exude confidence and power, the polar opposite of the stance of a victim.

SE: I remember one of the first notes I made when I first started making this: "Brutal content with elegant execution." That's how I wanted it to be. Or to tell a chaotic story in a coherent form—something like that. How could I pull that off? It's a very messy story in a way but that's also how I think about dealing with trauma. Most stories are handled in an either–or way and I like to see works where characters are unpredictable because that's how life is. I'm invited to many of these "female gaze" talks now and the conclusion I always come away with is that it's always in the character development and how complex or unpredictable—therefore realistic—the characters are that you create. Female characters are quite often one-dimensional. The sexy female characters don't have any resistance to the gaze of the director, the director usually being a man. If a female character is to be taken seriously, she's either asexual or older—you know, either the slut or the mother. I wanted to bring all the aspects of my life into the piece because I'm different with my family or with my partner or whatever other situation I might be in.

One of the reasons I decided to film only men is that I was really sick of women being there merely to have someone else's fantasy projected onto them. Now we're used to the female gaze turned inwards in a similar way with the selfie culture. That's great in some way because we're finally living in an era where women can control how they portray themselves. But for so long it was frowned upon when women used their own bodies in their art, even though it was perfectly fine for men to use women's bodies for their art. But more women can now claim that their body and their image *is* their art and they use their sexuality in a freer way. But for me, that was not really enough, to just look at myself. I couldn't find a female artist whose topic was men so I decided to become that artist. But I didn't want to do it in a way that would just be the polar opposite of the male gaze. I wanted to give men the freedom to create the portrayals themselves—as *they* wanted to be shown. I also gave them the choice to take the camera and gaze at me if they wanted to. Even though that didn't happen very often, I gave them that possibility.

PART SEVEN

THE EMBODIED CAMERA

"Drawing from the history of image-making as well as technological innovations, this course explores the possibilities of the embodied camera. We will consider filmmaking methods that activate our bodies and the bodies of others as we explore strategies that embrace the physicality and sociality of the filmmaking encounter." This is, in part, the course description for "The Embodied Camera," John Paul (J.P.) Sniadecki's film production class at Northwestern University in Chicago. I use it here to talk about the various possibilities of intersectional experiences when a body holding a camera reveals itself through the act of making. I love a breathing camera where through the slight rise and fall of the framed image, it's palpable that the person operating the camera and the apparatus itself have cohered, becoming the very manifestation of Vertov's Kino-Eye—the observer–participant.

ADAM & ZACK KHALIL

The Ojibway people make up the fourth largest Native American tribe over lands that spread across Canada and the United States. A once powerful and bountiful nation, the Ojibway are known for their sacred birch bark scrolls, legendary documents that contain prophecies along with the group's history, songs, maps, memories, and stories. Raised in Michigan's Upper Peninsula and currently making their home in New York, Indigenous filmmakers Adam and Zack Khalil (twenty-seven and twenty-four years old respectively) have been working on their latest project for several years. It's one they started with their mother, a scholar in their hometown of Sault Ste. Marie. Carrying on her legacy of documentation, they posit that the history of an oppressed people can be rescued from complete extinction by reclaiming their own narratives from the archives and museums that would have their people's history buried or hidden away, behind glass, perpetually confined to the past.

Since making *INAATE/SE*, Adam and Zack have started what they call "a public secret society (as opposed to an artists' collective)." Called The New Red Order, they are working with Jackson Polys, a Tlingit Native visual artist and filmmaker working between Alaska and New York. The trio's first commission was from Light Work. The film *Culture Capture: Terminal Addition* was projected onto the façade of the Everson Museum of Art in Syracuse, New York. They also built an expansive installation at the Whitney Museum of American Art in June 2018 titled "The Savage Philosophy of Endless Acknowledgement" and will present a new work in September 2019 as part of the film program at the Whitney Biennial curated by Sky Hopinka.

In February 2016, I spoke with Adam and Zack a week before the film's premiere as the closing night piece at the 15th edition of Documentary Fortnight at the Museum of Modern Art.

PC: I want to start with the title. Visually it's captivating, two Ojibway words juxtaposed with the dozen or so words it takes to define them in English. Can you talk a bit about the language itself, and how embedded that structure is in your work?

AK: *Inaate/Se/* is an Ojibway word that loosely translates to "movie magic." Most literally, it means it's a certain kind of movie. That's the most straightforward translation, but there's inherent meaning in every syllable of those words. So it does say in English that it's a certain kind of movie, that it shines a certain way to a certain place. It flies. It falls. It's describing the basic mechanism of film projection. And for us, this "certain way to a certain place" means returning home to Sault Ste. Marie, the spontaneous nature of the film's creation, and how we allowed the process to unfold. We followed it. The original Ojibway language has had to adapt and Ojibway academics now have this popular school of thought around the notion that every syllable is an action verb. Basically, the language describes a series of actions. And then there are the words that had to be invented, the title being one of them, describing the moving image. It's talking about the screen, the light in the frame, the 16mm film flying in and out of the projector.

ZK: I can give you a really funny example of this, which is the word "refrigerator." That was also an invented word and it translates essentially to "stingy box." The refrigerator allows you to preserve food so you don't have to share it before it goes bad. [*Laughs.*]

PC: From the beginning, the film presents layers of water imagery, a metaphor for the flow of life and spiritual connections between the generations that are described in the various prophecies. Then everything literally gets stuck when you start to talk about this "trapped culture," the appropriation of objects that signifies that there was once a great nation of people whose history is now relegated to things behind glass in museums, or other non-Native reliquaries that hold all of that captive, away from their origins.

ZK: That moment comes relatively early on and is meant to establish certain ground, a way to prepare the audience for the less conventional nature of the rest of the film. It was important to confront the audience with the impact of the consumption of Native culture by showing the museum and tourists on their Segways, then showing those objects in the archive, much of which had been sitting there for a really long time. We wanted that very obvious acknowledgement of how Native culture is consumed by audiences in museum settings.

AK: There's also an implication of some sci-fi narrative there. That place is the size of a football stadium. Our mother was getting her PhD at the University of Washington in Information Sciences with a focus on indigenous information ecology. Her stance was that information should be accessible and available to everyone. But something like *knowledge*, which is different from information, shouldn't be, especially when it comes to First Nations peoples, mainly because of how such things had been taken away from us in the past.

The people that took it wanted knowledge of something they could never have. It's just not accessible in the way they perceive it. So her work was in collaborating with institutions to repatriate ancestral remains and objects. And five years ago, she was documenting tribal library and museum archivists. That footage was shot at the National Museum of the American Indian at the Smithsonian. Basically, it's footage of the museum's cold storage. You might see certain objects that have a tag on them saying "chosen," and those are the objects now on display at the American Indian museum in Manhattan.

There was a Dutch banker named George Gustav Heye in the early part of the nineteenth century. He was a collector of Native American artifacts, almost in a kind of fetishistic way. He hired all these scouts across the States to collect anything Native. There was a 3" x 5" note card for each object with the name of what it was and the place and year they found it, which wasn't really useful information. So the collection that the federal government acquired from Heye is a mix of tourist trinkets and sacred objects. The museum itself has no idea what's what for the most part. Our mother was making this film as part of her dissertation, documenting tribal researchers who go into the archive to try to figure out what's there. I was an undergrad at Bard and she wrote me into her project description, so together we shot in the archives in DC. We also did video chat with family and friends back home to try to identify things. It was a very bizarre process.

ZK: The scene's inclusion in the film comes after Paul, the historian from the Tower of History in Michigan, informs us that he probably has our grandfather's canoe in their archive somewhere. Paul has just described how Sault Ste. Marie was industrialized and how the Native community was kicked off the land. But that building and space are incredibly futuristic, though it's meant to be from the perspective of the people whose objects those were, to a certain extent. The depiction of the space is cold and surreal, almost baffling from a human perspective, I would argue.

PC: There are so many sly ironic moments in your film where it feels like you're taking the piss out of traditional portrayals of Indians in the way someone might try to emulate what it *feels* like to be Native for a non-Native audience. What is this film saying in response to those portrayals we've all grown up seeing, particularly as they're represented in pop culture? Can you remember that moment when you decided there's got to be a better way to describe what the Native experience feels like?

ZK: So many of the decisions in the film, I could say, might have been reactions against what you're describing, those horribly realized, misleading, overly-romanticized or pitying views that are typically applied to Indigenous people. In terms of what we wanted to provide, it was a bit different since we're making work about our own tribe. So that's a good start. Avoiding clichés was important, of course. One of the things you might have noticed about the score is that there's no powwow music at all, no beating drums. Whenever I'm watching a documentary on Natives and hear that music come in, I sort of stop thinking. I already know what's being communicated to me. We wanted to challenge that directly and come up with something that had less of a view of the past and far more to do with the future, and with what it means to be Native placed in that future. So we had to think of creative and narrative ways of portraying things that had nothing to do with typical documentary. It's about the stories and genesis of the prophecies, but it's also about being in Sault Ste. Marie in 2015.

AK: There's this way that Native culture is projected out into the world where it's all about authenticating this lost past. It's something we even do internally within our own tribes, and it's problematic. It creates a big issue between tradition and culture. That's what the heart of the film is trying to address, to figure out how we move forward and keep this way of life, but also at the same time, how we can adapt. There are now some people thinking and writing about an Indigenous worldview as kind of post-Apocalyptic, in a way. We're trying to imply that narratively. But it's not the end of anything so much as it's a paradigm shift where we no longer have to always authenticate ourselves through some past history. That's why collections of Native art are very rarely contemporary. Instead, it's a tomb of anthropology and ethnography that's part of, and a result of, colonization. We just aren't allowed to be visible as contemporary individuals.

PC: I appreciate the way you illustrate the repercussions generated by brutal colonization. The film's language describes that adeptly and in such odd and unexpected

ways. Thirty minutes into the film, there's a scene that I found profoundly moving, the scene about the Indian school the Jesuits ran and all the horrendous things that happened there to the boys and girls that attended.

ZK: There are a lot of layers to what's happening there. The origins of that scene are from a Hi8 tape shot by our aunt. She was taking Ojibway language classes at a local community college. The language instructors would go on an annual field trip, and many of them went to boarding school or residential school when they were younger. It was important for them to show the people trying to learn the language about how and why the language was lost in the first place. Our aunt is in her seventies now but she studied anthropology and taught ethnography at Harvard for a while. So of course her approach is very different from ours in encountering this issue. We found her footage and by happenstance had the opportunity to visit this building as well and take our own footage.

PC: That story appears in the narrative right before a pretty significant tonal shift where you move from this simmering rage to a kind of psychedelic *Twin Peaks* mash-up of spirit quests and sweats, much of which is quite goofy and playful.

AK: In Ojibway storytelling and mythology there's this character called Nanaboozho. He's kind of a shitty, teenage version of Jesus. He's the first man on Earth and he's creating the way it exists by fumbling through it, messing things up, like the episode where he gets the Raccoon into trouble and ends up burning his tail and that's why it's bushy. Lots of wacky stories about Nanaboozho fucking shit up. It's the trickster element that exists throughout Ojibway storytelling and history, engaging both the sacred and the profane, turning things upside down and looking at them from a fresh perspective. It's necessary, especially when people are really lost and confused about what it means to be Ojibway in the twenty-first century.

ZK: Our mother passed away about three years ago and that's when we started working on this film in its first incarnation. So that's where you might feel the very personal grief and rage and healing and all that stuff embedded in the bigger story. It's a *very* personal film. It also feels like a completion of what she was doing with her own work.

AK: She was trying to dismantle the archive in hopes of repatriating these objects back to where they came from. But she was also looking at it in a very critical way, as this tool of colonization to keep our culture in the past, making it inaccessible, making it feel dead when it's very much alive.

ZK: To further elaborate on the humor of the piece and how that plays off the rage: humor is incredibly important for Ojibway or Anishinaabe people, as it is all across Indian Country. A lot of it comes from a very tragic place. That's especially true among Native communities. There's also another arc that is very typical: you're a teenager or in you're in your early twenties, and you're Native, but that's not a very important part of your life. Then you start to meet people who are searching for what it means to be an Indigenous person. You realize that this requires a renewed commitment and a necessary expending of effort to learn about your culture however and wherever you can. In the film, Adam and I are going through that process, as are Alicia and Darrell. We're all going through a similar cycle. You're confronted with a lot of things that will make you incredibly angry. So there has to be a healthy way to deal with that rage in order to continue to move forward. That's the role humor plays in the process, and it's the role it plays in the film as well.

PC: There's also a consistent conflation of religion and belief. It becomes really potent particularly in the last part where you talk about the decision to take on that mantle and figure out how much of your life you want to invest in these excavations of personhood, identity, and the ways you relate to the rest of the world. Almost everyone in the film talks about this. We learn, of course, that spirituality, religion, and modes of belief are accompanied by huge amounts of violence. How do you dismantle the damaging part of that and keep the part that's healing?

AK: That's a powerful question. Obviously there's a contrast between religion and how Ojibway spirituality functions. There's no source of authority. It's all localized. There are all these ceremonies we may or may not have lost, but we've been making it up on the fly anyway. I mean we've been told what to do, and we're still being told what to do even as we're maintaining those traditions. But they are changing. A basic tenet of the Ojibway lifestyle is to live life in a good way. That history of the Jesuits and Catholicism where we're from was only about trying to take people away from that kind of living. "Get in line. Assimilate." This has gone on since the 1600s. That segment with Wild Bill in the film, this recluse, this trickster, well, he's also a messed-up alcoholic. But he's still doing his thing the way that we've always done it. Not in the purest or best way possible, but he's continuing the tradition anyway.

ZK: When you're trying to reconnect with your heritage, and trying to decide how much to invest, and acknowledging that it's about encountering this fucked-up history, there does come a point where dwelling on it becomes something that does *not* help you out, nor does it for those of your community. For us, the process of

making this film was trying to deal with this. That's why the film feels so angry at certain points. We create this effigy of a Jesuit to burn. It's important to go through that anger and process it precisely in order to be able to let it go.

AK: And to show it to a wide audience is important because I don't see that in Native cinema anywhere.

PC: The film succeeds in line with your goals on so many levels because it feels so utterly human, as many attempts at this kind of "argument" distinctly do not. But as was mentioned before, sometimes we're hard pressed to know the difference between a trinket you can buy at the res shop off the highway in Arizona and a precious object used in an intense and meaningful way by the people who made it.

AK: We're smiling really big right now hearing this. One of the most important goals for us in making this film was communicating to multiple audiences by making things clear and explicit, but not in a condescending way. It's a conversation with three to six different groups at any given time: our tribe and Indian Country in general, but also to the experimental documentary world in New York City, the film world, and the art world. We want all those people to understand what it means to be Ojibway in the twenty-first century. And for us, this comes from movie magic and commercial editing. That means trusting what's happening when it's happening and then putting it through a meat grinder and working it over and over again until things really start hitting.

ZK: That's how all these moments we've been talking about came to be. For me, Darrell is such an important voice here. He's the first one to take the medicine. He's standing in front of the Tower of History exhibit, and we're hearing about how he was in the hospital where the doctor told him he would die before he was thirty-five unless he stopped his use of drugs and alcohol. That was a particularly potent moment for me because it really connected with the colonial way of shutting Indian history away behind glass cases. It really showed how violent that is to Native youth. We have our fun with the Tower of History, using that cut-up video with Paul as the tour guide who's dressed up as a Jesuit priest. There's a lot to laugh about there. But at its core, it's a vestige of an incredibly violent institution. That tower sticks out like the biggest fucking sore thumb you've ever seen in that city. It felt really good for me to connect it to an Indigenous person's experience in Sault Ste. Marie.

J.P. SNIADECKI

This conversation with J.P. Sniadecki was meant to center mostly on *El Mar La Mar* (2017), a feature J.P. co-directed with Joshua Bonnetta. However J.P. also sent me links to seven other films and I watched, or in some cases rewatched, them all with pleasure. J.P. is one of the most curious, erudite thinkers and artists making work today. I've wanted to talk with him for a long time. A trained visual anthropologist, he studied at Harvard as a graduate student where he was a Film Study Center Fellow from 2007–2013, where J.P. met his filmmaking cohort. His first year at Harvard coincided with the first year of the Sensory Ethnography Lab, the university's first initiative allowing graduate students to indulge in a practical course of study where they could make their own films instead of just studying and writing about works of others.

For me, there is an evocation of palpable loneliness in much of his footage, revealing something private and vulnerable while simultaneously vying for communal connection. I find this quality in his camerawork emotionally resonant and something that sets it apart from other work being made by his contemporaries. As a spectator, I'm immersed in the various relationships he builds whether between himself and his protagonists, an individual and community, human-to-machine, human-to-landscape—bespoke variations on experimental and ethnographic space-time cinema.

J.P. has made a lot of work in China, a country he visited as a college student where he promptly fell in love with the culture, language, and manifold complexities of the country. The connections and friendships he's made over decades are still a very fruitful source for his filmmaking. When we spoke in November 2018 he had just returned from China.

PC: Would you describe some of the ways you might prepare when you're on your own shooting digitally versus working with colleagues making something on 16 mm with Bolexes as you did for *Yumen*? Watching that film, I was captivated by this endeavor because I could sense that the group cohered creatively really quickly. You speak the language fluently and China might feel like a second home, but being a perpetual foreigner puts you in a distinct place of solitude, and as I read it, loneliness.

JPS: Loneliness is an interesting thread to think about throughout the work. Most of the projects, whether they're shot on 16 or digital, emerge from this response to place. My pre-production process is more about being a sensing, living, thinking being in a network of connections—as well as disconnections. Just as in a film where a moment or a gesture can grab you, there's something about place or people or environments or particular events that seize you and take hold of you.

The roots of every film are very different, some more interesting than others, but all have to do with autobiography. The idea of *Yumen* began back in this independent film world in China. There used to be something called the Beijing Independent Film Festival that happened every year. But there were always efforts by certain people, the city, or local and national governmental entities to interfere, censor, and generally monkey-wrench the proceedings. One year, we were at the opening ceremony barbeque. People were giving talks and everyone was milling about in the courtyard of the Li Xianting Film Fund in Songzhuang, an artists' village in a suburb in the east of Beijing. Suddenly a bunch of policemen and national security agents came in and started asking for ID cards and basically putting a big dark cloud over the whole opening, telling us to get out of the courtyard.

I saw Xu Ruotao there, a filmmaker I kind of knew and whose work I really liked. From the Harvard Film Studies Center, I had brought over a little stockpile of 16 mm film in hundred foot rolls, a Bolex with three lenses, and about forty-five pans of color negative. Since all the screenings were cancelled he and I sat together and talked. I asked him if he had any interest in working in 16 mm and he did so we began to discuss what we would do. At his house we continued to talk over tea about adopting a sort of 1950s social scientific reportage style, something along the lines of Chen Kaige's *Yellow Earth* [1984] where a soldier from the propaganda department is tasked with collecting peasant folk songs in remote regions of China. We thought we'd adopt that kind of role in our approach to Yumen, a place known to be a quasi-ghost town after the oil production that drove the town's economy dried up. But once my co-directors Xu Ruotao, Huang Xiang, and I actually entered Yumen, this

initial framework was discarded very quickly because we were so impressed by the reality of what was there.

When it comes to discussing the celluloid versus digital decision, for me, that decision has to do with the way we think about the materiality of time. There was a kind of very facile but interesting connection between the fading world of Yumen and Gary, Indiana and the area near Detroit where I'm from, a post-industrial landscape. This coincided with what was then the supposedly fading medium of celluloid, especially around 2012-2013. People were saying it was the end of film. There are, as well, the constraints that are part of the production. For *El Mar La Mar* the decision to shoot in 16 mm was the desire to have a slow, deliberate, dialogue-based process and that lends itself to the indexical quality of the image, of the people and artifacts, animals and ecologies, that we encountered in a photochemical, physical way.

PC: In *Yumen* and almost every other film you've made—oddly, with the exception of *El Mar La Mar*—machinery inhabits those landscapes, presenting another entity that resides there. It's part of your anthropological gaze, the machinery's animation or the animistic quality machines can have. They look alive, as if they have their own agency. Do you know what you want to capture and then go looking for it?

JPS: There's a general kind of awe I have for most things around me that doesn't really have to do with anthropology or filmmaking. Most of the time, I'm just overwhelmed by the world and I tend to be very sensitive to that. One way to communicate that kind of awe or what I consider a mode of affection—even when tinged with loneliness or a harder reality—is to film it.

I'm as interested in the process of making films as I am in being in a certain location with the individuals, animals, machines, and ecologies that comprise it. The disciplines of anthropology and cinema give me the framework and the space for spending that kind of time. Along the lines of a lot of scholarship today, non-sentient beings as well as sentient beings all have an agency and a life force but there are limits to our perception of that. We're all walking around most of the time pretty dulled and dumbed-down both by these conceptual limitations as well as by this particular cultural moment we're in.

PC: What was your initial draw to China?

JPS: I grew up on the west side of South Bend, Indiana, which is pretty far from China, in some ways. But it's also very much tied to the kind of third-tier city experiences that are distinctly not Shanghai or Beijing but more the hinterlands of China

in terms of the cultural possibilities. My mother home-schooled us kids for a couple of years. There was a copy of the *Tao Te Ching* for young adults in the house and my brother and I would read it on a semi-regular basis. Sometimes we'd read passages from Confucius' *Analects* or the *Mencius* or the *Zhuangzi*. That was my introduction to the basics of Chinese philosophy and it stayed with me. As soon as I got to Grand Valley State University for undergrad, a large but largely unknown state school in southwest Michigan, I met a philosophy student who'd just come back from China. He was a senior and I thought he was really cool. He told me I should go check out China if not for anything else but the food.

I learned about a program where you could study philosophy in China for the summer and so I signed up for that. I got a scholarship a couple of years later to spend a full year there as the first exchange student from Grand Valley to go to East China Normal University in Shanghai. It was all about the Chinese philosophy when I first got there. But it quickly became about the reality of China today, the rapidity of life, the rawness and intensity of that urban experience. It was my "big city awakening" like the experience of moving to New York or Los Angeles for my friends back home. In Shanghai, I also had entrée to an international community. Just in my dorm alone there were students from Mali, Iraq, Japan, France, Korea, Sudan, Angola—all these different places.

PC: Let's switch gears to talk about *El Mar La Mar*, a film made in the US but that captures a disorientating and seemingly foreign place—even for most Americans. Here, the landscape becomes your main protagonist. That's true in *Yumen* as well, but in *El Mar* you're not imposing anything performative on the landscape as you do in *Yumen*. What were your initial conversations with Josh about how you would describe the human element? We see people once in a while but you untether images of them from their voices so we're not sure who's speaking. And we don't see the migrants at all—we hear their stories and feel their fear.

JPS: Josh and I went back and forth, discussing the various issues of representation quite a lot.

We liked the idea of a cinema space where audience members could create their own image of the speakers, the image of the story, or the situation being described only by what they could hear. There could be all these possible personal cinemas for the people sitting in the dark. There are tons of films that feature sadness on the human face, the difficulties, and the traumas. We thought we would do something that didn't use that approach and that allowed for different openings into the

experience of the desert. Looking back on it, the other very practical aspect of all this is we didn't have a lot of film stock or any kind of real money to shoot the movie. Shooting entire interviews on 16 mm is quite expensive. [*Laughs.*] Recording voice is obviously a lot more affordable.

Initially, we weren't planning on making a film about the borderlands in the Sonoran Desert. We were actually shooting another project in New Orleans when I had to head west for a residency at Headlands Center for the Arts in Marin County, California. So we drove west across Texas, deciding to stick to the southern route. As we got closer to the borderlands, we saw sections of the wall and took in the presence of the border patrol agents and began to gain a feel for the terrain.

We shot as we drove from west Texas to New Mexico, through Arizona, into California, and up into San Francisco. When we got the developed footage back, we realized that the most interesting, compelling footage was what we'd been drawn to in the Sonoran Desert. We started to do research and connected with Jason de Leon who wrote a really powerful book called *The Land of Open Graves.* Jason's an incredible writer, ethnographer, and photographer. He does multimedia representations that depict the injustices that happen in the Sonoran Desert, the terrible violence inflicted upon people through our government's policy of prevention through deterrence that pushes them to cross this dangerous terrain. Jason introduced us to a lot of his contacts, a huge help in pushing the film forward.

So we kept going down and meeting people and shooting. We tried to understand the situation through our filmmaking process. The film is focused on the Sonoran ecology and for some viewers, perhaps, doesn't deliver the expectation they might have of a more purely human-centric documentary of what's going on there. Probably people can pick up on our politics in the film, although Josh and I have different stances. It's more open than perhaps an activist film would be. So being open, not marshaling forth a message, I think the film can land in a perplexing place for a number of spectators that might be expecting something more didactic.

PC: I'd like to talk about post-production sound work, specifically your long-term collaboration with Ernst Karel. The ways in which you use music are unexpected and really lovely, especially when you film aspects of how music can connect us. We see this in *Foreign Parts* and *People's Park* in very clear ways. But it's also used more subtly such as on the train in *The Iron Ministry* when we can hear all those songs from people's phones and radios while they gaze dreamily out the window at the passing scenery.

JPS: I met Ernst when I was a graduate student at Harvard. When I first got there, I wanted to run away. I'm from the Midwest and the elite culture on the East Coast was something odd for me. I'd spent a lot of time in China but I'd never really spent much time on the American eastern seaboard and it's a different environment that wasn't really for me. But then I met Lucien Castaing-Taylor and Ernst and the other folks who were the early core group of the Sensory Ethnography Lab—Toby Lee, Diana Allan, and Stephanie Spray. I thought: Finally, this is my tribe. I had had a similar feeling when I met independent filmmakers in China.

Ernst was a key member of that tribe at Harvard and having him there from the very beginning was really great for the Lab because just his presence and his acumen as a sound artist emphasized the possibilities of sound and also the importance of core practices for quality field recording. It was the first time graduate students at Harvard had a chance to be enrolled in a production or practice-based course so we were all really excited at having the chance to go out and record, shoot, come back and edit, and share our work together. And we were super lucky because Ernst did the mixing for the films because he graciously felt it was part of his job as the Lab's manager. I don't think he'd ever mixed films before but it was a wonderful benefit to have an unconventional sound mixer coming at work from the perspective of an anthropologist and a sound artist. And as you can tell, one of the things that unites most or all of the SEL films is their attention to sound and their inimitable sound mixes. And that is in large part thanks to Ernst. None of us had any idea what was to come, whether the films were going to be accepted, embraced, or rejected when they went out in the world. They were all of those things, both embraced and rejected from various communities. But I think the creative, compositional, textural and embodied dimensions of the sound mixes really stand out, regardless.

If you do good quality sound recordings and let the fundamental musicality or the complex layers of the existing soundscape register and then bring them into the film and don't overburden it with extradiegetic sound or music or dialogue, I almost guarantee that audiences will tell you the soundscape was amazing. China, as a place of space-time manipulation and compression is just incredibly cinematic. And that goes to the sonic level as well.

Making cinema for me is a vehicle for discovery and experience, not necessarily knowing and mapping out what I want to do. There are still some great films made that way. But this is why I don't make three-act fiction films because the part I really love is the discovery and uncertainty of production. Of course inevitably accidents

and spontaneity arise regardless. But the way some films are made is not really about embracing those things. It's more about trying to limit those things. That ruins the whole premise of documentary, which is supposed to be about exploring the world and the world itself is often beyond our mastery. It's a set of relationships and beings and ecologies that have a kind of power that far outstrips any of our planning or any kind of framework we want to throw on it. A form that doesn't accommodate the fundamental power and elusiveness of the world to some degree doesn't seem all that captivating or fascinating enough to pursue.

LYNETTE WALLWORTH

Australian artist Lynette Wallworth is working at the forefront of moving image work through virtual reality storytelling. In one way or another, her art, video, and installation works have always manifested using some form of augmented and mixed reality technologies that present virtual content in real world environments. Even for her foray into making traditionally linear documentary, the goal of crafting experience for the spectator is paramount, moving us beyond the dimensions we only know through our senses.

In April 2019, Lynette joined the Sundance Institute's board of trustees. In the past, many of her works have screened in the Sundance Film Festival's New Frontier program beginning in 2009 with her installation *Evolution of Fearlessness*, an apt tagline for both her life and work. She also received the Institute's inaugural New Frontier Virtual Reality residency for *Collisions* (2016), a project she made with the Martu Tribe indigenous to Western Australia. For that project, the Institute partnered her with Jaunt VR, a company "at the forefront of developing technology to understand and create immersive content experiences." Jaunt was behind many of the earliest cinematic 360-degree video productions. A second Sundance New Frontier residency placed her at the Technicolor Experience Center in Culver City, California where she did post-production on the mixed reality work, *Awavena* (2018), a project, as she and I talk about, that was realized as a direct result of *Collisions*. *Awavena* describes the story of the first woman shaman of the Yawanawá community in the Brazilian Amazon. For a new walk-through section of *Awavena* called "The Blessing Space," Lynette, along with a team at TEC, created an experience that would enable a participant to impact the ethereal altered state reality of the Yawanawá with his or her own breath.

Lynette also makes work commissioned by the World Economic Forum, held annually in Davos, Switzerland and Tianjin, China, and is a member of the Forum's Global Future Council in Virtual and Augmented Reality. We spoke about her extraordinary journey in January 2019 when she was home in Sydney.

PC: You work in very tactile ways in fact and I'd love for you to speak a bit about your trajectory as an artist that's based her practice on exploring these spaces. Even using the most technologically advanced tools for image making that exist right now, the baseline of your work vibrates at a very deep emotional level.

LW: One of the pathways to various states of being is to trigger emotion, to open up the participant or experiencer of the work to an emotional resonance. But I don't think I set out with a particular drive to make the work itself emotional. There is a great deal of restraint in the work itself. What I've found is that it's this restraint that causes the emotional response or reverberation in the watcher or in the immersive VR experience.

PC: You've garnered attention from an unexpected audience through your work for the World Economic Forum. It's so antithetical to the way this rarefied group of people go about solving all these really big issues. You have the ears and eyes of some of the most important policy and decision makers in the world. That must be pretty heady stuff.

LW: Yes that's true! [*Laughs.*] You mentioned the emotion in the work—let's say the soft diplomacy in the work—that evokes something that is there but not fore-grounded. Inside the work I'm holding a state of inquisitiveness around the story or what I'm trying to evoke in the work, but I'm not an activist affirming one pathway or one approach or one idea. There's an invitation inside the work that allows many people to come to it because that openness in the work is sensed. I try to construct it in such a way that there is a level of openness, that you can feel yourself come to an understanding of how it's impacting you that sets your own thought processes going. That process is the reason I've continued to be invited by the World Economic Forum. Those decision makers, heads of state, and heads of industry are able to experience an immersion deep inside the work, to feel at once the personal effects of it.

PC: In much of your work, you're offering stories from cultures that don't yet have the same kind of access to these tools but can recognize the power to be able to tell their own stories in as authentic a way as possible. You've become, let's call

it, a midwife that helps these stories emerge. You mentioned this dream state of Einstein's to solve problems he couldn't manage to do in his waking hours. Is this how you perceive VR when you're figuring out the technology to tell these stories?

LW: I've been working with new or emerging technologies for a long time now. Technologies change and VR and XR are the latest ones. I worked with augmented reality as far back as 2011 and when I conceived of *Coral*, there were no digital full-domes in Australia, so I had to go to Albuquerque, New Mexico to do a residency in the planetarium there since that was also an emerging immersive technology. I've worked with interactive installations since 2001. The big difference with VR is that it's been commercialized so quickly with so much financial investment poured into the form early on. The Sundance Institute came to me with an interesting offer from the New Frontier program, not from the presentation side, but from the lab side. I was invited to work with one of the VR start-ups called Jaunt, to be there while the company itself was developing the form. We'll all reflect back on this time in VR at some point because at the moment I actually don't know where it's heading in terms of distribution. That's the impact that I would wonder about. Is this going to be in people's homes and if so how will they experience it? Will it become as ubiquitous as television used to be? We don't know the answer to that yet. At the moment, that's still up for grabs, really. What I'm appreciative of is to be able to develop work that might show the possibilities in the form at this stage when it is still emerging, where it's still finding where it's going to fit within our culture.

PC: What was it about your experience with the Martu people that made you so confident that *Collisions* had to be told in 360?

LW: It was so clear that immersive 360 video was really best suited to the kind of storytelling that the Martu do with their paintings. I'd laboriously filmed the emergence of a painting over ten days, taking a frame every eight seconds, recording layer upon layer. That had to be done aerially and then I needed to get back on the ground to shoot close up. I had to engage in two ways of seeing, one very close and then one from a perspective above to get the whole effect. I had developed two large-scale immersive installations with the Martu and there's something about the ability to be placed in that country and in the location of that story that has asked to be shared. It is completely located in place as with any indigenous storytelling. You can't separate the people from their place because their stories are embedded in the country.

So from this residency at Sundance with Jaunt, two cameramen from Palo Alto and I came to this very remote location and put the VR camera down in front of Nyarri, whose story we were there to film. He said: "Oh, it's got sixteen eyes." I knew that I would have to ask him to help me work out what it could see and what it couldn't in terms of sacred or secret places held in the landscape especially when the camera was on a drone flying at different heights. And that was completely not a problem for him. It's very clear in Australian indigenous work that that level of incredible spatial comprehension in every aspect of the country is how they see. So this all-seeing camera made sense to him and to the community. *Collisions* in many ways became an affirmation of what I was imagining, that it was the most powerful immersive form in which Nyarri's story could be shared.

When Tashka—the chief of the Yawanawá people in Acre, Brazil—saw *Collisions* at the Skoll World Forum where we'd met a couple of years earlier, he also had an instantaneous reaction to it in terms of the way it matched the Yawanawá's way of visioning and that was another compatibility between the form and the visioning experience of this community. Tashka took off the headset after watching Nyarri's story and immediately understood virtual reality. He told me that it acts like their visioning medicine does. It opens a portal. It was a beautiful description of what you might say is the transporting aspect of VR. It carries you without your body to a place you've never been. Colors and sounds are intensified as they are in the Yawanawá ceremonies. You meet the elders, and as in *Collisions*, you are given a message. And then you return. He told me that they could use this and told me that now I'd have to come to the Amazon. That's the summation of the conversation we had that led to the making of *Awavena*. Both tribes practice and have different visioning or out-of-body experiences that are deeply embedded in their traditions and in their country.

PC: I want to shift the conversation away from this new technology for a bit to talk about *Tender*, the feature documentary you directed in 2013, a 2D representation of looking at different states with a more traditional storytelling approach. Pain, grief, and resilience are major themes in your work. The issues surrounding death are things that people quickly want to intellectualize and it's rare to see a treatment of death expressed in such a grounded, natural way, particularly in white cultures. The death industry exists precisely to alleviate our responsibility to deal with it if we don't want to or can't. This is a story of a group of extraordinary women challenging that industry.

LW: I can say that from the work that I do it is clear that frequently the most resilient people I encounter are women. Jen, who is the manager of that community center in Port Kembla where the film takes place, is my oldest friend. She'd talk to me about the struggles people in that community were having dealing with the funeral industry. She understood it intellectually because she saw people coming in to get help in figuring out how to get loans to pay for headstones years after a loved one had been buried because they were still paying off the funeral costs. The funeral homes tell them there can be no headstone until the funeral is paid for. Then Jen's mother died and I was with her when that happened. That was when the reality of that situation hit for her. We talked about what could be done.

She came up with this not-for-profit funeral company idea. I told her that if she was going to do that then we needed to film it, not in the way I normally approach work but to make a document that can be shared across the country, to talk explicitly about altering the funeral industry in Australia. So I met with the community and said that if they did this—if they allowed me to film it—we could lift it from a solely personal experience into a universal one and they could change things beyond their community and seed change across the country. And they agreed. That became our contract, really. Jen had tried for seven years to get the funding and no one would fund it. So in all honesty, it was very unlikely to be funded. But I had received funding to do the film and they had received some funding to do workshops. Not money to start the funeral company but to hold workshops to teach themselves the things they would have to do should they actually be able to go ahead. Those two things came together at the same time so we could be in lock step in presenting the seeding of the ideas and thoughts and plans. In the film, you see their struggle because while they're learning about all of this, they must deal with Nigel's impending death, a man who's close to them.

On the back of the film's initial release the community had raised a large amount of money to try and buy an old fire station to set up the entity but they were far from having the amount of money they needed. Part of the film's funding had come from our national broadcaster and they had two opportunities to broadcast it. The first screening was a terrible late-night timeslot and I was ruing the fact that the very people who needed to see it may not know it was on. But the second screening was on a Sunday afternoon. Unbeknownst to me there was a gathering of potential philanthropic investors to consider funding the funeral company the very next day. So the day before this gathering of social investors, *Tender* had screened on the ABC

[Australian Broadcasting Corporation]. What we found out later is that the people who were in that room that had watched it the day before convinced those who hadn't to back the idea.

Today, it exists as a full-fledged funeral company. They've done hundreds and hundreds of funerals and they are now helping others across the country replicate their model. The film acted as a catalyst to unlock those doors that had been locked for so many years. When I asked Jen why she thought the film achieved this she told me that for so long everyone had thought it was a good idea. "But no one could *picture* it." It was such a beautiful acknowledgement of the power of those images, those moments, those frames, and the power of the documentary form. For me, *Tender* is a wonderful tangible story of the way documentary can make something real for us, can help us envision a different reality.

SARA FATTAHI

Watching Sara Fattahi's films is reminiscent of the experience of reading the stories of Gabriel García Márquez, the Colombian novelist known for his multi-generational family tales told through a magical realist lens. Sara's films are intimately told narrative accounts from inside the households of her female relatives and female friends. The penetrating shots and closely-lensed framing of the faces of Sara's subjects—all women—and the daily household rituals of making Turkish coffee, smoking, talking, praying, and watching soap operas, present a circumscribed, mundane existence residing side by side with the world of Sara's imagination. Hallucinatory aspects of shock and displacement take hold. The once-familiar surroundings of her native city of Damascus are under siege and memories from the past and present collapse against one another.

When Sara's début feature *Coma* was invited to the 2015 Viennale, odd as it was, she immediately felt a kinship with the city of Vienna. Upon returning to Beirut, where she had edited and finished post-production on *Coma* and started shooting *Chaos,* the second feature of a trilogy, Sara contemplated a move to Berlin in search of a more stable place to develop and produce her films. However, at the airport she changed her ticket at the last minute and flew to Vienna instead. She has made her home there but she is separated from her family who remain in Syria. Sara's mother and grandmother are the protagonists in *Coma,* and we see how close and dear the three women are to one another.

The ongoing civil war in Syria, which began in 2011, continues to escalate even though Damascus is relatively safe. This only means that the sound and smoke from the bombs the family sees and hears from their apartment fall within close distance

instead of directly into their home. In *Coma*, three generations of women are in self-imposed exile together in the midst of the city center. The film received funding support from Bidayyat for Audiovisual Arts, a non-profit civil organization launched in early 2013 to support and help produce documentaries and experimental films from Syrian makers, something that had never existed before war and terror took hold of the country.

Chaos centers on another pair of women to whom Sara is closely bound. Raja is a close companion of Sara's mother and Sara's known Raja since childhood. Dressed in black, head covered, opaque frames enveloping not only her eyes but almost her entire face, Raja is self-sequestered in her own very dark Damascus apartment, grieving for her murdered son. Sara met Hiba at art school; Hiba sought refuge in the north of Sweden after the death of her brother. The film also takes place in Vienna, Sara's adopted home, and with the words and spirit of Viennese poet and author Ingeborg Bachmann and the physical presence of Viennese actress Jaschka Lämmert, these four ghostly female presences help Sara to explore ideas of home and exile, perpetual dislocation, and how war can steal one's memories.

When I spoke to Sara in December 2018, she was home in Vienna preparing the third installment of the trilogy. As in the first two films, *Calm* will be based on a narrative script written by Sara, and the main protagonists will be women she knows.

PC: *Chaos* takes place partly in Damascus but also in Vienna and a small town in the north of Sweden. In each location, we find women who have cordoned themselves off from the outside world, even when there isn't a war going on outside such as in Hiba's case. Can you talk a bit about the decisions around where you set up your camera and how you would bring yourself into the frame? Even though there are long observational moments, you're also addressed directly by your grandmother and mother in *Coma*, as well as by Hiba and Raja in *Chaos*. However, we only see you in fragments or hear your voice off-camera most of the time. So much is mysterious about your relationships with Raja and Hiba.

SF: Specifically, my interest is in showing the female perspective of the war. *Chaos* presents itself as a portrait of three people scattered in various places and Vienna is where I live now. But I'm much more interested in the female interior instead, in other words where women happen to be based most of the time. It so happens I'm surrounded more by women than I am by men. This was the case in

Damascus as well. What's the definition, let's say, of this world only inhabited by women? The media, in general, sidelines women's stories in favor of politics. There are no stories of us in the general media landscape.

In *Chaos*, the idea was to illustrate a state of mind, not the events taking place in Syria, Sweden, or Austria. It's more about my state of mind, those women I film, and also, somehow, a portrait of my nightmares. My idea was to connect with, understand, and also debate about the catastrophe we're having in Syria. The camera was not just an object to record something physical. I considered it my eyes, my brain, my body and how the physical movement of the camera is an extension of me.

However, in the middle of *Chaos*, there is a scene of me in the MRI machine. I have to say I kind of hate the word "metaphor" and hate to use metaphors in my films. [*Laughs.*] But in this case, there is both a physical and metaphorical scanning because I want to see myself—my whole self. The films, for me, are experiences that enable me to let go of something, my fears, anxieties, even dreams. I didn't use this conceit in *Coma* because I didn't really see that until making *Chaos*. So this is where you see an extreme close-up of my face, just like I frame the other women. The detachment from self is a true state of being. But this was a way to put the parts back together to make my image whole instead of the fragmented parts you see in the first film. That constant fragmentation is destructive.

In cinema, you can collect the sensations, memories and dreams, everything you left behind and knit them together in one piece.

PC: In *Chaos* you're also playing with the idea of doppelgänger, even in the ritualized way you echo some of the domestic tasks in *Coma* such as the opening scene of coffee making. In your own apartment in Vienna, you imitate the way your mother makes coffee in Damascus. Are these ways of giving physical heft to your existence, to take on habits that are imprinted and that bring you comfort? I found that imitative impulse to be very poignant, a simple gesture to bring an absent person closer to you.

SF: Yes, I want to invite my past into this new home or this new flat where I am at the moment. I want to feel home. This is one of the only possibilities to feel home, to cook the coffee the way my mother does and I imitate the same beginning shots in both films. It was my attempt to build some kind of bridge from there to here. But really I don't feel home in this place. All I had were these materials and some thoughts and memories when I left Damascus to come here, an attempt to bring back what the violence in Syria took away. I'm trying to tell the story of how I

remember it and that's very fragmented. The war is the actual division, this violent interruption.

PC: In *Coma* there are these familiar domestic tools you can use to describe your grandmother's state of mind that you don't really have at hand in *Chaos*, specifically what manifests as her nostalgic attachment to watching the television—she is not listening to news reports. When she's not praying or talking to your mother, she's watching old melodramas as your camera lingers on her face. Did she and your mother understand what you were trying to capture?

SF: What you hear coming from the TV is the soundtrack to an old black and white Egyptian film. Most of the audio coming from the television is from a film called *There is a Man in Our House,* an Egyptian drama from 1961 by Henry Barakat. I wanted it to be the sound of memory because growing up in this flat I heard these sounds from almost every corner of the flat, this canon of black and white films from Egypt. I wanted to create an atmosphere where I was watching my family move around like ghosts with that sound in the background. It doesn't really sync with the image but I feel home when I hear that sound; I feel safe. It also contrasted so much with the sounds coming from the city. Damascus was safer than any other city in Syria but we still heard bombs almost all the time. It became something to hang onto to feel safe, something to make me feel I was still alive.

This film was challenging in many ways in the way making a film about people you are so familiar with can be. Creating distance is very difficult. I had to make a plan every day and turn the flat into a kind of bunker. In a war zone you choose a place to observe that is safe and from there I could observe their movements, observe them as human beings, but not necessarily people related to me. After some time, they were very easygoing with the idea of me moving around with my equipment so they never really knew when I was shooting and when I had finished shooting. When they finally saw the film, they were relaxed. The only part that surprised them was the old footage of my grandfather placed as if he were sitting there with us, talking to the camera as if he's still in the same room. This is very emotional for me to talk about because I haven't really seen them since that time. I just saw them in Beirut for a few days this past year. *Coma* is a home I take with me everywhere I am. So from them to me, this film is a huge gift.

PC: Hiba's presence in *Chaos* is magnetic and powerful. Trauma defines her but it's also her shield. Oddly, she reminded me of your mother, something in her eyes and in the way she spoke to you as if there was no reason at all to hide anything.

SF: Even the city itself is female because in Arabic the word for city is feminine [*madina*]. When we talk about empowerment in Arabic literature, we use this metaphor of cities as female. Raja, who is in Damascus, is my mother's best friend and I've known her very well since I was small. I also knew her son all his life. I did not want to make a film about people I don't know. I needed to know them. I am interested in personal films. But my films are not autobiographical—they're not about me, but they are from me and made by me.

Hiba is a close friend. I needed that deep connection and that intimacy to tell this story. There could not be any kind of wall between the protagonists and me. The mystery you felt with Jaschka—Jaschka is meant to be the doppelgänger of the spirit of Bachmann.

My style of working is to write more than I shoot and I write a lot. I write them as fictions with scenes. I'm not trained in cinema but it's my way to control my shots, to control my concept, and to try to understand which perspective I should use so I can enter the film. *Chaos* was more about this process of writing and slowly, slowly, it took form including this space that I wanted represented physically. That's why I asked Jaschka to be a part of it. It was about the circumambulation she makes in Vienna as if she was guiding me through the city. As I said before, it's a state of mind so she also could not be there at all, in fact. This represents my imagination or my nightmare. But she could also be my doppelgänger or Hiba's or Raja's. She has many aspects to her.

PC: We see Jaschka mostly from the back or in quarter profile, and then brief glimpses of her face. We never hear her speak—or we do, but it's in Bachmann's voice. This is a superb actor because her performance becomes key to the whole film. So whatever you discussed together about her posture and body hold so much expression in them that speaks of anxiety, fear, and pain on so many different levels. But she's hidden from us most of the time.

SF: [*Laughs.*] I also always hide myself.

PC: Yes, unfortunately it's a very feminine trait to do that. Every single woman you film is in hiding whether it's self-imposed exile or detachment as you put it—there in body but emotionally somewhere far away.

SF: Working with Jaschka wasn't easy but it was exciting for me because it was the first time I worked with an actress. I was also asking her to be a part of something where she hadn't seen any of the materials so only had to go on what I asked of her. In a general way, she knew the story and what I had done so far. In the film, it would

seem that the scenes with her take place all in one day, from early morning until late at night, even though we shot together for a week. This woman just appears in the middle of the city but the more time we spend with her, the more we are meant to realize the exhaustion coming from her body language, that she's collapsing in a way, holding herself up until she reaches this underground station and then disappears. Jaschka took herself to those states of mind. And then Raya [Yamisha] and I worked together to reduce all of that into what you see in the film. As far as not seeing her face and her silence, in Syria we say that when a dead person visits you in a dream, he or she doesn't speak to you. That person is always silent. And you don't see his or her face clearly. I used this tradition of how we deal with people who have passed away for those scenes we selected with Jaschka. Silence is another language in my films. Jaschka does speak quite loudly, but only with her body.

PC: The polar opposite of this is your portraiture of Hiba. Even though she's fragile, she's also very connected to her dream state.

SF: Hiba's presence is incredible. Her agreement to film with me was a gift, not because I wanted to make a film about her, or her story, or a certain idea about her, but she was essential for me because I needed that kind of treatment too, to connect deeply with somebody so that she could be my mirror. In many ways my time with her was a healing process for both of us. This friendship is really precious on many levels. It goes beyond just the artistic collaboration.

When I decided to go to her home in Sweden, I had zero idea of her environment. But just after a few days, I knew where I wanted to put my camera and the established friendship made it easy to get used to one another again. What surprised me the most when I was shooting with her was that I shot her almost exclusively in extreme close-up. It was only something I realized afterwards, that I had done that subconsciously even though I had written those scenes. It was just me taking sound and filming so when I returned to Vienna and looked at the material it surprised me how all the scenes with those close-ups were very much the same. Some of these close-ups were *very* close. Somehow it seemed to be a translation of this connection, this intimacy I have with her. But I have to say when I watched the film on a gigantic screen and finally really saw how close I did get I became afraid of my own film. I told my producer Paolo Calamita that I had made a *disaster*. He's a friend and told me to calm down, that this is what makes the work unique.

PC: Hiba's presence can sustain those close-ups. It's what draws us into her story—and yours—even more deeply. The scene with the two of you in the forest is

startling and disturbing on many levels. As Hiba is telling you the story of the episode that revealed how sick she was, your own body gives out on you. Why did you keep that in the film?

SF: The scene where Hiba and I are together in the forest was one of the last days we shot together and I wasn't doing well. With the atmosphere she created there in the forest and the story she tells, I really had to pull myself together to hold the camera still. When I first watched that scene where I fall down with the camera, I decided not to use it. When I reviewed the materials again, I saw that I hadn't even realized how badly I was doing. It was, somehow, spooky in many ways for me. I decided I would end the film with that scene because that holds up a part of me that I can distinctly see as a mirror. The camera was so shaky and that illustrated so much of what I was physically feeling in that moment.

PC: Part of what makes it so odd is that Hiba doesn't really react when you fall down. She's so caught up in her own story and its particular traumas as you are caught up in yours. It's a devastating scene in the way that it shows no matter how intimate and close we are with the people around us, no matter how much we think we can share, we are essentially alone each in our own pain, in our own world.

SF: Yes. When I look at that scene now, I think if I had been in Hiba's situation, maybe I would have reacted—or not reacted—similarly. We are both questioning ourselves in these new lives and we are disconnected. We have also moved through those stages and we are in different realities now. But when I fell down with the camera in my hand, it stayed in my hand and you see in the frame that Hiba is holding her hands together; she's holding herself. She is fully imprisoned in her own inner world at that moment.

Specifically in *Chaos*, my obsession was trying to create these feelings with images, to try to film the un-filmable, things you only sense or feel. I wasn't interested in facts because we all have facts about what's going on in Syria or elsewhere in any war zone or conflict zone. What's going on in the human interior zone is something you can't easily reach. My drive was to try to illustrate alienation because I felt and still do feel like an alien all the time. Even in Syria, I was not like most others. I was also strange in my own country. Here in Europe, I'm "the Syrian"—this is what I'm actually called. This kind of alienation that you hold in yourself wherever you go or wherever you try to orient yourself was what I wanted to try and film. How could I translate that visually? In *Coma* my obsession was about trying to capture

every single moment in the life of my family before losing them. I needed to put my finger on something before it was completely gone.

There is similar alienation but also this isolation and disorientation that comes into play in *Chaos*. I felt like a newborn, an orphan. This baby has no family. That's how it felt. These close-ups are there because consciously I knew that's what I wanted. I had written it down. Subconsciously I was moving my body during filming towards those characters seeking protection for them and from them.

In my country, there is no logic to what is going on now—no logic in any aspect of life in general. Many Syrians have left the country. We are scattered around the world; we are a family that is not living together anymore. That is the truth. There is no way to put all those characters in one place. It's impossible. I was obligated to accept those conditions and deal with it and to find a way to connect them. I was that connection or bridge, but a broken bridge in many ways, so wherever my presence happened to be, more times than not it was just a space, a space through another dimension, the dimension of imagination.

ACKNOWLEDGMENTS

The seed for this book was planted in 2008 during a conversation with filmmaker, author, and activist Astra Taylor at a bookstore in Woodstock, New York. We were standing in the film section noticing how so few of the books on those shelves were authored by women. Astra was living in Woodstock at the time and I was attending the Woodstock Film Festival. Her film *Examined Life,* which was playing at the festival that year, inspired me greatly. The format with which she approached long and in-depth conversations with some of the world's most renowned philosophers was very much in line with how I wanted to converse with filmmakers. She told me I should write that book.

I never quite let go of the idea, so ten years later in 2018 I wrote to Astra to see if she could recommend a publisher that would possibly be open to a pitch. She connected me with John Oakes and Colin Robinson at OR Books. And here we are. I am grateful to John and Colin for giving me this opportunity, and particularly to John for his continual encouragement and support. He and the team at OR made it possible for this book to come to light and I deeply appreciate their care and dedication. Thank you, Emma Ingrisani, Antara Ghosh, Marcus Hijkoop, and Damara Atrigol Pratt.

I'm also grateful to all the individuals who were instrumental in helping me with research, ideas, resources, introductions, and access to the materials I needed. This page can by no means hold a comprehensive list of all the people along the way who have inspired and assisted me. Huge thanks, in particular, to Colin Beckett and Thomas Logoreci for astute and essential editorial counsel. Thank you to those who had a direct hand in providing advice and contributing hours of their time to reading drafts and encouraging me throughout the process: Rastislava Mirković, Ina Cohn, Sokol Ferizi, and Scott Macaulay. Thanks also to Clinton Krute and Andrew Bourne

at *BOMB*, Chloe Trayner, Oliver Wright, Peter Taylor, Sonja Henrici, Rachel Stollery, Noé Mendelle, Flore Cosquer, Finlay Prestsell, Steve Holmgren, Gabriel Rufatto, Viviane Letayf, Jasmin Basic, Leah Marino, Raya Yamisha, Ingrid Kopp, Leah Giblin, Nichelle Dailey, Karl McCool, and Florrie Burke.

Special thanks for long-lived mentorship and friendship to: Veton Nurkollari, Sonja Henrici, Orwa Nyrabia, Lisa Leeman, Simon Kilmurry, AJ Schnack, Chi-hui Yang, Chris Boeckmann, Ian Birnie, Sara Garcia, Ángel Sánchez, Rachael Rakes, Srdan Keca, Tabitha Jackson, Kirsten Johnson, Shannon Kelly, Ray Pride, Dennis Lim, Jurij Meden, Brian Geldin, Ariane White, Laura Janssen, Kibibi Springs, Alicia Jackson, Neil Young, Anna Zamecka, Christopher Allen, Jenny Miller, Lena Kilkka Mann, Sebastian Saam, Clare Molloy, and Natalia Imaz. My everlasting love and admiration go to my parents, Nat and Ina, and to my sister Mindy.

I am most deeply indebted to the subjects of this book for their time, trust, open-heartedness, and collaboration. Thank you.